SECRET GARDENS
OF SOMERSET

ABIGAIL WILLIS

PHOTOGRAPHS BY
CLIVE BOURSNELL

SECRET GARDENS OF SOMERSET

A PRIVATE TOUR

F FRANCES LINCOLN

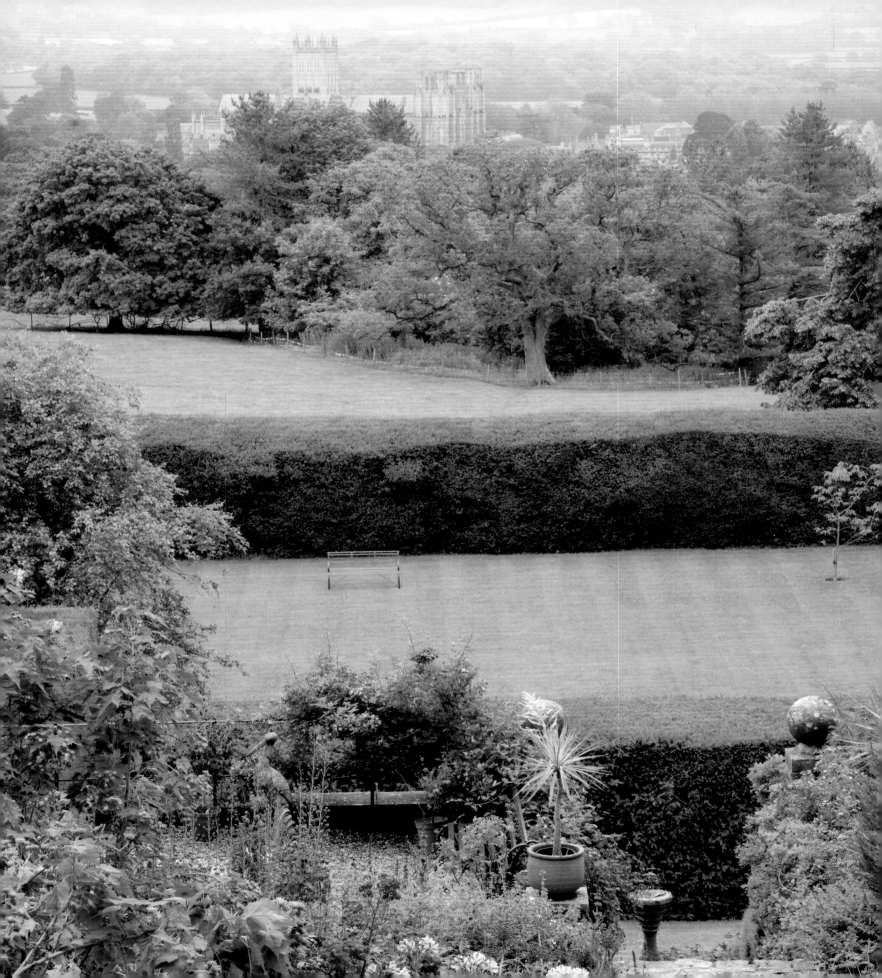

I would like to dedicate the book to my ever-supportive husband and 'first reader' Alexander Ballinger, and the memory of my much-missed parents-in-law, Richard and Penelope Ballinger

First published in 2020 by Frances Lincoln, an imprint of The Quarto Group.
The Old Brewery, 6 Blundell Street
London, N7 9BH,
United Kingdom
T (0)20 7700 6700
www.QuartoKnows.com

Text © 2020 Abigail Willis
Photography © 2020 Clive Boursnell
Copyright © The Quarto Group 2020

ISBN 978 0 7112 5222 6
Ebook ISBN 978 0 7112 5223 3

10 9 8 7 6 5 4 3 2 1

Designed by Anne Wilson

Printed in China

HALF-TITLE A beautifully planted stone font makes an elegant eye-catcher in the Yew Walk at Cothay Manor.
TITLE Africa was the inspiration for the exuberant wildflower meadow borders at Stoberry House.
LEFT Wells Cathedral is the splendid backdrop to the Arts and Crafts garden at Milton Lodge.

Contents

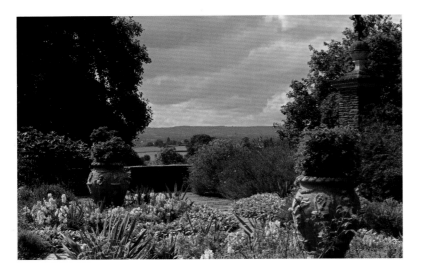

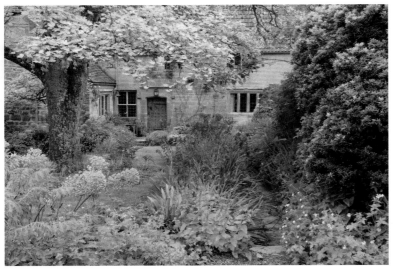

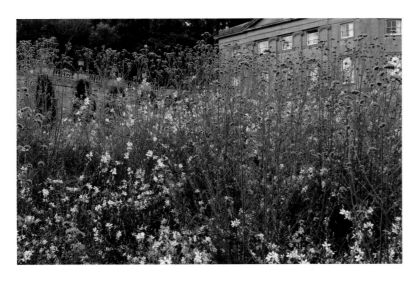

Introduction

SOMERSET STEPS INTO the limelight every summer for the internationally revered Glastonbury Festival and its 'three Cs' (cricket, Cheddar cheese and cider), but it is the county's outstanding gardens that should be grabbing our attention. Blessed with a mild moist climate and fertile soil, Somerset has long been a good place to garden. The remarkable trilogy of historic gardens at Hestercombe (see page 78) bear witness to centuries of creative garden making, and thanks to Margery Fish at East Lambrook Manor (see page 48) Somerset can claim to be the birthplace of modern cottage gardening. But Somerset's gardens are not preserved in aspic; at Iford Manor (see page 86) a new generation is reinvigorating an iconic garden, and within the past ten years alone high-profile new gardens – such as those by Piet Oudolf (see Hauser & Wirth Somerset, page 72) and Oehme, van Sweden (see The American Museum and Gardens, page 8) – have put Somerset in the vanguard of contemporary gardening.

Horticulture has shaped the land here. Horticultural peat was extracted from the Levels on an industrial scale between the 1960s and 1990s, and, although many gardeners have forsworn this non-renewable medium, peat digging continues today albeit on a much smaller scale. The nursery trade too has flourished here, and featured such notable plantspeople as James Allen (the Victorian 'Snowdrop King' of Shepton Mallet) and James Kelway (founder in 1851 of the eponymous nursery, which is still the UK's largest grower of peonies and irises). The modern herbaceous border would be the poorer without such indispensable selections as *Papaver* 'Patty's Plum' and *Geranium* 'Rozanne', both 'raised in Somerset'.

The county's varied geography is part of its allure and the borrowed landscapes it offers to gardeners are second to none. As well as the low-lying Levels, its borders encompass a Jurassic coastline, pastoral vales and remarkably diverse hill ranges – the Mendips, the Poldens, the gently rolling

LEFT TOP The Dutch Garden at Hestercombe is a superb example of a Lutyens and Jekyll collaboration, as well as being part of a much-acclaimed and pioneering garden restoration.
LEFT CENTRE At East Lambrook Manor the intricately woven tapestry of cottage plants epitomizes a uniquely English style of gardening.
LEFT BOTTOM Confident colourful perennial planting at The American Museum brings contemporary American garden design to Somerset.

Mid Somerset Hills, and to the west the Blackdown, Brendon and Quantock hills. Therefore many gardens in these pages revel in stunning hillside settings (see, for example, Milton Lodge Gardens, page 104, and Barley Wood Walled Garden, page 14), while others such as Cothay Manor (see page 40) weave their unique magic on level ground, or like Kilver Court (see page 92) and The Bishop's Palace (see page 28) hold their own against inspiring architectural backdrops.

More than ever Somerset is worth the detour, but don't expect cookie-cutter 'English gardens'. This county has always been independent minded; it's not as 'smart' as the Cotswolds or Wiltshire. When asked to define Somerset's appeal, the gardeners in this book responded with variations on a theme. 'It's unpretentious', 'it's a working county, not a museum', they would comment approvingly: 'It's not been "tidied up".'

Thus liberated, Somerset's gardens can be bracingly non-conformist as you'll discover at Midney Gardens (see page 98) and Stoberry House (see page 118), and it's perhaps not surprising to find pioneering organic gardens within their ranks too. This book includes several inspirational examples including Joan Loraine's Greencombe Gardens (see page 66), organic since 1966, and Sarah Mead's contemporary, chemical-free site at Yeo Valley Organic Garden (see page 130).

Somerset is a large county and, although I've lived here for twenty years, one of the joys of writing this book has been the chance to explore it in more depth over a glorious year. The gardens in these pages will similarly take you on a cross-county tour and I can think of no better introduction to Somerset, particularly when accompanied by Clive Boursnell's beautiful photographs.

Whether visiting Somerset for the first time, or the fifth, its gardens will always be rewarding, for like all the best ones they are living works of art and are continually evolving. I hope you enjoy discovering them too.

RIGHT TOP Somerset's hill ranges are heaven sent for gardeners in search of dramatic borrowed landscapes. Here the Mendip Hills form the panoramic backdrop to Barley Wood Walled Garden.
RIGHT CENTRE In the shadow of Wells Cathedral lies The Bishop's Palace, whose ancient gardens radiate tranquillity and spirituality.
RIGHT BOTTOM Greencombe's location on the Somerset coast provides a sheltered microclimate for its organic woodland garden.

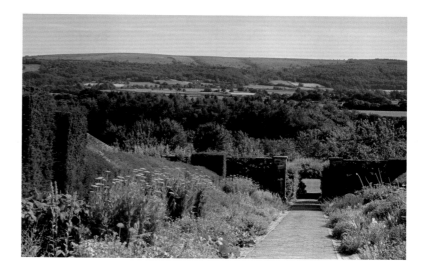
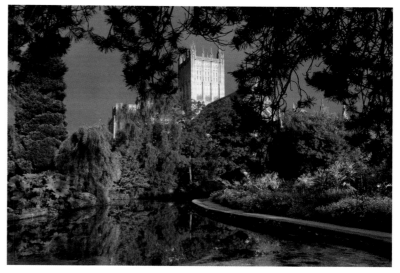
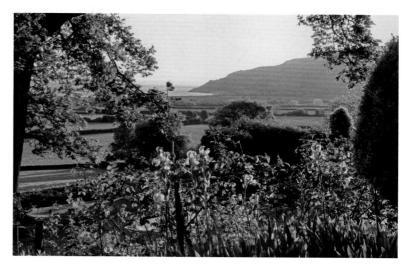

1
The American Museum and Gardens
Claverton

JUST A COUPLE OF KILOMETRES from the World Heritage city of Bath is the museum's home at Claverton Manor, a honey-coloured stone mansion designed by Jeffry Wyatt in 1820 and overlooking the Limpley Stoke Valley, at the southernmost tip of the Cotswolds Area of Natural Beauty (AONB). It is this dramatic hillside setting that the museum's latest acquisition — a bespoke new garden by American architectural landscapers Oehme, van Sweden (OvS) — responds to with thrilling elan.

The American Museum in Britain was founded here in 1961 by Dallas Pratt and John Judkyn, an Anglo-American couple who used their collection of American decorative and folk art as the starting point for a groundbreaking museum that would tell the American story from the days of the early settlers onwards to a British audience.

Period interiors, shipped across the Atlantic and painstakingly reassembled in Somerset, have been a popular feature of The American Museum from its inception, and in 1962 the museum created an outdoor 'room', a recreation of George Washington's Upper Garden at Mount Vernon. Later an American Arboretum and a Lewis and Clark trail were added to the 6-hectare/15-acre gardens.

But by 2011, when the museum celebrated its fiftieth anniversary, the Mount Vernon Garden was overgrown and out of date, its 1960s' interpretation having been overtaken by new research at the original Mount Vernon in Washington DC. The rest of Claverton Manor's 50-hectare/125-acre estate meanwhile remained tantalizingly untapped, and it was this situation that prompted the museum's trustees to commission a new garden as part of its strategic plan for the museum's next half century. 'We wanted to enhance the immediate environs with proper gardens that complemented the house and its setting and which were completely accessible to everyone', explains the museum's director, Richard Wendorf, 'and of course we wanted an American designer.'

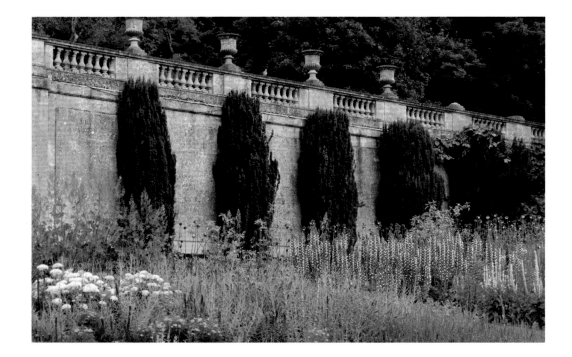

LEFT The fastigate yews (*Taxus*) against the nineteenth-century curtain wall echo the vertical accents of *Acanthus hungaricus* 'White Lips' and plume poppy (*Macleaya cordata*) in the New American Garden.

RIGHT Layered planting in the New American Garden creates interest at different heights, from the ground-level pyrotechnics of *Coreopsis verticillata* 'Zagreb' and *Liatris spicata* 'Kobold' to soaring *Allium* 'Summer Drummer'.

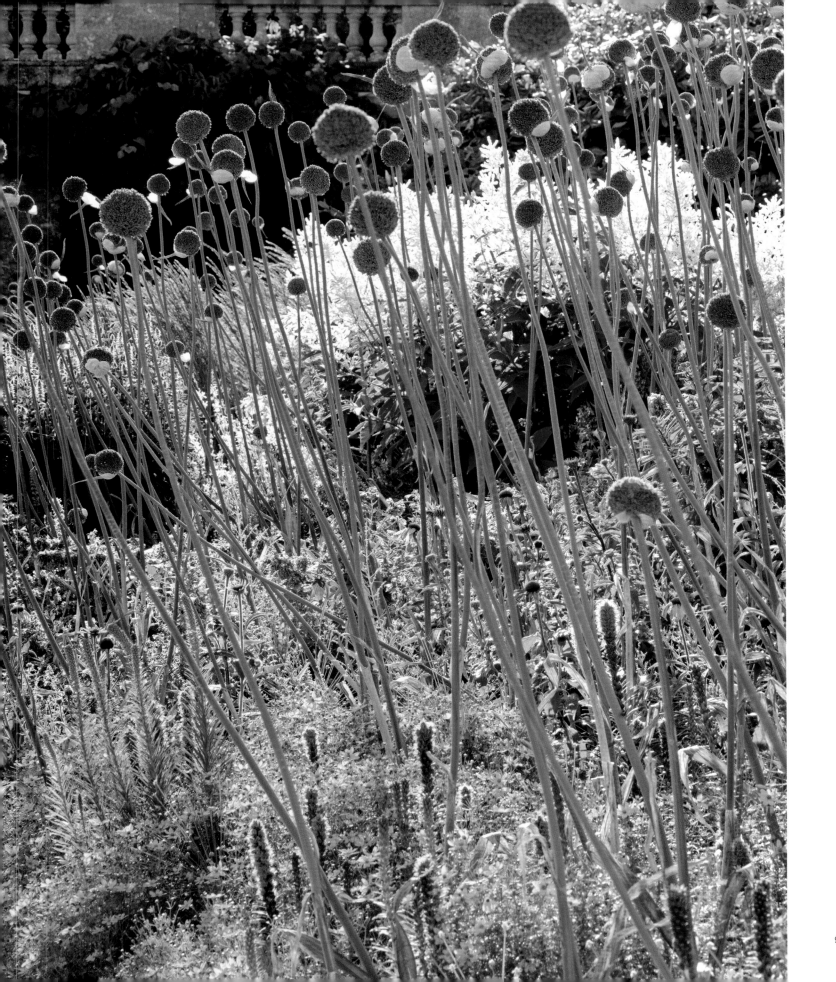

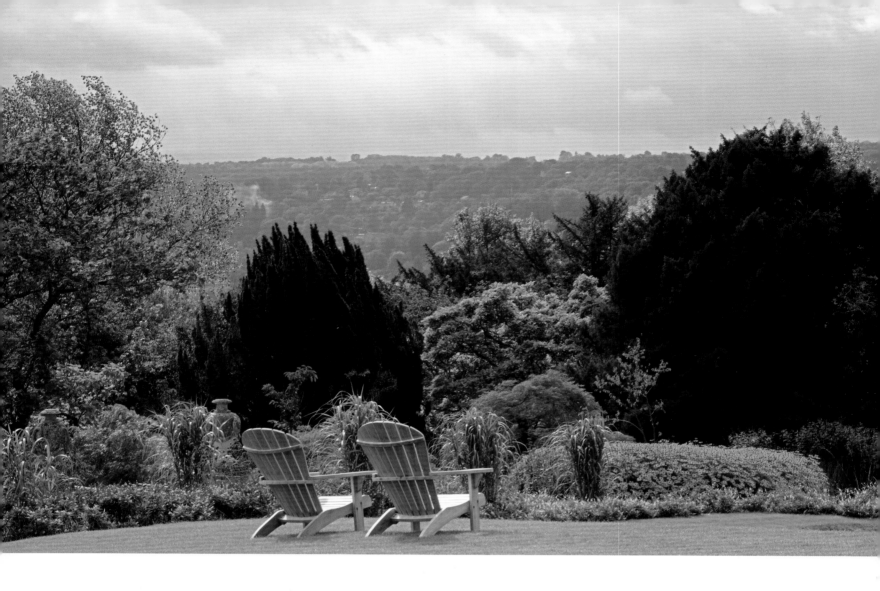

OvS was an inspired choice. Founded in 1975 by landscape architects James van Sweden and Wolfgang Oehme, the partnership pioneered a radical style of gardening that became known as the 'New American Garden'. Placing ecology at the heart of their practice, OvS shunned the ubiquitous American lawn in favour of a naturalistic tapestry of sustainable hardy perennials, grasses and native plants, deployed on a grand scale. This concept of beauty based on nature and its systems blazed a trail for the New Perennial Movement in the 1990s.

Hands across the sea

Work on the museum's own 'New American Garden' began in 2012, six years before it opened to the public. As Eric Groft, the second-generation OvS designer responsible for the project, recalls: 'The first step was to draw up a landscape inventory, recording all the physical features of the site, its soils, hydrology and solar orientation.' A master plan followed, and divided the estate into four historic 'campuses' to tell the American garden story on a cinematic scale.

The eighteenth-century Colonial Campus nearest the manor was earmarked as the first phase. Planning permission took a tortuous two years to secure (during which time Richard Wendorf raised the necessary funding from supporters in the US), and the groundworks began in early 2018.

With OvS in Washington, building the garden was a transatlantic effort. Local landscape architect Tom Chapman was on site regularly and provided extra design solutions where needed, coming up with the concept of the grass Amphitheatre, which doubles as landform art and open-air performance space. It was down to head gardener Andrew Cannell and his team of dedicated gardeners and volunteers to implement Eric's planting scheme. This marathon endeavour over the hot summer of 2018 involved thousands of perennials, hundreds of shrubs and roses and was followed by 30,000 bulbs in the first autumn.

The scheme actually starts in the car park, from where an accessible path leads to a pair of chinoiserie entrance pavilions designed by the Nash Partnership in Bath. These take their

When it comes to location, location, location,
The American Museum ticks all the right boxes.

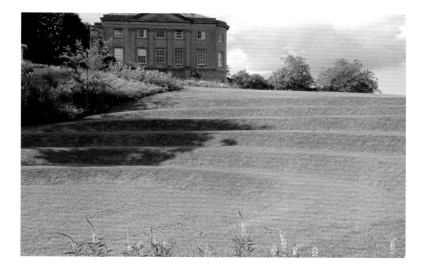

inspiration from Regency follies and tea caddies and allude to America's China tea trade (a story told inside the museum). The latticework screens through which one glimpses the garden and its panoramic view are a revelation in more ways that one, because this vista had previously been obscured by thickly planted evergreens.

Immediately below the pavilions, the American Rose Garden packs a powerful floral punch. Roses are so synonymous with pastel pretty 'English gardens' that it is refreshing to see American cultivars such as 'Mister Lincoln' and the cherry red 'Knockout' radiating New World confidence in Somerset. These and heirloom varieties such as 'Harrison's Yellow' (the Oregon Trail rose) were chosen not only for their American provenance but also because their freeform habit would associate well with the informal style of the adjacent New American Garden.

The Winding Way, which charts a serpentine course around the garden, offers glimpses into American history as it unfurls. Reminiscent of Thomas Jefferson's Winding Walk at Monticello, his estate in Virginia, this wheelchair-friendly path is waymarked by portrait busts of six American Worthies by British sculptor Angela Conner.

Signature plants

The DNA of OvS is also embedded within the design. Blocky planting near the Rose Garden recalls its early work, with sturdy stands of signature plants including *Achillea* 'Coronation Gold', *Macleaya cordata,* coreopsis and rudbeckia. Eric has also used structural plants such as *Hylotelephium* (Herbstfreude Group) 'Herbstfreude' and *Acanthus hungaricus* to 'anchor' the corners of borders. It is a typical OvS touch, although Eric has been surprised at how the plants have performed in Somerset: 'They have just gone berserk – I had no idea that the acanthus would become seven to nine feet!'

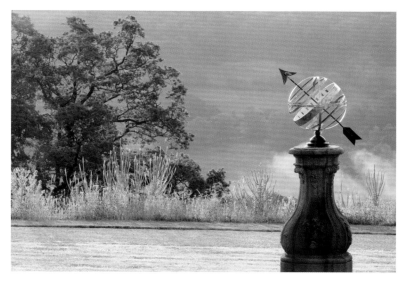

OPPOSITE The South Lawn is the perfect vantage point from which to enjoy views over the Arboretum to the wooded hillside of the Limpley Stoke Valley.

RIGHT TOP The grass terraces in the Amphitheatre encompass a drop of some 15m/50ft.

RIGHT CENTRE An armillary sphere makes a punctuation mark on the South Lawn.

RIGHT BOTTOM The stone eagles guarding the entrance to the Arboretum were sourced by the museum's founders.

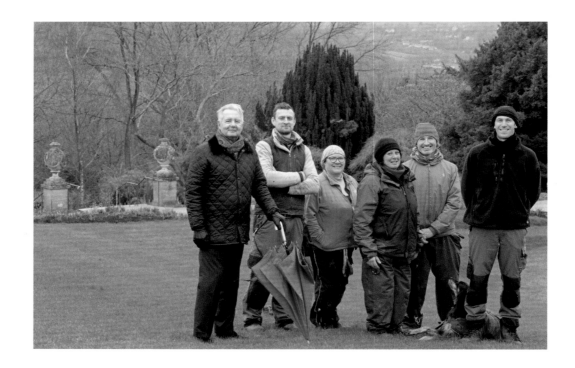

The vertiginous planting is further underscored by masses of the toweringly tall, late-flowering *Allium* 'Summer Drummer'.

The area near Mount Vernon brings the OvS story up to date with references to the firm's second-generation work at the New York and Chicago Botanical Gardens. Here plants such as *Aster* 'Raydon's Favorite' and *Rudbeckia laciniata* 'Herbstsonne' channel New York while *Gaura lindheimeri* 'Whirling Butterflies' and *Molinia caerulea* subsp. *caerulea* 'Moorhexe' stand in for Chicago.

Designing in the OvS idiom

Wisley-trained Andrew has been living and breathing the New American Garden since his appointment as head gardener in 2015. As part of his research, he travelled to the States to see OvS designs *in situ*, as well as Mount Vernon, and he liaises regularly with Eric.

While keeping the garden true to Eric's concept, Andrew has been able to flex his creative muscles, notably designing the East Lawn borders in the OvS idiom. His tiered plantings of *Artemisia lactiflora* 'Elfenbein', *Deschampsia cespitosa* 'Goldtau' and *Echinacea pallida* take full advantage of the garden's easterly orientation to catch the early morning sun as it rises above the hills.

For 'Mount Vernon' — an American potager with ornamental and productive plants — Andrew has sourced a bounty of heirloom varieties such as 'Kentucky Wonder Wax' French or pole beans and asparagus 'Connover's Colossal', which was developed in New York in the 1860s and, perhaps somewhat belatedly, awarded an Award of Garden Merit (AGM) by the Royal Horticultural Society (RHS) in 1993.

Mount Vernon is a sunken garden so its quadriform box (*Buxus*) parterre is a particularly significant feature. At The American Museum this has been redesigned to reflect how it looked in 1799, the year of Washington's death, and it marshals some two thousand *Buxus microphylla* 'Herrenhausen' in a fleur-de-lis pattern, to commemorate Washington's friendship with the Marquis de Lafayette.

Andrew manages the site ecologically, in line with the OvS ethos, and the garden has responded in kind. By easing off his mowing regime, Andrew has been rewarded with spontaneous swathes of dyer's rocket (*Reseda luteola*) and evening primrose (*Oenothera*) along the lower edge of the South Lawn — two architectural wild flowers that are perfectly in keeping with the New American Garden.

The New American Garden at Claverton realizes James van Sweden's long-held ambition to design a garden in Europe. Happily Eric was able to tell his old mentor about the commission before van Sweden passed away in 2013. 'Van Sweden had been good friends with many English twentieth-century gardening greats — John Brookes, Rosemary Verey and Christopher Lloyd — so for us to be represented in the UK meant a great deal to him.'

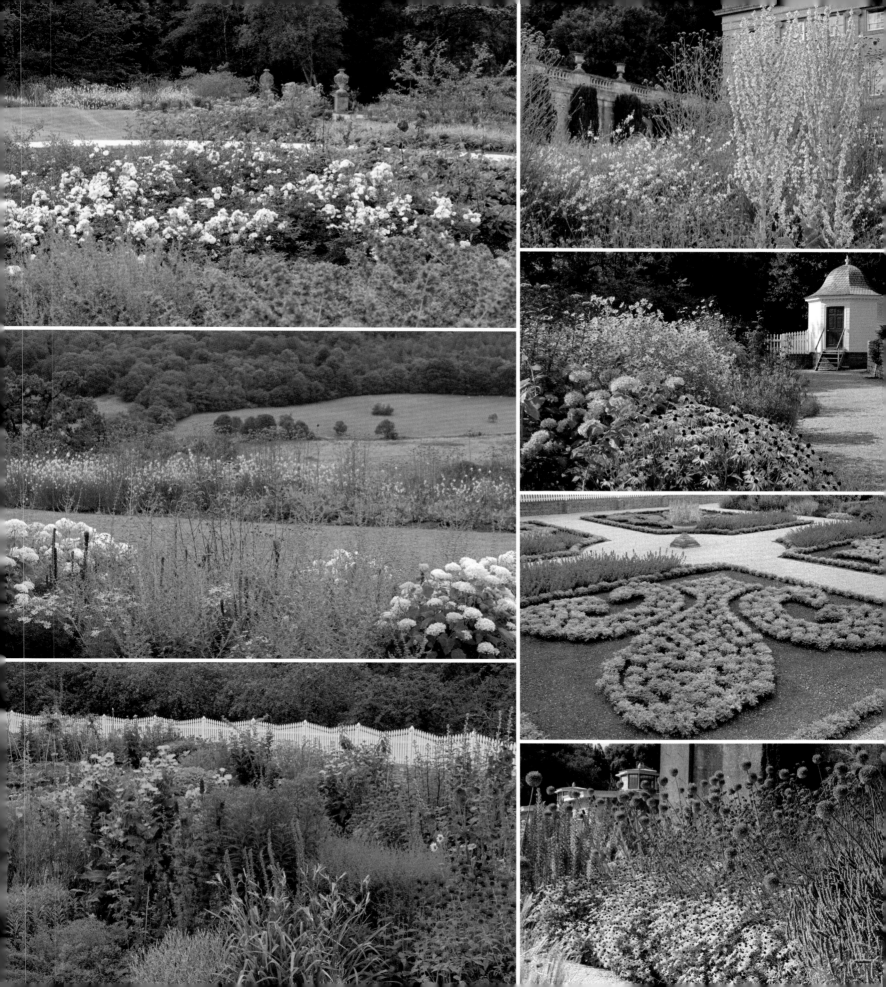

2
Barley Wood Walled Garden
Wrington

SOMERSET'S GEOGRAPHY is defined as much by its hill ranges as by its famous Levels and, although many gardens in this book enjoy glorious hillside settings, none perhaps puts their incline to such practical use as Barley Wood Walled Garden.

Basking on a gentle, south-facing slope with a panoramic view across the Vale of Wrington to the Mendip Hills, this Victorian kitchen garden has reinvented itself for the twenty-first century. As well as being a zero food kilometres pioneer, it is also a showcase for traditional and radical horticulture, and it throws in a (Michelin-listed) restaurant and a community of artists for good measure.

Unusually, the garden at Barley Wood is at the front of the house — an indication that it was intended as a showpiece for its owners. The view certainly comes with bragging rights, being aligned perfectly with Burrington Combe, the limestone gorge on the opposite side of the valley and whose 'Rock of Ages' is believed to have inspired the hymn of the same name.

Barley Wood Garden has had a sense of purpose since 1901, when it was built for the Bristol-based tobacco magnate Henry Herbert Wills.

But like so many places, the walled garden eventually fell into disrepair. The Barley Wood estate was split up in the early 1970s; by the early 1990s developers were circling.

Fortunately the garden was rescued by Ian Hillman, who purchased it in 1993. On walking through the top gate he was immediately smitten. 'It was a combination of the view, and the aura of the whole garden, I just loved it', he recalls. 'And I had a feeling that it would be quite happy if I was the one who put it back.'

LEFT The Walled Garden, which looks out to the Vale of Wrington, capitalizes on its south-facing slope by having its lower walls 1.2m/4ft shorter than their opposite counterparts.

RIGHT The herbaceous borders have the most challenging conditions, being the hottest in Barley Wood Walled Garden, so they are mulched each winter with a mix made from hedge clippings.

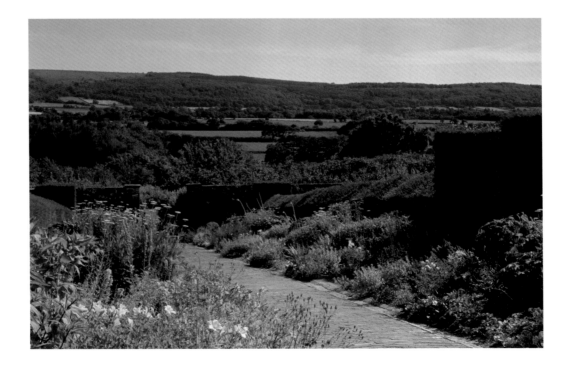

And put it back he did. The productive areas were grassed over, and broken land drains mended. Then Ian, a traditional builder with a passion for using vernacular materials, began to restore the old estate workshops. It was his best friend Tony King, a Royal Naval helicopter observer based in Cornwall, who saw the garden's potential and suggested that Ian 'do a Heligan', having taken him to visit the recently restored Lost Gardens in 1994.

Heirloom fruit

Reconstruction of Barley Wood's Walled Garden started in 1998, with Ian gleaning valuable insights and inspiration from

ABOVE The sturdy yew hedges provide the dark green foil for a colourful display of herbaceous plants, whose diversity reflects that of the productive garden.
OPPOSITE The garden is intensively worked. As soon as one crop comes out, another replaces it: 'We've always got something ready to go in', says head gardener Mark Cox.

BBC TV's *Victorian Kitchen Garden* series and accompanying book. One of the first things he did was to restore the paths, replacing tarmac with brick on the central pathway and relaying the bricks on the side paths in sand – previously they had been set in concrete. Ian's next step was to restock the soft and wall-trained fruit, choosing nineteenth-century varieties such as 'Doyenné du Comice' and 'Beurré Hardy' pears, 'Laxton's Delicious' plums and, on the east-facing wall, the heirloom dessert cherry 'Black Eagle'. Ian also recreated the box (*Buxus*) hedges around the borders, adding in some cheeky topiary animals for fun. Handsome as they are, the hedges serve a practical purpose because they are sturdy enough to keep the soil from running away downhill. Box blight has so far been held at bay by following the traditional practice of trimming the hedging on Derby Day (the first Saturday of June).

By 1999 the project had gathered momentum. The greenhouse had been restored, new asparagus crowns planted and the double herbaceous border, which runs like a colourful spine

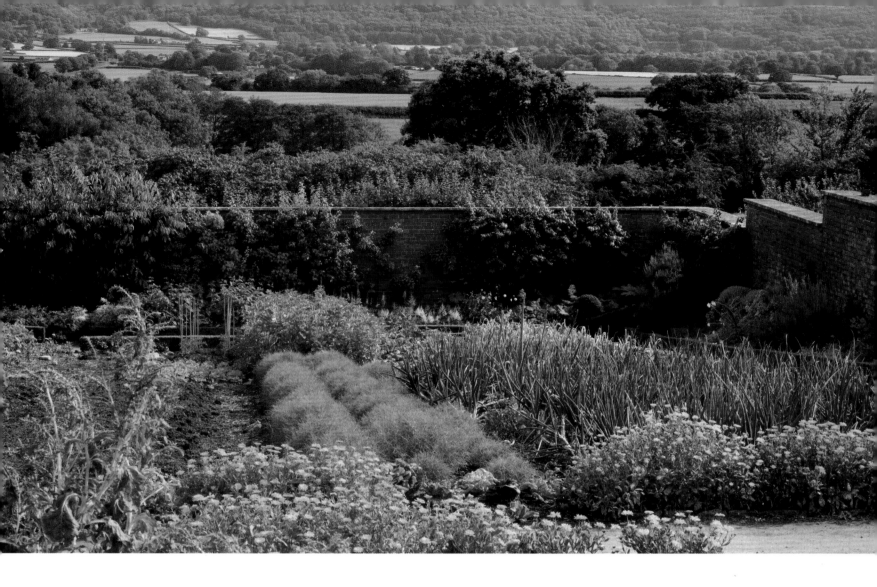

through the centre of garden, reinstated. In 2000 the garden, productive once more, was opened to the public, with a café in the old orangery, and artists' studios in the estate workshops.

High-impact herbaceous

Barley Wood's show-stopping herbaceous borders are the work of Ian's wife Monique and gardener Martine Bavetta. Extending to nearly 60m/200ft long and 3.5m/11½ft wide, the borders are planted for biodiversity and a long season of interest from spring to autumn. On this scale planting needs to make an impact and Monique and Martine have used stands of statuesque *Achillea filipendulina* 'Gold Plate' and *Echinops* 'Nivalis' as the backdrop to a colourful mixed scheme that also includes *Anemone tomentosa* 'Robustissima', lysimachia, bergenia and penstemon. The borders' hot microclimate and due south orientation are a challenge, but drought-tolerant *Echinacea purpurea* and *E.p.* 'White Swan' have proved successful additions, as have traditional border plants such as sweet Williams (*Dianthus barbatus*) and dahlias.

A design for growing

Having got to know the garden intimately, Ian is full of admiration for its Victorian designers. 'They really knew what they were doing', he says, pointing out the smartly chamfered yew (*Taxus*) hedges, which were designed to disrupt wind eddies. These living windbreaks are cut with spirit-level precision every autumn by Josef Mazur, who also helps with mowing and tree pruning. The garden's red brick walls, which absorb and radiate heat from the sun, are calibrated to the slope, and the gate in the south wall can be opened to let the cold air escape in the event of a frost.

Within the warm embrace of its walls the garden achieves a gain of about six weeks on the season.

Spare the spade and spoil the soil

The garden has been managed on organic principles since it opened, and for the past decade has been run by Mark Cox, an evangelical convert to no-dig gardening. Mark discovered its benefits on a course run by Somerset-based gardener Charles

Dowding, an expert on the method, which was pioneered in the 1930s and 1940s at Levens Hall by head gardener F.C. King. 'We used to spend two days a week weeding', he reports, 'but now the mulch locks the weed seed in a layer where they are not disturbed and don't geminate.' Another plus point is that the soil stays put; before Mark's no-dig epiphany, a mechanical digger was needed to move it back up the hill.

Thanks to year-round mulching with compost and manure, Barley Wood's soil radiates vitality. Even the compost heaps are on message, and are allowed to break down naturally without being turned.

As well as staples Mark grows cut flowers such as dahlias and sweet peas (*Lathyrus odoratus*), and more adventurous vegetables such as agretti, a succulent Mediterranean annual.

The garden that once fed 'the big house' now feeds the local community, through a veg box scheme and farmers' markets. Mark delivers daily to The Ethicurean, the on-site restaurant whose chefs – brothers Iain and Matthew Pennington – are known for their creative, ethically sourced, sustainable and seasonal British food. Zero food kilometres never tasted so good, especially for Mark's heritage tomatoes such as 'Blush' and 'Paul Robeson', which do not travel well. 'Mark's tomatoes are on another level', confirms Iain Pennington, 'but whatever Mark grows we take.'

Walled gardens such as Barley Wood used to be run by large teams of gardeners, so for Mark, his assistant Ellie Wimshurst and ad hoc volunteers working here is all-consuming. Ten years on the garden is quite literally under Mark's skin; he is so devoted that he has a tattoo of the garden inked on his back.

Pressing matters

Barley Wood's bounty is not just edible; thanks to its apple orchards it is also deliciously drinkable. This too is down to Ian's friend Tony King who encouraged Ian to make juice and cider from the garden's underutilized apples.

For Barley Wood's enterprise Ian sourced two antique Somerset cider presses, and built the circular cider barn to house them, using Douglas fir timber grown on the estate. He planted a second orchard, stocking it with Somerset cider apples such as 'Harry Master's Jersey', 'Yarlington Mill' and 'Kingston Black'. Some of the varieties have practically zero-kilometre credentials: for example, Ian found rarities such as 'Black Vallis' and 'Red Vallis' nearby and grafted them himself.

Cider production is now in the hands of Mike Atkins and Isy Schultz, but all soft fruit and tree care remains Ian's province, with assistance from Josef. 'Pruning is a year-round operation here', he says, 'although we prune the pears and apples through the winter.'

Barley Wood Walled Garden has come a long way since Ian and Tony's trip to Heligan. Sadly Tony was killed in the Iraq War in 2003, but the garden he envisaged endures, a vibrant and inspirational living memorial. 'If it wasn't for Tony dragging me up to Heligan and saying "You could do this" ', says Ian, 'I can't say for certain that this is where we'd have ended up.'

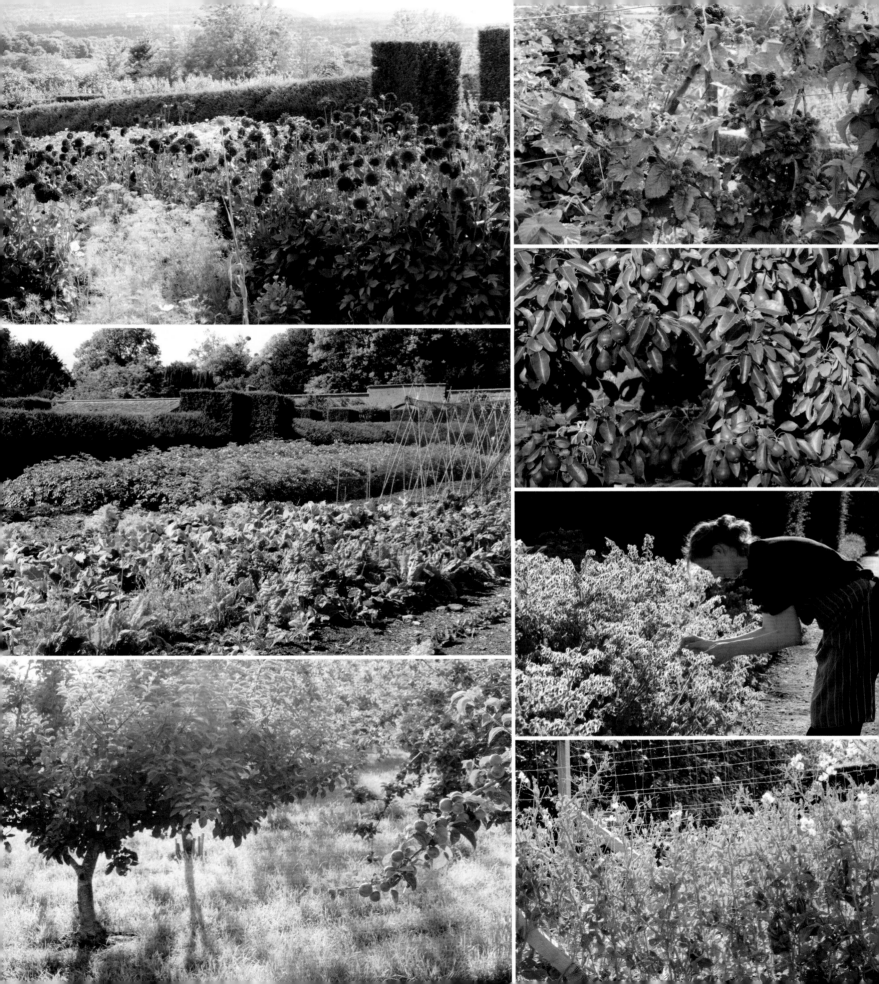

3
Batcombe House
Batcombe

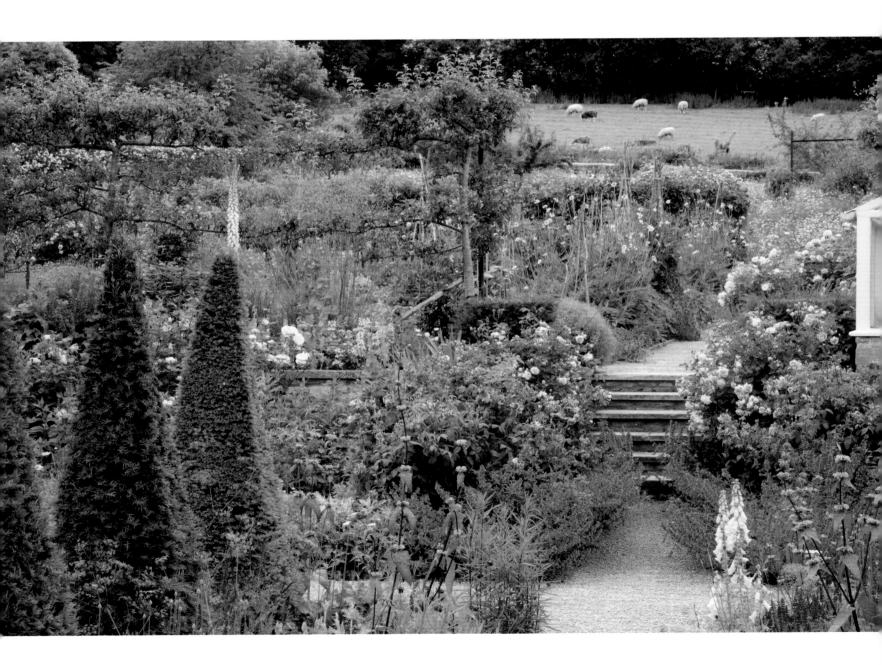

A PLACE OF GREAT NATURAL BEAUTY was top of the search criteria when Libby and Alexander Russell were house-hunting for a family home in the countryside. They found their dream location at Batcombe, one of the prettiest villages in east Somerset, whose origins stretch back to Saxon times, and which today is a thriving community that lies enfolded into the steep valley of the river Alham between Bruton and Frome.

'The house needed quite a lot of work', recalls Libby, 'and the vendor dropped me off in the meadows belonging to the property and told me to walk down. From the meadows there are fantastic views to Creech Hill and Glastonbury Tor and by the time I got to the house I had fallen in love with the whole place, it was so beautiful.'

The house in question is Batcombe House, a handsome former rectory whose classically symmetrical, ashlar masonry facade was added in the late eighteenth century by an upwardly mobile rector. Its grounds were also in need of attention, providing the ideal blank canvas for Libby, a garden designer who worked for many years for the renowned designer Arabella Lennox-Boyd before setting up her own practice, Mazzullo + Russell, in 2014.

Working as her own client, Libby followed one of the cornerstones of her practice – to 'let the site inspire the design' – and the garden that she has lovingly created over the past fifteen years is notable for the sympathetic ways it responds to its setting. 'It's a Somerset garden', says Libby, 'so there's a softness about it; I didn't want it too rigid.'

While this hillside terrain enjoys glorious views to the woods and fields on the other side of the valley, its lowest area is a damp frost pocket that loses the light early. 'It's a tricky site', admits Libby. 'The way the land falls down towards the house could feel oppressive, so my approach was all about pushing the garden back and opening it up.'

OPPOSITE A bucolic borrowed landscape forms the horizon of the Walled Garden and its sequence of terraces.
BELOW A flower-filled path leads through the Potager to the Kitchen Terrace and the Pointillist Border.

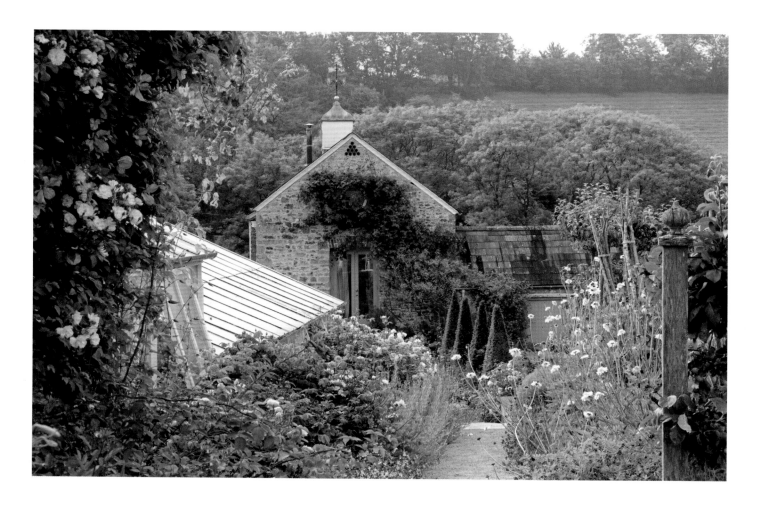

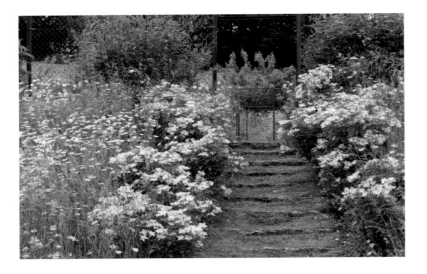

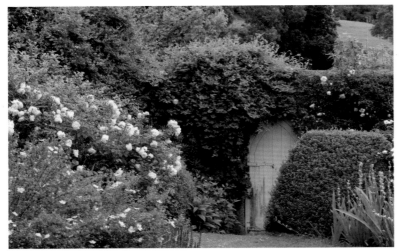

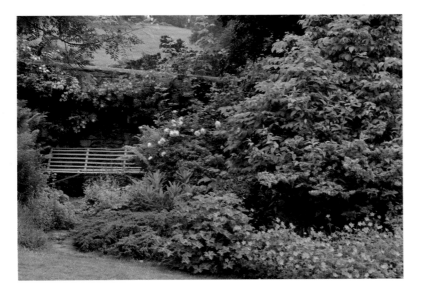

Libby Russell's garden is testament to her passion for seeking out the best plants.

Just as she would with a client, Libby began with a master plan, and divided the 1.2-hectare/3-acre garden into an enclosed family garden and a larger lawned expanse. Implementing the scheme in phases, she started with the Walled Garden, which rises in a series of terraces from 'ground floor' Kitchen Garden up to a Potager and on to the swimming pool and tennis court terraces.

A wildflower bank, studded with hip-bearing roses, separates the two sporting arenas. The modern shrub rose Lyda Rose is the guard of honour running alongside the steps, with dainty, pink-edged, white blooms that go on forever. In the uppermost terrace, a rose-swagged arch leads through an orchard to the garden's dramatic second act – a grass amphitheatre whose terraces cascade down to the back of the house.

The curvaceous banks were designed to echo the striations of sheep-grazed fields on the facing hills ('where God is the best gardener', in Libby's view) and were originally intended to be framed by a branch of the cedar (*Cedrus*) – 'an original feature from the Georgian garden, but then we had a minor hurricane and that wonderful old branch came off!'

It is not the only unexpected event that Libby has taken in her stride. An early challenge arose when moving the old dipping pond in the Kitchen Garden. The pond turned out to be home to rare, white-clawed, native crayfish – a protected species that required a specialist wrangler to supervise their relocation, albeit only by a few metres, to their new bespoke tufa, spring-fed stone tank. More dramatic was the unexploded wartime bomb discovered when the bed at the top of the Amphitheatre was being prepared. An unwelcome souvenir of the US Army's wartime stay at Batcombe House, the ordnance thankfully was swiftly and safely removed by a bomb disposal unit.

A painterly approach

The Kitchen Garden lies within easy herb-snipping distance of an elegant triple-aspect kitchen extension designed by local architect Martin Llewellyn. This is a morning garden with late interest and a muted colour palette that 'gathers pace' as the season progresses and the light levels drop. By summer's end it is a crescendo of brilliantly hued salvias, dahlias and asters such as *Aster × frikartii* 'Mönch' and *Symphyotrichum* 'Little Carlow', which take on a luminous intensity in the 'magic hour' after the sun has left the garden.

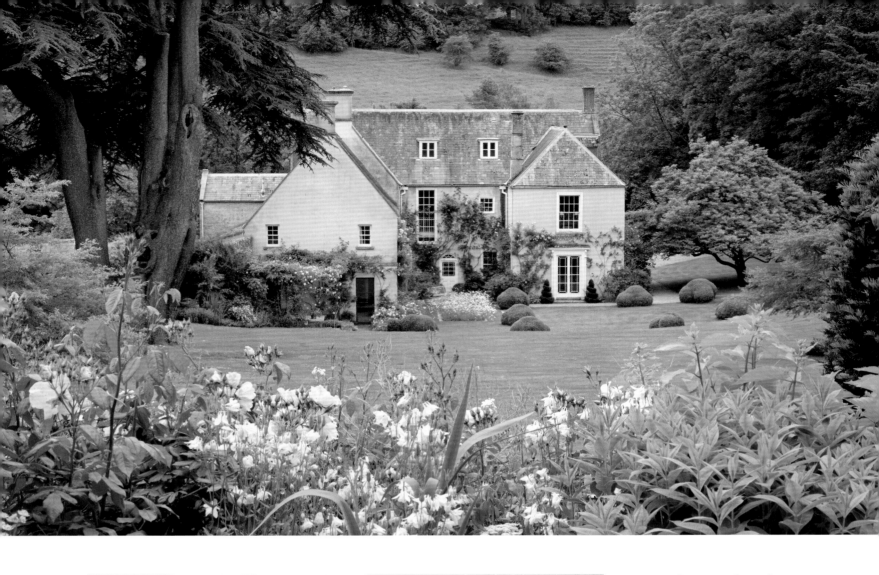

OPPOSITE Roses are a Batcombe signature and used generously throughout the garden.

ABOVE The grass terraces and deliberately amorphous box (*Buxus*) topiaries in the Amphitheatre set up a call and response between garden and view.

LEFT Libby Russell laid out the elegant curves of the Amphitheatre by eye, and then determined the final levels by 'good old-fashioned string and a plumb bob'.

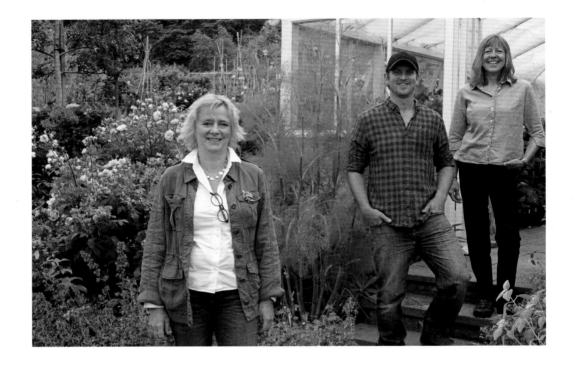

The Kitchen Garden's Pointillist Border also builds in tempo, animated by a cast of extrovert 'plants that go whoosh' as Libby puts it. Clipped yew (*Taxus*) pyramids add *gravitas* to an eye-catching company that includes Carthusian pinks (*Dianthus carthusianorum*), *Phlomis tuberosa* 'Amazone', *Agastache* 'Blue Fortune' and *Berkheya purpurea* among many annuals, ornamental onions (*Allium*), dahlias and salvias against a backdrop of the flamboyant pink *Rosa* 'American Pillar'.

The Potager is a productive 'muddle of fruit and flowers', where hazel wigwams supporting clouds of fragrant sweet peas (*Lathyrus odoratus*) jostle alongside tasselled sweetcorn and burnished orange sunflowers (*Helianthus*). Even the path edges earn their keep, being lined with chives, lavender (*Lavandula*) and 'Mignonette' strawberries. Set out in diamond patterns for extra interest, leaf crops such as red Russian kale and cavolo nero combine with espaliered crab apple (*Malus toringo* var. *arborescens*) to ensure colour and beautiful shapes even in deep winter.

Sense of cohesion

While the Walled Garden terraces are *intimiste*, the Amphitheatre Garden takes a more impressionistic approach, with naturalistic planting that provides monthly flushes of interest. In spring the daphnes, magnolias and deutzias take their bow, and by late summer it is the turn of billowing hydrangeas including *Hydrangea paniculata* 'Great Star', an uncommon variety whose paper-white blooms are long-lasting and fragrant.

The top border is a tale of two halves. When viewed from the house it is an essay in bold contemporary planting anchored with strong verticals such as *Eryngium agavifolium* and *Sanguisorba tenuifolia* var. *alba* that read well from a distance. The other side is a romantic intermingled planting, with *Rosa* 'Sally Holmes' threaded through as a leitmotif; the flowers flush from pink to peach to white and are rarely off duty.

As elsewhere, a firm framework maintains a sense of cohesion. Among the structural plants in the long border that flanks the sunny side of the Amphitheatre Garden is *Crataegus × grignonensis*, a useful hybrid hawthorn with large red fruits and tough enough to withstand the north-east winds, which can whip through the top of the garden. Also growing there is elderberry *Sambucus nigra* subsp. *canadensis* 'Maxima', a nod to Libby's family history making Belvoir Cordials, the company started by Libby's late father Lord John Manners ('a great tree planter'), next to the family estate at Belvoir Castle.

My tour of the garden finishes where Libby first discovered Batcombe all those years ago – in the flower-rich meadows above the village. Libby farms these ancient fields with conservation in mind; the land is a Somerset Wildlife Site, and managed as part of a Countryside Stewardship scheme, with carefully calibrated grazing regimes by cattle and sheep. It is a profoundly moving experience to be in old meadows that link

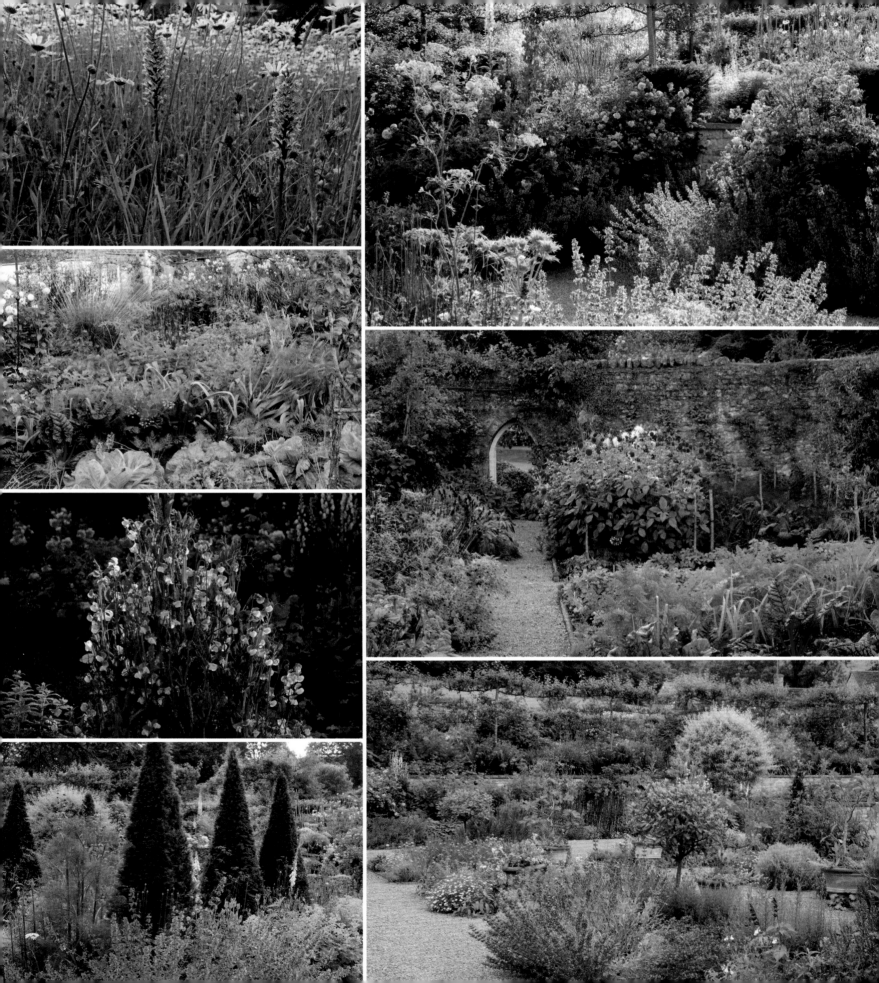

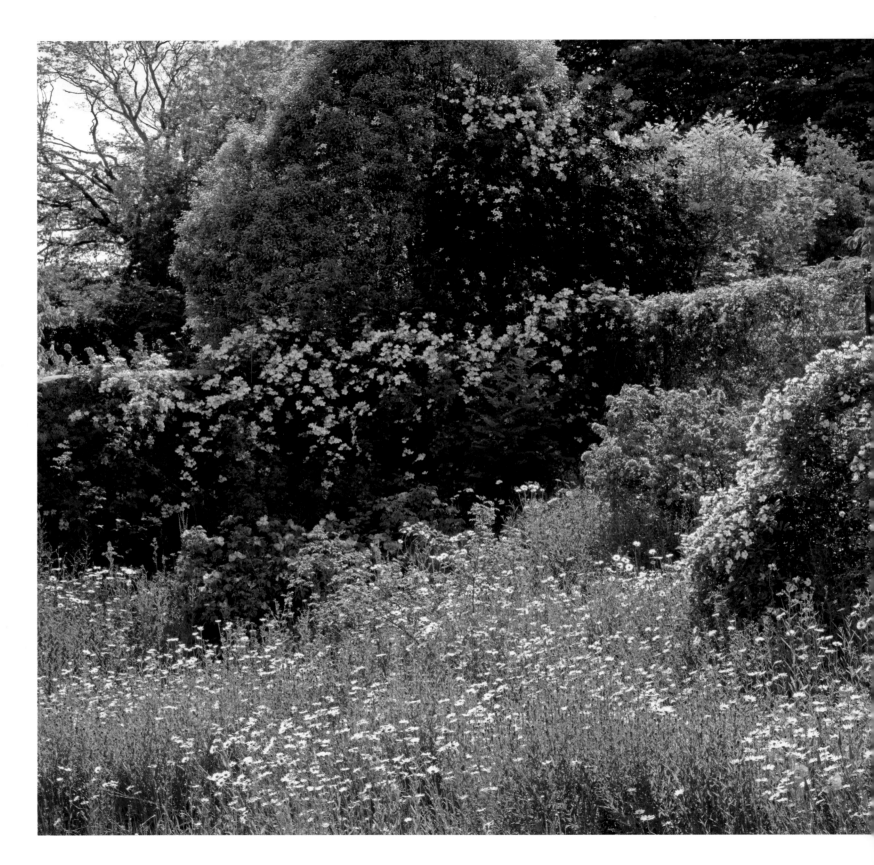

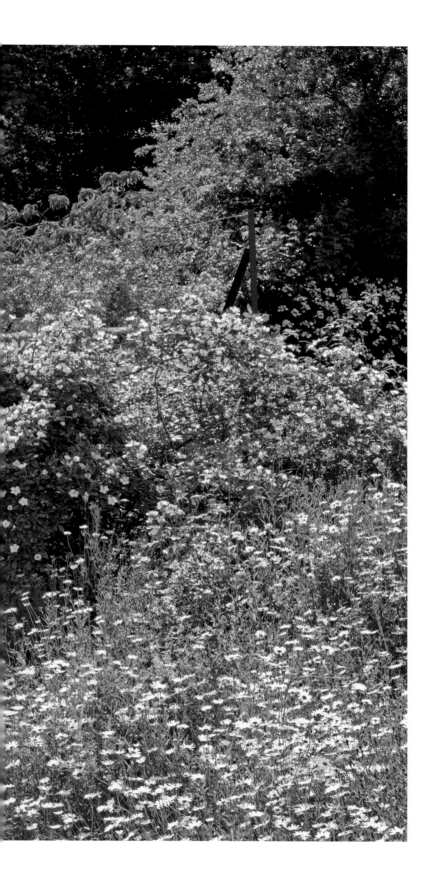

directly to an agricultural past before chemicals and heavy machinery changed the countryside.

Libby is thrilled that her wildlife-friendly approach is successful; there are around 300 species of moths in the woods and she points out the rich diversity of plant species packed within a single square metre of turf: purple knapweed (*Centaurea*), scabious (*Scabiosa*), devil's-bit scabious (*Succisa pratensis*), betony (*Betonica*), cowslips (*Primula florindae*), oxlips (*Primula elatior*) and orchids. 'We have never had so many orchids', Libby reports proudly.

A passion for plants

As a knowledgeable plantswoman, Libby serves on the Royal Horticultural Society (RHS) Herbaceous Plant Committee as one of the panel of experts who assesses plants for the coveted Award of Garden Merit (AGM); she also judges in the floral marquees at RHS shows such as Chelsea and Tatton Park.

'My garden's a bit of an observatory and always evolving', she explains. 'As a designer, plants have to become your vocabulary and it's only by looking that you learn.' Plectranthus and salvias are two current enthusiasms and are everywhere, in containers, in the greenhouse and in the plant 'theatre' under the pergola by the kitchen.

As summer draws to a close, head gardener Tom Price (formerly gardens curator at the University of Oxford Botanic Garden) and assistant gardener Sue McCardle are kept busy taking insurance cuttings and bringing precious plants such as Libby's favourite double white brugmansia into the greenhouse for safekeeping.

Always alert to new ideas, Libby enjoys seeing plants in their native habitats, as well as visiting gardens and nurseries. On a recent visit to Le Vasterival garden in Normandy, Libby was fascinated by the technique of transparency pruning pioneered there by Princess Sturdza. Ever curious, she will be trying this next year in Somerset: 'That is the reason I love gardening', Libby says. 'It is so difficult and there's always something to learn.'

LEFT In early summer the bank between the swimming pool and tennis court is blanketed with ox-eye daisies (*Leucanthemum vulgare*) and roses, while clematis scrambles over the surrounding wall and fence.

4
The Bishop's Palace
Wells

HISTORY AND HORTICULTURE go hand in hand at The Bishop's Palace, whose gardens have been cultivated in the shadow of Wells's Gothic cathedral for more than 800 years. The palace was begun by Bishop Jocelin shortly after his appointment as Bishop of Wells in 1206 but its site, beside the sacred well springs that give England's smallest city its name, is much older, with an archaeological record that stretches back to Saxon, Roman and earlier periods. The cathedral's origins date to the eighth century; the present building was dedicated to St Andrew in 1239.

At first glance the medieval palace looks more like a castle with its encircling moat and crenellated battlements. The latter are a legacy of Bishop Ralph of Shrewsbury, who obtained a licence to crenellate in 1341 at a time of famine and civil unrest prompted by the 'Little Ice Age'. While climate

BELOW Richly textured planting in the multi-themed Knot Garden adds to the dynamic views within the moated enclosure of the inner gardens. RIGHT The thirteenth-century Bishop's Chapel, built by Bishop Burnell, provides an atmospheric backdrop to the Hot Border.

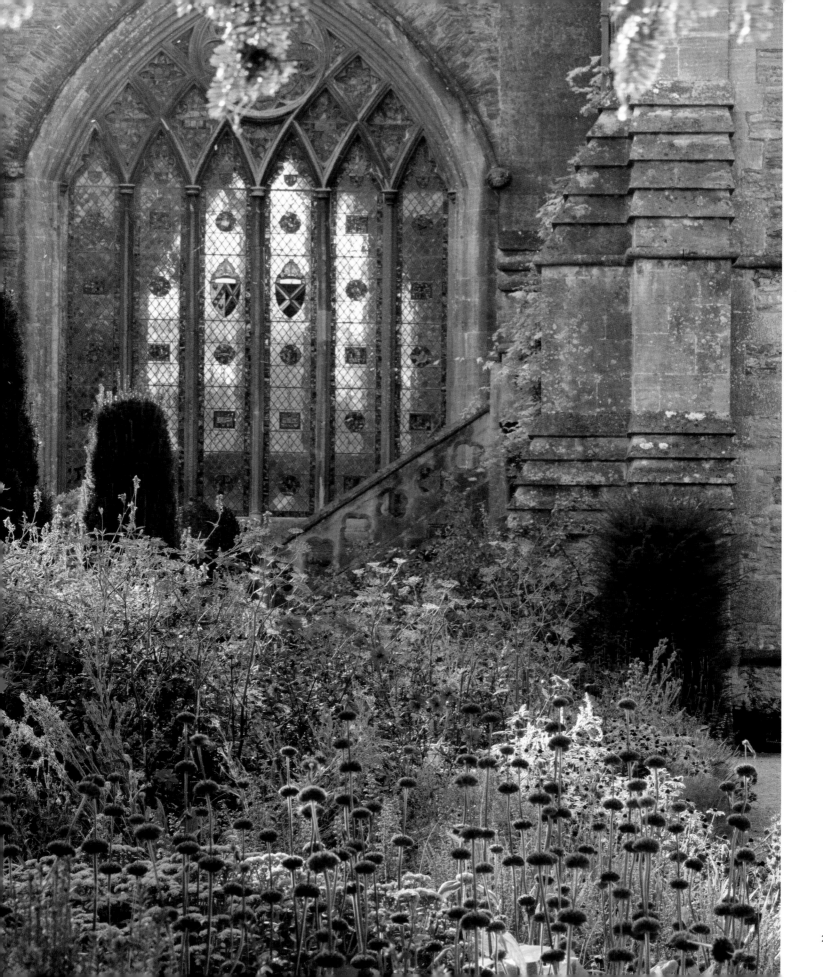

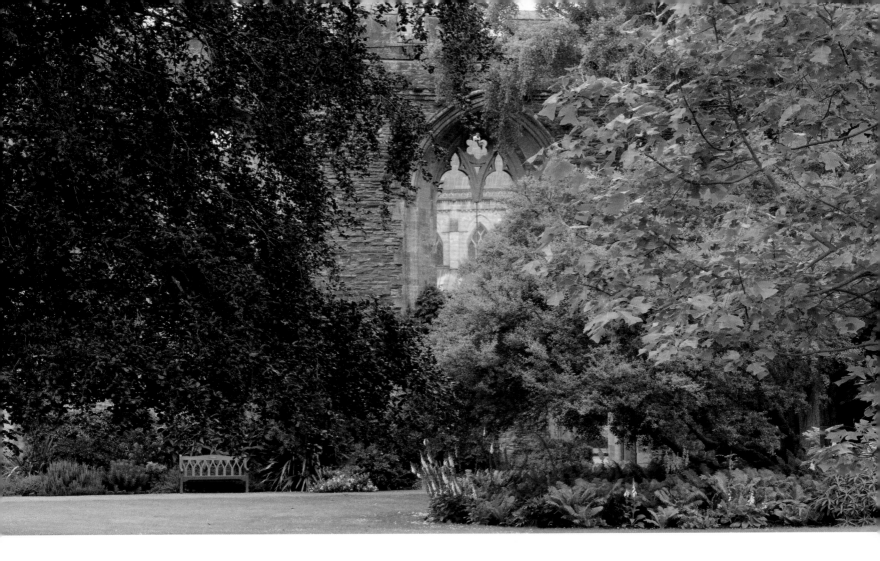

change regrettably is still an issue, the palace is altogether more hospitable these days; its drawbridge hasn't been raised since 1831 and visitors are warmly welcomed.

The gardens within these fortified walls are in the care of talented head gardener James Cross, who in 2002 was appointed by Bishop Peter Price to implement a major redevelopment. When James arrived, the gardens were well tended but underplanted and his aim has been to increase diversity, paying particular attention to foliage. His previous experience working for the National Trust (at Sissinghurst, Sheffield Park and The Courts Garden) has stood him in good stead for a role that requires historical sensitivity as well as horticultural flair.

With 5.6 hectares/14 acres of land and water to manage, and only a small team of staff and volunteers, James's focus is on reliable and easy-to-maintain plants, making The Bishop's Palace an inspirational yet relatable garden. Royal Horticultural Society (RHS) Partner Garden status was conferred in 2016 – a coveted seal of approval from on high in British horticulture.

The current bishop of Bath and Wells, Bishop Peter Hancock, also appreciates James's achievements: 'Although I live in the palace, it's my place of work too and I don't have much time to get out into the garden, but when I do – usually in the still of the evening – it unfailingly delights me.' For Bishop Peter, the gardens are not only a peaceful refuge for visitors, but they also resonate directly with the Bible story: 'The garden is there in Genesis, when God speaks to Adam and Eve, it's there again in the Easter story, in the Garden of Gethsemane, and of course on Easter Sunday, when Mary Magdalene sees the risen Christ and mistakes him for a gardener.'

A palimpsest

The head gardener's development brief has to be balanced with respect for history. And that is never far from the surface – as proven by the outlines of the formal, seventeenth-century garden that materialized in the drought-scorched South Lawn in 2018. Formality gave way to the Picturesque in the nineteenth century, when Bishop George Henry Law created the open sweep of the South Lawn and stage-managed

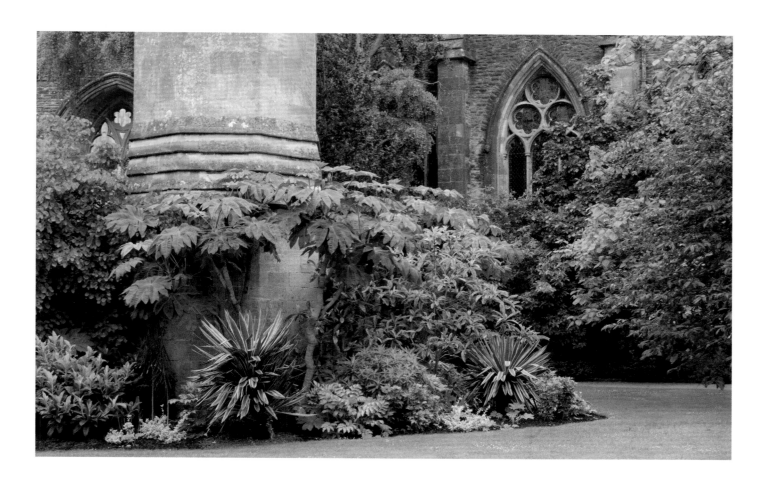

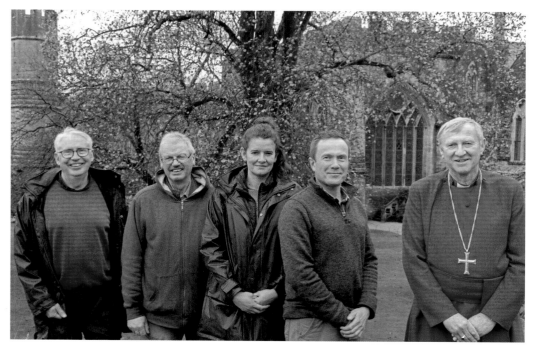

OPPOSITE On the South Lawn, mature trees and the ruins of the Great Hall frame the splendour of Wells Cathedral.

ABOVE The exotic planting around the ruined tower lends an air of otherworldly romance to the South Lawn.

LEFT Bishop Peter Hancock (right) is the latest in a line of bishops to take an interest in the gardens of The Bishop's Palace. The gardening team there is headed by James Cross (second right), helped by Colin Shepherd, Rob Hole and Suzy Hawkins.

'Gardens are a place where people meet with God, and where God walks with people. There's the sense that God is there alongside us.'

BISHOP PETER HANCOCK

here', he notes. 'On the shady side I've used ferns and hostas under the existing *Osmanthus × burkwoodii*, while on the sunny side I've gone for *Yucca gloriosa*, tetrapanax and loquat (*Eriobotrya japonica*).' The prehistoric-looking *Pseudopanax ferox* is, he says, 'a bit of fun'.

Seasonal colour and scent are the priorities in the recently planted winter borders, where James has combined dogwood (*Cornus*) and conifers with fragrant sweet box (*Sarcococca*), daphne and witch hazel (*Hamamelis*). The intensely perfumed *Edgeworthia chrysantha* 'Red Dragon' was a connoisseurial choice here, but worth the expense, says James: 'It's a very good late winter flower.' This cultivar name also neatly recalls Bishop Jocelin's legendary exploits as a dragon slayer.

Ancient and modern

The East Garden underwent a radical overhaul early on James's watch, when he replaced a lawn with a contemporary Parterre and Hot Border. 'Bishop Price was rather alarmed when he saw the turf being stripped off!' James recalls. Enclosed within crisp hedges of *Euonymus japonicus* 'Green Rocket', each of the parterre's square beds centres on a quince (*Cydonia oblonga* 'Meech's Prolific') and is stocked with modern roses such as *Rosa* Winchester Cathedral and older cultivars such as *R.* 'Reine des Violettes' and 'Great Maiden's Blush', a variety sometimes known by the less decorous name 'cuisse de nymphe'.

The Hot Border packs its punch in high summer, with a golden chorus of *Geum* 'Mrs J. Bradshaw', *Achillea filipendulina* 'Cloth of Gold' and *Helianthus* 'Lemon Queen'. The fiery presence of *Crocosmia* 'Lucifer' is no doubt ironic, but James has tempered its heat with the cooling blues of *Anchusa azurea* and *Echinops ritro* 'Veitch's Blue'.

Inspired by the coats of arms carved in a nearby oriel window, the Knot Garden is a modern twist on a medieval favourite. The Portcullis Bed is a chequerboard of *Euonymus japonicus* 'Jean Hughes' (an upgrade from *E.j.* 'Green Rocket'

the ruins of the thirteen-century Great Hall and tower as its centrepiece. James's twenty-first-century additions follow the spirit rather than the letter of the historic gardens. 'The Picturesque style is a difficult one to pull off', he observes.

Immediately inside the entrance arch, James has deepened the sunny border at the foot of the Great Hall's surviving north wall to allow more generous planting. Being careful to keep the palette muted to avoid competing with the cathedral, his deceptively simple response includes the irrepressible *Nepeta* 'Six Hills Giant', whose soft blue flowers lap luxuriantly on to the path, and the frothy white flower spikes of *Persicaria alpina* (syn. *P. polymorpha*) – 'a useful feature plant'.

Opposite this, a new border recreates the Great Hall's south wall with a latter-day shrubbery that includes *Hydrangea quercifolia*, *Acer palmatum* 'Garnet' and a dwarf *Ginkgo biloba* 'Mariken', which artfully echoes the statuesque *G. biloba*, a survivor from Bishop Law's garden.

James has steered the planting towards the exotic around the base of the ruined tower. 'There are several microclimates

ABOVE LEFT Seen here from the Knot Garden, the sublime Gothic architecture of Wells Cathedral is a powerful presence in the garden.
RIGHT A variety of contemporary planting styles are framed within the formal knots and parterre of the East Garden.

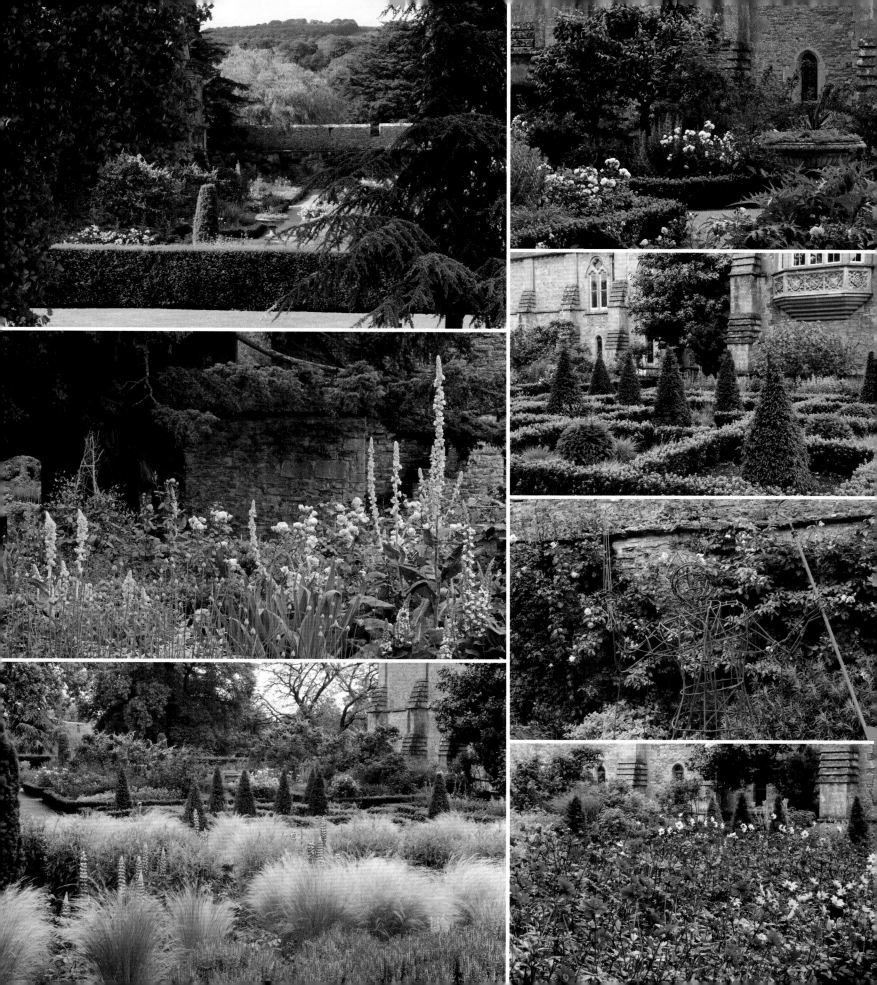

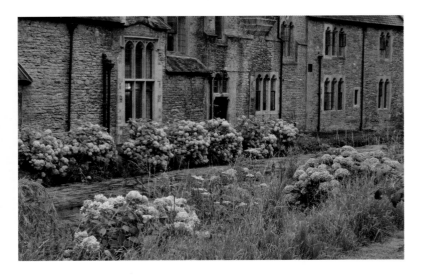

– 'it's bushier and better', says James) studded with yew (*Taxus*) topiaries surrounded by the metallic counterpoint of blue fescue (*Festuca glauca*) and *Libertia ixioides* 'Goldfinger'. By contrast, the St Andrew's Cross Bed is a blowsy, cottage-garden affair, with hazel wigwams supporting clouds of *Clematis* 'Praecox' and *C*. Pretty in Blue.

It's appropriate that a high summer synod of 'Bishop' dahlias should congregate in a colourful knot of their own. Rubbing shoulders with *Dahlia* 'Bishop of Canterbury', *D*. 'Bishop of Dover', *D*. 'Bishop of Auckland', *D*. 'Bishop of Llandaff', *D*. 'Bishop of Leicester' and *D*. 'Bishop of York', the magenta *D*. 'Bishop Peter Price' is the only one to have the accolade of being named after an individual.

Across the moat and into the rambling Outer Gardens – also known as the Bishop's Camery, the mood shifts from the worldly to the spiritual. Commissioned by Bishop Price and completed in 2013, the Garden of Reflection is a contemporary retreat. Its centrepiece is a poustinia (meaning 'desert' in Russian), a pristine-white, circular structure designed for silence and contemplation. In spring the surrounding Birch Grove erupts into new life with thousands of red tulips.

The Wells Pool, created by Bishop Law in the 1830s, offers a more literal reflection. 'It's the iconic image of Wells', says Bishop Hancock, 'but there is a real sense of peace, and prayer here; the water reflects the beauty of the cathedral, the cathedral is enhanced by the beauty of the garden.' The Wells Pool Border was designed by Mary Keen in 2003 and was refreshed in 2017 by James using a similar pastel palette. Its serpentine path is edged with a joyous froth of astrantia, cranesbill (*Geranium*) and *Hemerocallis* 'Golden Chimes', to which James has added cardoons (*Cynara cardunculus*), *Philadelphus* 'Belle Étoile' and deep pink roses such as *Rosa* 'De Rescht' and *R*. Young Lycidas to key the planting into the rest of the garden.

James has had more freedom when developing the Boardwalk Garden beside the clear waters of St Andrew's Well. Created with the help of horticultural lecturer John Horsey and his students, the adventurous planting features the exotic foliage of soft tree fern (*Dicksonia antarctica*), *Phormium cookianum* subsp. *hookeri* 'Tricolor' (so named for its green, cream and red leaf colouring) and the intriguing hybrid × *Fatshedera lizei*.

With over 100,000 visitors a year, The Bishop's Palace does not claim to be the most secret garden in Somerset, but what is remarkable – miraculous even – is how gracefully it absorbs those visitors, their children and their dogs. Even the mercantile hubbub of Wells's busy twice-weekly market, floating over the walls for the past 800 years, can't puncture the garden's tranquillity and the sense that, here, heaven might indeed be a place on earth.

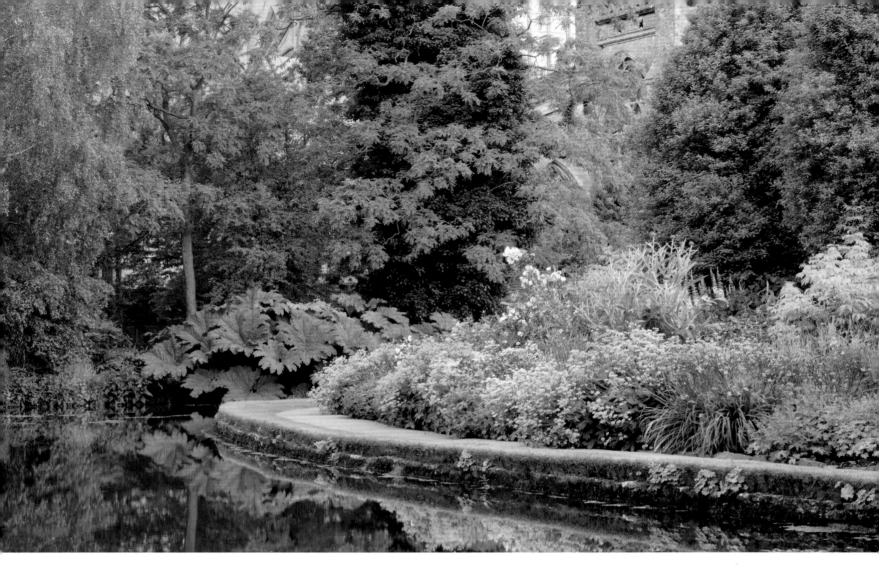

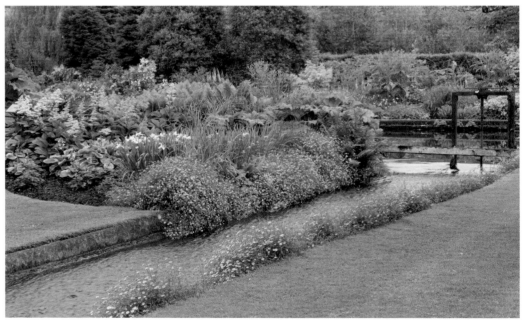

OPPOSITE TOP Hydrangeas line the banks of the moat.

OPPOSITE CENTRE Bishop Beckynton's fifteenth-century Well House is clad with romantic festoons of *Rosa* Malvern Hills and *R.* Graham Thomas.

OPPOSITE BOTTOM A naturalistic woodland setting complements the minimalist architecture of a poustinia in the Outer Gardens.

ABOVE Lush planting is mirrored in the still waters of the Wells Pool.

LEFT Water is the defining element of the Outer Gardens and so managing its sluice gates is one of the responsibilities of the head gardener.

5
Common Farm
Charlton Musgrove

Remaining true to their environmental principles, Fabrizio Boccha and Georgie Newbery have created a modern Arcadia at Common Farm, a productive garden that enriches rather than exploits its surroundings.

Although familiar to thousands from the pages of Instagram and Twitter, where owner Georgie Newbery is a popular presence among the gardening community, Common Farm is a delightful discovery in the real world too. Inconspicuously sited alongside a rural lane, it is a working flower farm rather than a traditional ornamental garden, and one where ecology rather than formal design is the driving force. The 2.8-hectare/7-acre plot lies on the south-eastern edge of Somerset, near the borders of Wiltshire and Dorset, where the eastern horizon is bounded by the wooded expanse of Selwood, the ancient royal hunting forest that once formed a belligerent buffer zone between Britons and invading Saxons.

A pioneer of 'grown not flown' British cut flowers, Georgie started Common Farm Flowers as a business that she could run from home while raising small children. And as the children have grown, so too has the business, from selling sweet peas (*Lathyrus odoratus*) at the farm gate to an enterprise with 1.4 hectares/3½ acres under cultivation and sumptuous bouquets being couriered year-round across the UK, to customers who love the elegant informality and eco-credentials of Georgie's flowers.

The proximity of Selwood is pertinent because Georgie's flower fields appear as glades in a timeless sylvan scene even though her garden is comparatively newly minted. The surrounding shelter belt of trees and hedges was planted by Georgie and her artist husband Fabrizio Boccha when they arrived at Common Farm to a blank rye-grass canvas in 2004.

Fabrizio's original vision was a market garden within 'hedge world', a rewilded place where nature could thrive. Ambivalent about the demands of livestock, Georgie shelved the market garden plan when a friend sent her a bouquet of flowers by post, triggering an inspired idea. Having grown up being paid to weed by her mother, a Constance Spry-trained florist, Georgie knew how to cultivate and arrange flowers, and as a former novelist and TV developer she was not afraid of freelancing. The flower farm was born but with Fabrizio's ecological ethos at its core.

Ecology first

Georgie's flower fields sit within Fabrizio's wildlife-friendly framework of hawthorn (*Crataegus*) hedges and alongside stands of nettles (*Urtica dioica*) and thistles (*Cirsium vulgare*) and a wildflower meadow studded with orchids in early and midsummer. The hawthorns offer shelter and forage for charms of goldfinches and other birds, and in spring froth with blossom, which ripens into autumn haws. A formal square of crab apples (including *Malus* × *robusta* 'Red Sentinel' and the Siberian crab *M. baccata*) performs a similar service while providing blossom for bridal nosegays and leading the way to Georgie's polytunnels.

'You cannot have enough cosmos — they sing with dahlias.'
GEORGIE NEWBERY

LEFT In the height of summer Georgie Newbery might start picking in the Cutting Garden as early as 5 a.m., when often she is surrounded by morning dew. RIGHT In line with her eco-principles, Georgie no longer uses foam in her arrangements, here being done in her studio.

Painstakingly established by Fabrizio with plugs and seeds is the meadow, which is now home to over thirty wildflower species. Managing this burgeoning haven is an ongoing voyage of discovery. This year the theft of some vital garden machinery turned the want of a hedge cutter into a triumph when the uncut hedges produced an unprecedented population boom of meadow blue, marsh fritillary and speckled wood butterflies. The flower fields too are beneficiaries of the couple's 'invertebrates first' approach. In late spring, when the rose buds are smothered with aphids, Georgie waits for the ladybirds and tits to arrive. They have never failed her yet, and by midsummer the roses are completely clear of infestation.

A plan for all seasons

Succession planting is the key to keeping the plot productive from mid-spring to late autumn, with spring bulbs such as narcissi, wild bluebells (*Hyacinthoides*), silver-grey scilla and blue camassia providing some of Georgie's earliest crops. Throughout summer Georgie regularly sows annuals such as zinnias, ammi, sunflowers (*Helianthus*) and cosmos to ensure a steady supply of blooms.

Sweet peas (*Lathyrus odoratus*) are started in the polytunnel in late autumn, with a second batch sown in late winter (the day after Valentine's Day – a significant moment in the flower farming calendar, being the first day with ten hours' local daylight). The practicalities of floristry determine her choices, with Georgie favouring modern Grandiflora sweet peas such as pale blue *L.o.* 'Charlie's Angel' and lilac and cream *L.o.* 'High Scent' because they are tall, strong and long-lasting.

Tulips are treated as annuals, and Georgie plants fresh bulbs every autumn. She grows doubles, which have the advantage of often being scented, and particularly likes *Tulipa* 'Angélique' with its pretty, pale pink, peony flower and zabaglione-scented *T.* 'Verona'.

Roses thrive here in the Somerset clay, their scented velvet blooms adding instant romance to bridal bouquets and summer arrangements. Laid out in colourful ribbons within the deer-proofed confines of the Cutting Garden is the Common Farm rose collection, which includes a considered selection of David Austin varieties such as myrrh-scented *Rosa* 'Queen of Sweden' and apricot-hued *R.* Dame Judi Dench. The versatile shrub rose *R.* 'Boscobel' is another stalwart – 'just look at that colour', enthuses Georgie. 'It can be salmon-pink or sugar-pink depending on what you put it with.'

Walking around the flower farm with Georgie is an education. She brims with knowledge and enthusiasm, sharing both generously; she is also the author of *The Flower Farmer's Year*, a guide to growing cut flowers. No wonder her workshops, on anything from social media to hand-tied bouquets, are in demand. In short order I learn how 'conditioning' cut flowers prolongs their vase life; find that *Hydrangea paniculata* 'Limelight' can be a cut-and-come-again crop; discover the virtues of cardoons (*Cynara cardunculus*) in pedestal arrangements; and am invited to admire a colony of tortoiseshell butterfly caterpillars on recently trimmed nettles.

The rule of thirds

Georgie's rule is that a good bouquet should be one-third filler, one-third accent and one-third foliage, and she plans her garden accordingly. Fillers come in many forms, from spiky clary sage (*Salvia sclarea*) and larkspur (*Consolida*) to daisy flowers such as leucanthemum and lacy umbellifers such as dill (*Anethum graveolens*) and *Orlaya grandiflora*. Eye-catching, accent flowers might be roses or dahlias: *D.* 'Chat Noir' and the dinner-plate *D.* 'Café au Lait' are especially favourite dahlias, along with *D.* 'American Dawn', whose blend of sunrise colours is strangely impossible to define. Seasonal foliage starts with the honeysuckle *Lonicera fragrantissima* in spring, followed by just-unfurling hornbeam (*Carpinus*) and lime (*Tilia*), with stronger foliage colours coming later in the season from maroon-red smoke bush (*Cotinus*) and richly purple *Physocarpus opulifolius* 'Diabolo'.

Georgie divides her time between creating postal bouquets, arranging flowers for events and weddings, and running workshops from her rustic stone studio. The launch of her business has been as perfectly timed as one of her successional sowings; the idea of 'British flowers' has captured people's imaginations as they realize the ecological toll of flowers being flown around the world.

The arrival of Twitter and Instagram have played their part too, skilfully deployed by Georgie to promote her rural start-up. But the success of Common Farm Flowers is also down to Georgie's entrepreneurial flair and determination to take British flower growing in a new direction. Citing Constance Spry, the doyenne of mid-twentieth-century floristry, as an inspiration, Georgie also acknowledges her mother, whose advice to 'never make a flower do what it does not want to do' remains a guiding tenet. The garden she has created alongside her business is a *locus amoenus* in its own right but one whose bounty is enjoyed well beyond its wooded boundaries, in floral bouquets that mark some of life's most significant moments.

RIGHT What was once, as the name of the property suggests, common land ('the poorest in the village', says Georgie Newbery) has become a productive plot, brimming with biodiversity.

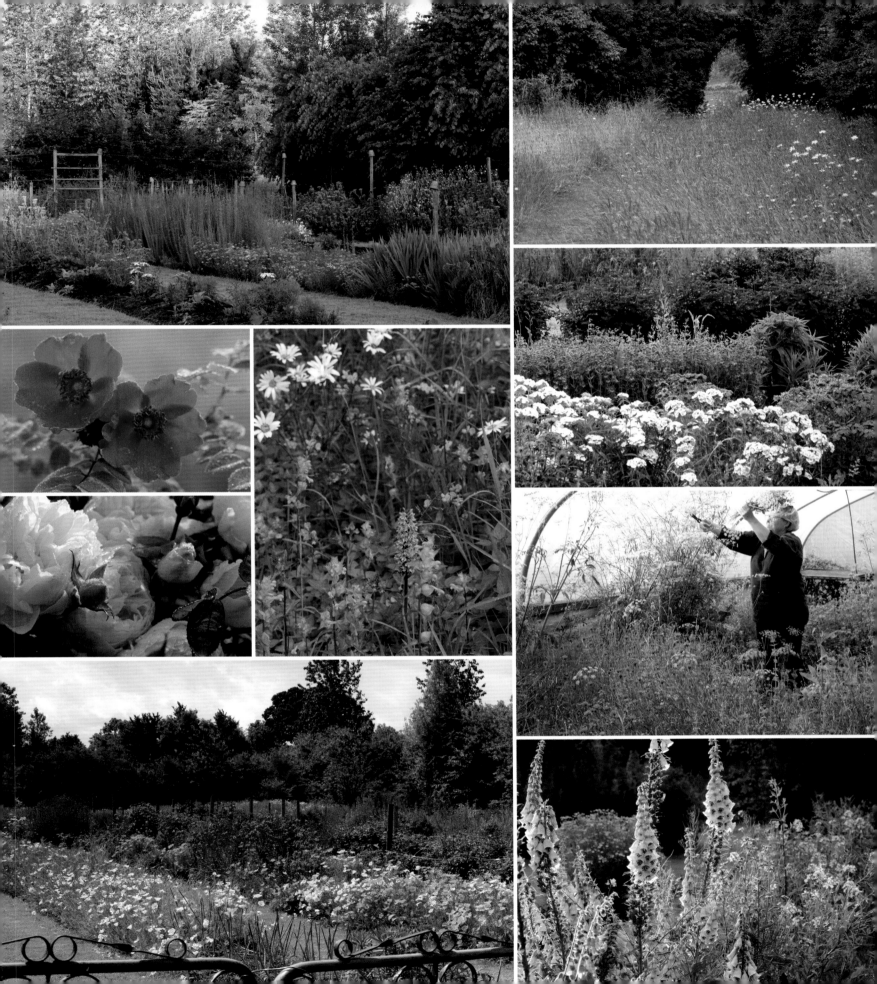

6

Cothay Manor

Greenham

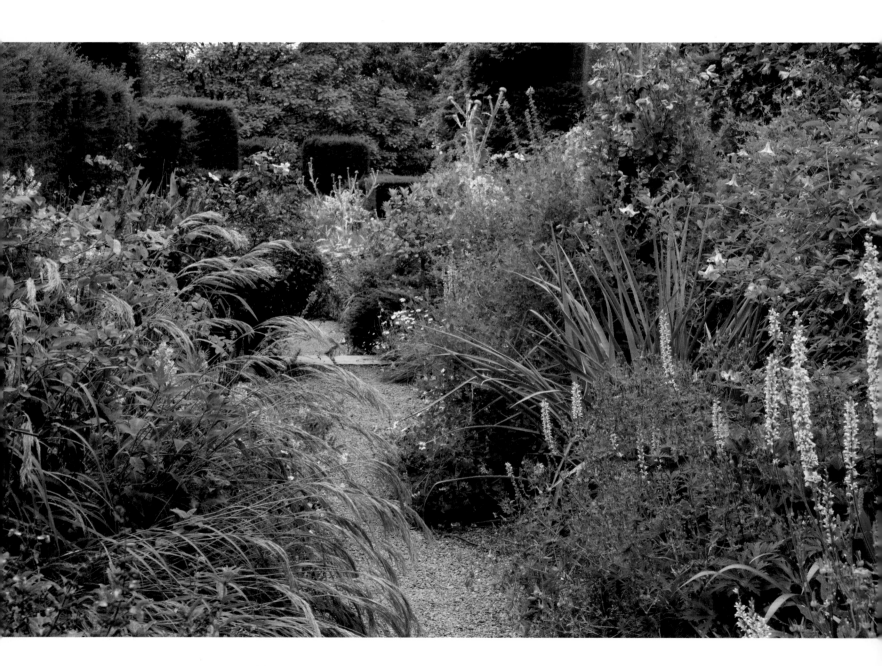

CREATED BY MARY-ANNE ROBB and her late husband Alastair, the sublimely romantic gardens at Cothay Manor have become a pilgrimage destination for the cognoscenti. Those falling under its fairy-tale spell for the first time discover Cothay like a sleeping beauty, deep in the Vale of Taunton and guarded by nerve-shredding, narrow lanes (to motorists at least). But, as in every good fairy tale, appearances can be deceptive, and Cothay – despite its timeless aura – is a dynamic and ever-evolving work of art at the hand of its indefatigable chatelaine: 'A garden that does not change', says Mary-Anne, 'dies.'

When she and her husband arrived in 1993, Cothay's garden was in need of rejuvenation. The medieval manor house built by Richard Bluett in the 1480s, with its great hall, oratory chapel and gatehouse, had been designed to impress, but over the following centuries it slumbered into obscurity, its lordly occupants replaced by generations of tenant farmers. Cothay's fortunes revived in 1925, when it was bought by Lieutenant Colonel Reginald Cooper, a well-connected former diplomat, who set out the grounds in a typically Arts and Crafts sequence

of garden rooms, arranged around a magisterial 180m/200yd Yew (*Taxus*) Walk.

Perhaps Colonel Cooper took his inspiration from friends, a circle that included Lawrence Johnston (the creator of Hidcote) and Harold Nicolson. The latter – co-creator with Vita Sackville-West of Sissinghurst – was a school friend of the colonel's and just before the First World War the two men served at the British Embassy in Istanbul. There Mary-Anne says: 'they dreamed of Old England and old houses, lit by candles and hung with tapestries'. Each went on to realize his dream, with the colonel's garden rooms at Cothay anticipating Harold Nicolson's at Sissinghurst by a few years.

Colonel Cooper sold up in 1937, and by the time the Robbs moved in the planting was, as Mary-Anne puts it, 'past its sell-

OPPOSITE Exuberant midsummer planting behind the house makes close encounters with Cothay's eclectic plants a delightful inevitability.
BELOW Brimming stone and terracotta containers are a Cothay signature and they are designed for a long season of interest.

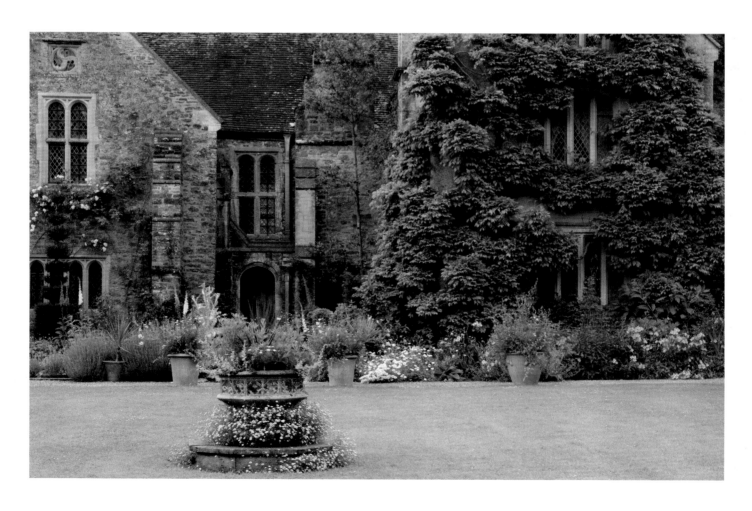

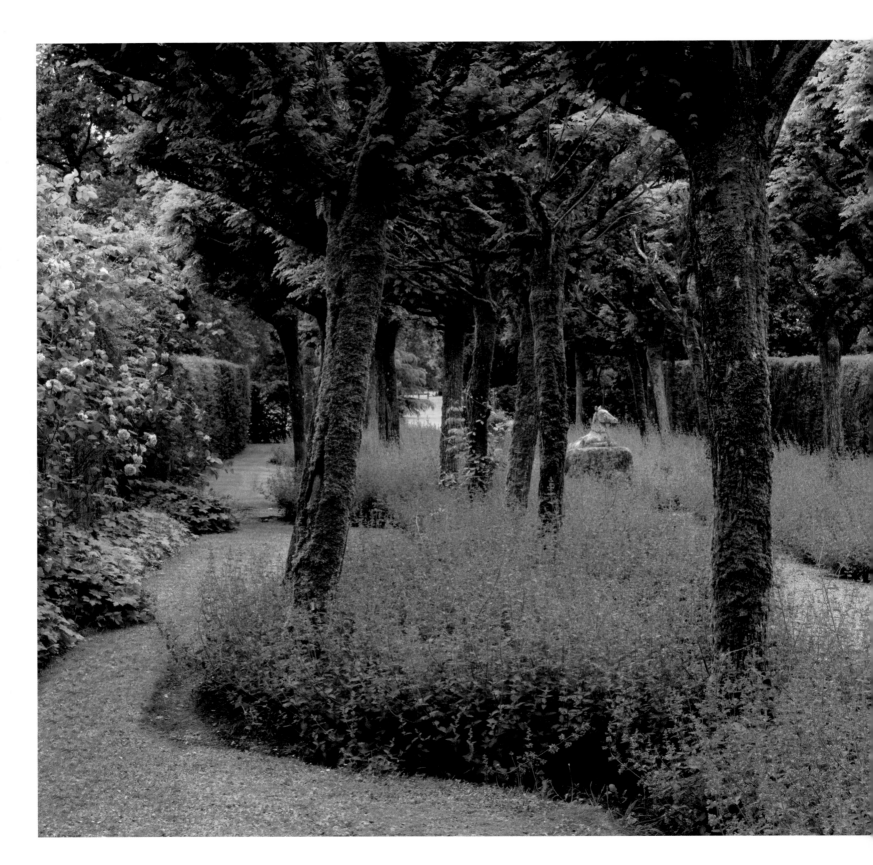

'To love and to labour is the sum of life.'

MARY-ANNE ROBB

by date' and consisted mainly of hybrid tea roses with black spot. Although the Robbs were not new to garden making, having laid out a 2-hectare/5-acre garden at their previous home in Wiltshire, Cothay's 4.8 hectares/12 acres presented a 'completely different challenge' recalls Mary-Anne. Fortunately the yew 'bone structure' of the colonel's garden rooms survived, and these Mary-Anne set about redecorating, each with a different theme and colour.

Out went the unhappy hybrid teas and in came the diggers, and a new gravel and flagstone terrace was created at the back of the house. Stark at first, the gaps between flagstones were soon filled with plants.

The terrace is a joyous hymn to maximalism, with structural support given by holly (*Ilex crenata*) lollipops and a luxuriant standard wisteria. In spring angel's fishing rods (*Dierama pulcherrimum*) make the terrace look like fairyland, confides Mary-Anne: 'I absolutely love them.' While roses scale the house (the single red *Rosa* Altissimo and a yellow *R. banksiae* among them), self-seeding foxgloves (*Digitalis*), libertia, fleabane (*Erigeron*), cranesbill (*Geranium*) and lady's mantle (*Alchemilla*) submerge the flagstones beneath a froth of foliage and flower as summer unfolds.

The enclosed Inner Court, its walls hung with wisteria and climbing roses, is similarly provisioned but its shelter allows for exotic flourishes amid the medieval ambience – spires of sky-rocketing *Echium pininana* and a happily overwintering tree fern, *Dicksonia antarctica*, by the kitchen door.

The silver thread

Under Mary-Anne's energetic direction the garden has 'grown like topsy', she says, but repeat planting is the 'silver thread' that holds everything together. Hard-working perennials such as purple sage (*Salvia officinalis* 'Purpurascens'), catmint (*Nepeta*) and *Geranium pratense* 'Mrs Kendall Clark' are stalwarts, along with the *Elaeagnus × submacrophylla* lollipops, which are an evergreen presence in both Inner and Outer Courts.

Although the terrace follows Oscar Wilde's dictum 'the best statement is over statement', elsewhere Mary-Anne's approach is 'less is more'. The Walk of the Unicorn – an avenue of pollarded *Robinia pseudoacacia* 'Umbraculifera' underplanted

LEFT 'The Walk of the Unicorn is soothing in its simplicity', says Mary-Anne Robb. 'I like the gentle look that leads you on, to the fields beyond.'

with *Nepeta* 'Six Hills Giant' and 'White Triumphator' tulips in spring – leads the eye gently past the captive stone unicorn to the borrowed landscape of fields beyond.

There is an almost monastic calm to the Outer Court, with its impassive yew and box (*Buxus*) topiary, lavender-edged lawns and climbing apricot roses such as 'Meg' and the reliable 'Phyllis Bide'. The orange-flowered *Campsis grandiflora* that flamboyantly scrambles the gatehouse tower is one of several exceptions in the garden that proves Mary-Anne's only semi-serious 'any colour but orange' rule (once you start looking, there are touches of orange everywhere).

Each evocatively named room has its own character: prickly and spiny plants in the Spike Garden; episcopal reds and purples in the Bishop's Garden; and cheerful yellows in Emily's Room (named for the Robbs' first grandchild). Here, as everywhere, Mary-Anne's planting roams expertly across the globe; Emily's golden treasures include *Kirengeshoma palmata* (from Japan),

the giant knapweed *Centaurea macrocephala* (from the Caucasus) and a dainty *Dactylicapnos scandens* (syn. *Dicentra scandens*) scrambling through the yew by way of the Himalayas.

Mary-Anne is unsentimental about making necessary changes and likes to have a new project each year. She recently replaced the blighted box parterre in the Fountain Garden with a Mediterranean gravel garden, studded with *Iris pallida* 'Argentea Variegata' and four olive (*Olea*) trees. With a combined age of 600 years, the olives were, Mary-Anne admits, an expensive purchase, but with age comes character. These expressively gnarled trees are underplanted with a 'shadow' of creeping thymes – a visual pun repeated in the Green Knight Garden, where a *Cornus controversa* 'Variegata' casts a diamond shadow over silvery *Thymus serpyllum* 'Snowdrift'.

The stone fonts and terracotta urns that explode with colour and interest until after the first frosts are a Cothay signature. The 'recipe' looks simple enough on paper, but is sensational in reality. Mary-Anne specifies up to twenty-five plants for a 45cm/18in diameter pot, packing in half-hardy perennials such as *Felicia amelloides*, *Glandularia* 'Sissinghurst', *Sphaeralcea munroana*, *Convolvulus mauritanicus* and *Salvia* 'Love and Wishes' into a free-draining compost mix. Cuttings are taken at the end of the summer to provide plants for the following year.

ABOVE Using the nom de plume 'China Girl', Mary-Anne Robb's Pekinese Darling Girl writes the Cothay blog, perhaps taking something of her literary style from her mistress, a former contributor to *Country Life* magazine. She is seen here in the Yew Walk.
OPPOSITE Each of Cothay's garden rooms has a character of its own.

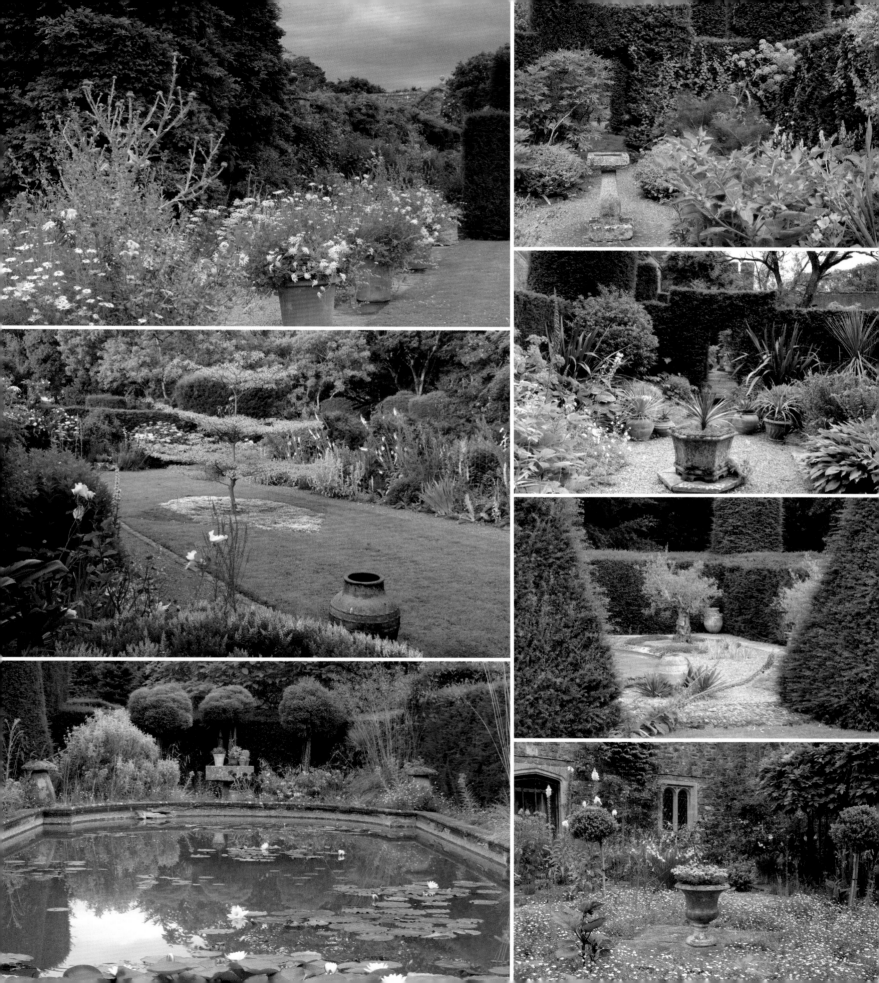

ABOVE The Herbaceous Garden has a pretty, blue and white colour scheme, with *Anthemis cupaniana* repeated throughout. It is enclosed within sculptural yew hedges.

RIGHT The Cothay gardening team (Chris Sowden, Wesley Huxtable and Markus Leary), here on the terrace, provide invaluable expertise for Mary-Anne Robb (and Darling Girl).

OPPOSITE Lollipops of evergreen *Elaeagnus × submacrophylla* add structure to the relaxed drifts of self-sown love-in-a-mist (*Nigella*), fleabane (*Erigeron*) and Welsh poppies (*Papaver cambricum*) in the Inner Court.

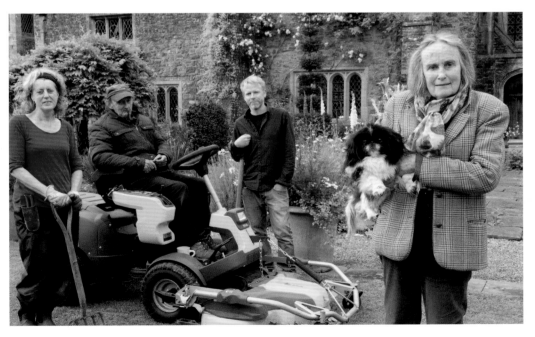

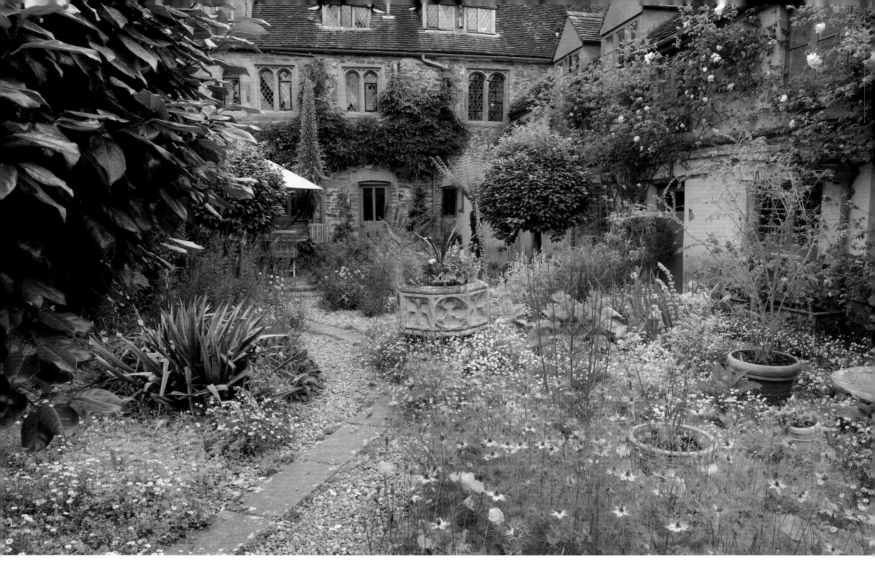

The collector's eye

A collector since childhood, Mary-Anne has furnished Cothay with exquisite antiques and its garden with unusual and beautiful plants. A recent purchase, *Alyogyne huegelii* 'Santa Cruz', has been showing off its blue, hibiscus-like flowers all summer.

Mary-Anne confesses to a weakness for pretty, small-flowered viticella clematis and single-flowered roses. She has persuaded shrubby *Rosa × odorata* 'Mutabilis' (through sheer force of will, one suspects) to grow as a climber, while Cooper's Burmese rose (*R.* 'Cooperi') is another success story, throwing a 30m/100ft cloud of creamy white flowers around the back door and requiring a thrice yearly prune to keep it in check.

There are treasures beyond the garden rooms, where the Robbs developed a Bog Garden and added a large pond and arboretum. Alastair put in fine specimens such as the incense cedar (*Calocedrus decurrens*) and Korean fir (*Abies koreana*), which produces magnificent, blue, upright cones. The statuesque dawn redwood (*Metasequoia glyptostroboides*) that overlooks the Bog Garden was already at Cothay, having been planted in the 1940s (not long after the species was rediscovered in China); Alastair added another near the pond.

Alastair Robb, who died in 2015, is buried at the top of the Snail Mound created from spoil from the pond. His grave is marked by a magnificent rusted steel sculpture of a stag, which gazes over the wildflower meadow towards the north front of the house. In spring the meadow provides another of Mary-Anne's favourite moments, when it becomes a millefleurs tapestry of different coloured, lily-flowered tulips.

Cothay is dreamy but hard work – a commitment that Mary-Anne shrugs off: 'to love and to labour is the sum of life'. She is helped in the garden by a part-time team, among them Wesley Huxtable, who tends the lawns and grass and has been at Cothay for nearly thirty years.

With the garden put to bed by Christmas, Mary-Anne is free to travel, often to India, but sometimes on botanizing trips. Such trips pay dividends in the garden, where she believes firmly that 'before you plant something you should know where it comes from so you can understand its needs'.

7

East Lambrook Manor

East Lambrook

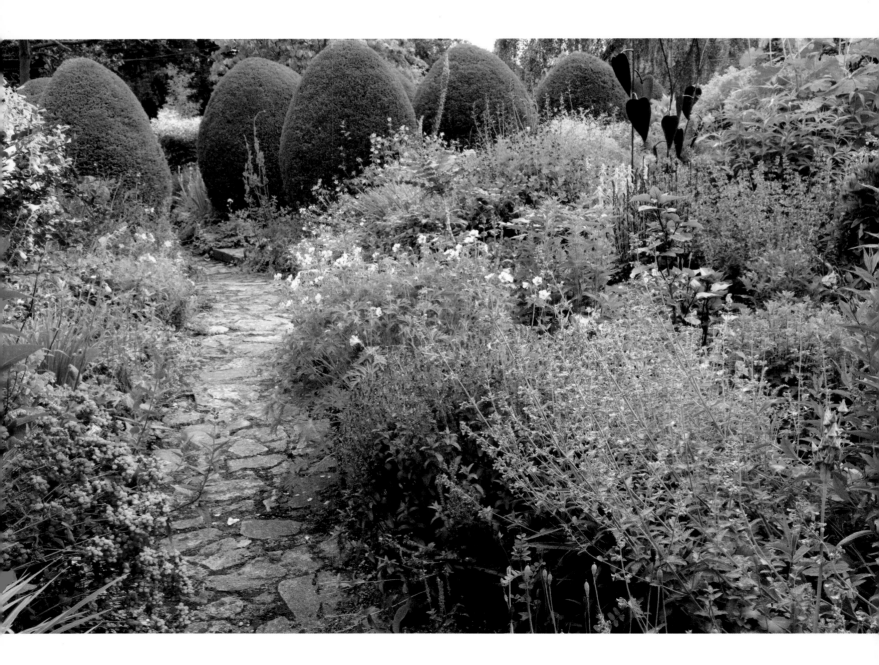

IT IS FIFTY YEARS since the death of Margery Fish, the doyenne of English cottage gardening, but her influence lives on, in her books and in the iconic garden she created at her home, East Lambrook Manor, in south Somerset.

On visiting this accomplished garden today, it is hard to believe that when Margery started it in 1938 she was in her mid-forties and a novice gardener. She was to bring to gardening the drive that characterized her earlier career in Fleet Street, when she worked for press baron Lord Northcliffe and Walter Fish, the editor of the *Daily Mail*, whom she married in 1933.

Foreseeing another war on the horizon, Walter and Margery moved out of London and purchased East Lambrook Manor in 1937. The manor's grand-sounding title belied its semi-derelict condition, and the garden was 'nothing but a wilderness', as Margery later recalled.

While she was new to gardening, Walter, seventeen years her senior, had previous garden-making experience. Renovating the house gave them time to consider what kind of garden they wanted to create but, as Margery's horticultural confidence grew, her informal style, influenced by the writings of William Robinson, jarred with Walter's more regimented approach. After Walter's death in 1947, Margery was able to develop the garden as she pleased, wryly recounting their horticultural differences in her 1956 book *We Made a Garden*.

This, the first of eight books, chronicles the couple's initial steps in what would become an internationally influential

Half a century after its creator's death, the 'home of cottage gardening' still casts a powerful spell, with visitors travelling from all over the world to see it at first hand.

garden. Margery's conversational prose made even backbreaking tasks such as laying stone paths interesting and accessible. And although she did not share Walter's devotion to dahlias (the brassier the better), Margery did credit her husband for insisting that 'perfect lawns, paths, hedges and walls', the four essentials of a good garden, were in place at East Lambrook.

Margery fleshed out the bones with a profusion of the 'small unshowy' plants that she observed in the humble cottage gardens of her Somerset neighbours, and shared her enthusiasm in her 1961 book *Cottage Garden Flowers*. Many of her finds such as *Astrantia major* subsp. *involucrata* 'Shaggy' (syn *A. major* 'Margery Fish') were spotted on botanizing drives around the West Country, while other signature plants such as *Artemisia absinthium* 'Lambrook Silver' and *Polemonium* 'Lambrook Mauve' were discovered closer to home.

In spite of its heavy clay soil (which Margery battled for years), East Lambrook was the perfect location for a self-confessed plant fanatic. Its 0.8 hectares/2 acres offered several

LEFT Margery Fish's 'pudding trees' form a sculptural backdrop to the exuberant cottage planting of the Terraces. RIGHT The rich yellow, local Hamstone of the manor house makes a wonderful foil to the garden's plant-filled borders.

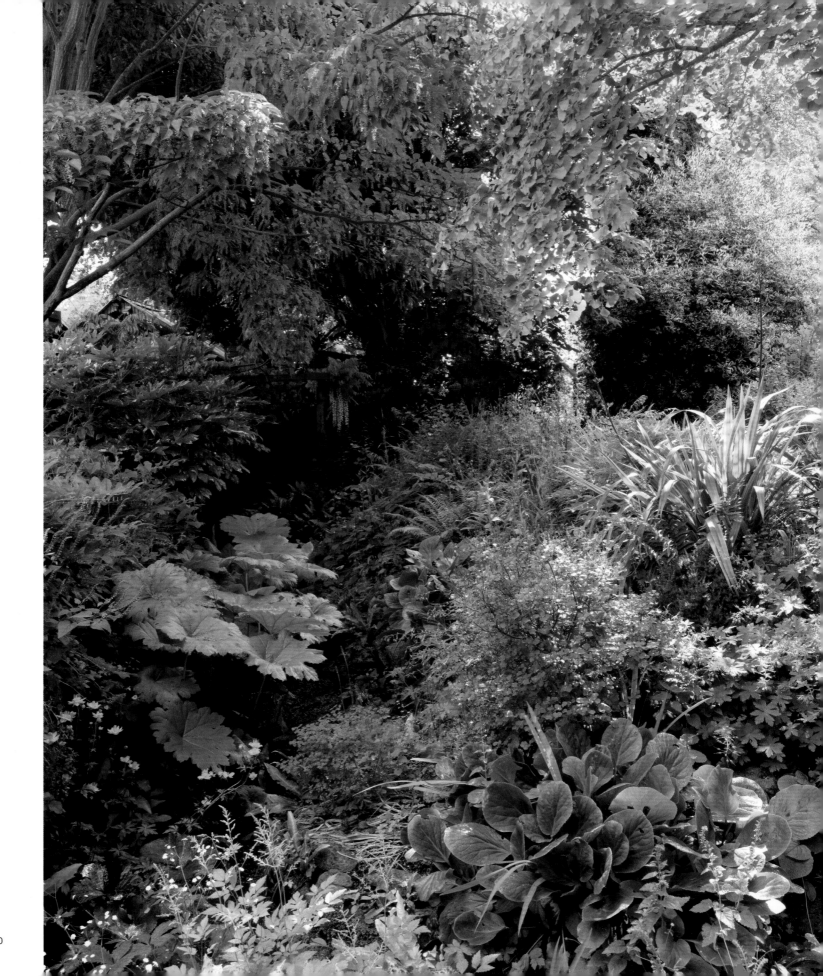

distinct environments, from the sun-baked, south-facing slope of the Silver Garden to the damp and shady Lido behind the old Malthouse. Margery saw opportunities everywhere, from walls of the Malthouse to cracks in the paving stones, where she encouraged creeping thyme (*Thymus*), Cheddar pink (*Dianthus gratianopolitanus*) and *Campanula carpatica*.

Famous for her generosity in sharing plants with friends and visitors, Margery set up a nursery, dispatching mail-order plants wrapped in damp newspaper from the Malthouse (now a café and gallery space).

Change and continuity

East Lambrook Manor has had only a handful of owners since Margery Fish's death in 1969. The current custodians are Mike and Gail Werkmeister, who arrived in 2008 having seen an article about the property in the *Sunday Times*. Like the Fishes before them, the Werkmeisters moved from London, since when Mike, a graphic designer turned English Gardening School graduate, has concentrated on the garden, working hard to ensure that it retains the spirit of the Fishes' original creation.

Great gardens inspire loyalty, and the Werkmeisters have been lucky to inherit long-standing gardening staff who have nurtured the garden's palpable sense of continuity. Head gardener Mark Stainer knows every centimetre, having gardened it for some forty-five years since his teens, while Maureen Whitty, who started at East Lambrook in 1965, is a living link to Margery Fish. Although recently retired, Maureen has stayed on as a volunteer, her long service commemorated by a geranium named in her honour. Ellie Hanscomb and horticultural apprentice Fin Hodson-Wright bring youthful energy to the team; Ellie manages the nursery, propagating stock from the garden, as well as raising plants from seed.

Mark and the gardening team still follow Margery Fish's ethos, allowing plants such as *Euphorbia characias* subsp. *wulfenii* 'Lambrook Gold' and *Papaver cambricum* to self-seed with artless abandon, while Mike also continues the garden's tradition of generosity, on my visit sending me off with a pretty species pelargonium from the polytunnel.

LEFT Moisture-loving plants thrive in the dappled shade of the Lido.
RIGHT TOP In late winter a circle of *Crocus tommasinianus* lights up the front lawn under the *Acer pseudoplatanus* 'Leopoldii'.
RIGHT CENTRE Three multi-stem birches were planted by Mark Stainer in the Woodland Garden.
RIGHT BOTTOM The wildflower meadow under the black mulberry lends a gentle naturalism to the Barton, which lies in front of the Malthouse.

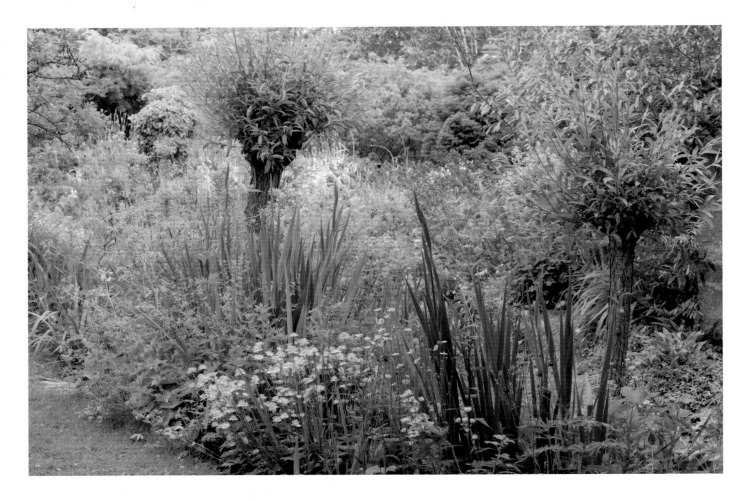

Working in this garden, Mark observes, 'is mostly about plant association and getting the textures right – some are deliberate, some accidental'. A quintessential East Lambrook combination can be seen on the top of the entrance wall, where a vivid pink *Rosa* 'American Pillar' contrasts with the pale blue flowers of *Campanula poscharskyana*.

The interplay between past and present is tangible in a garden that is recognizable from photographs from the 1960s. But there are some subtle changes: Mike has transformed the grassy knoll in front of the Malthouse into a mini-wildflower meadow woven with snowdrops (*Galanthus*), winter aconites (*Eranthis hyemalis*) and snake's-head fritillaries (*Fritillaria meleagris*). The handsome black mulberry (*Morus nigra*) tree, which shades the grass, was planted in 1969, shortly after Margery Fish's death.

ABOVE In early summer the extrovert magenta blooms of *Gladiolus communis* subsp. *byzantinus* contrast with fresh green foliage in the Ditch.

OPPOSITE Seen here in its summer pomp is the garden's profusion of plants, underpinned by 'good bone structure' and carefully placed evergreens.

The drive, so laboriously laid by Walter, was tarmacked over by Margery but has since been restored to gravel. Softly edged with lambs' ear (*Stachys byzantina*), Mexican feather grass (*Nassella tenuissima*) and lady's mantle (*Alchemilla mollis*), this gravel garden also provides the ideal conditions for the unusual autumn-flowering snowdrop *Galanthus reginae-olgae*.

Original plants

Nowhere are the trials of old age more evident than in the garden's trees and shrubs. The original *Acer pseudoplatanus* 'Leopoldii' in the lawn is feeling its years, and Mike has air-spaded and fed the roots to rejuvenate it. Honey fungus – the scourge of mature gardens – has made its presence felt in the White Garden, where Mike has replaced an amelanchier felled by the disease with a handkerchief tree, *Davidia involucrata* 'Sonoma'.

The Woodland Garden was redeveloped early in the new millennium – this area having also been ravaged by fungus. The Werkmeisters' predecessors replaced the infected soil, and Mark created a new garden in the Margery Fish idiom, adding a trio of multi-stemmed birch (*Betula*) trees and arranging a patchwork of shade-loving plants designed to complement and contrast. Mark's pairing of the rose-pink flowers and foliage

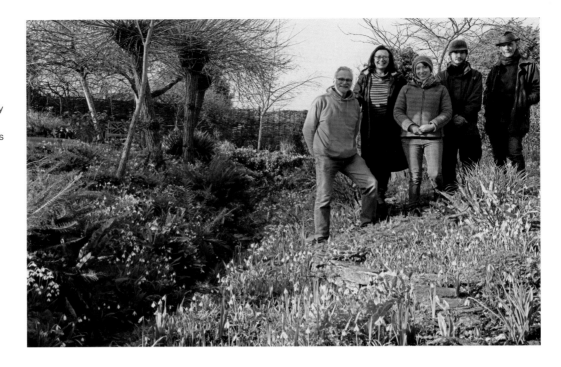

of *Geranium psilostemon* with the purple foliage of *Lysimachia ciliata* 'Firecracker' exemplifies his deft plantsmanship.

Some of the first areas developed by Margery Fish – the Terraces – have recently been renovated, not an easy task in densely planted beds that can be viewed from all sides. The Terraces are still home to some of Margery's original plants – a *Miscanthus sinensis* 'Malepartus', which looks wonderful backlit in low, late summer sun, and a twisted laurel (*Prunus laurocerasus* 'Camelliifolia') that Mike suspects may have been sourced from the Edwardian plantsman E.A. Bowles.

East Lambrook's iconic 'pudding trees' (*Chamaecyparis lawsoniana* 'Fletcheri') are now in their third incarnation, having been replanted in 2000. Mark clips these tightly once a year, to help keep the formal element in this otherwise quite wild style of garden. Margery's choice of evergreen for this important structural feature has been much debated: 'Why didn't she use yew', wonders Mike. 'It would have been so much easier!'

The Werkmeisters have not been afraid to add themselves to the East Lambrook story. *Rosa* 'Penny Lane' has been planted in honour of Mike's wife Gail (who is from Liverpool) by the Coliseum (the mini-amphitheatre of stone steps beside the house), and several plants from Mike's previous garden in Wimbledon have happily relocated to Somerset. Among these are *Molinia caerulea* subsp. *arundinacea* 'Transparent', which forms an airy screen between the White Garden and the Top Lawn, and the olive (*Olea*) tree in the Silver Garden, which seamlessly blends with a community of grey-leaved plants including pungently scented curry plant (*Helichrysum italicum*), whose burnished gold accents were much loved by Margery.

Spring fever

Margery was an ardent galanthophile, and East Lambrook remains a destination for snowdrop-lovers, with a collection of around 130 cultivars and a snowdrop festival in February. From late summer onwards Mike is busy propagating bulbs and preparing hundreds of display pots. The precious portfolio includes *Galanthus plicatus* 'Lambrook Greensleeves', *G.p.* 'Walter Fish' and *G. nivalis* 'Margery Fish', all cultivars that were discovered on the banks of the Ditch, an old drainage channel running alongside the Woodland Garden. In spring this part of the garden is white with snowdrops, then flushed blue with *Scilla bithynica*; in late spring it is shot through with the shocking pink of *Gladiolus communis* subsp. *byzantinus* and dusky pink Sicilian honey garlic (*Nectaroscordum siculum*).

Half a century after its creator's death, the 'home of cottage gardening' stills casts a powerful spell, with visitors travelling from all over the world to see it at first hand. 'It's a very English style of gardening', says Mike of its enduring appeal. 'It's on a human scale and like most people's gardens it's evolved over time rather than being designed in one go.'

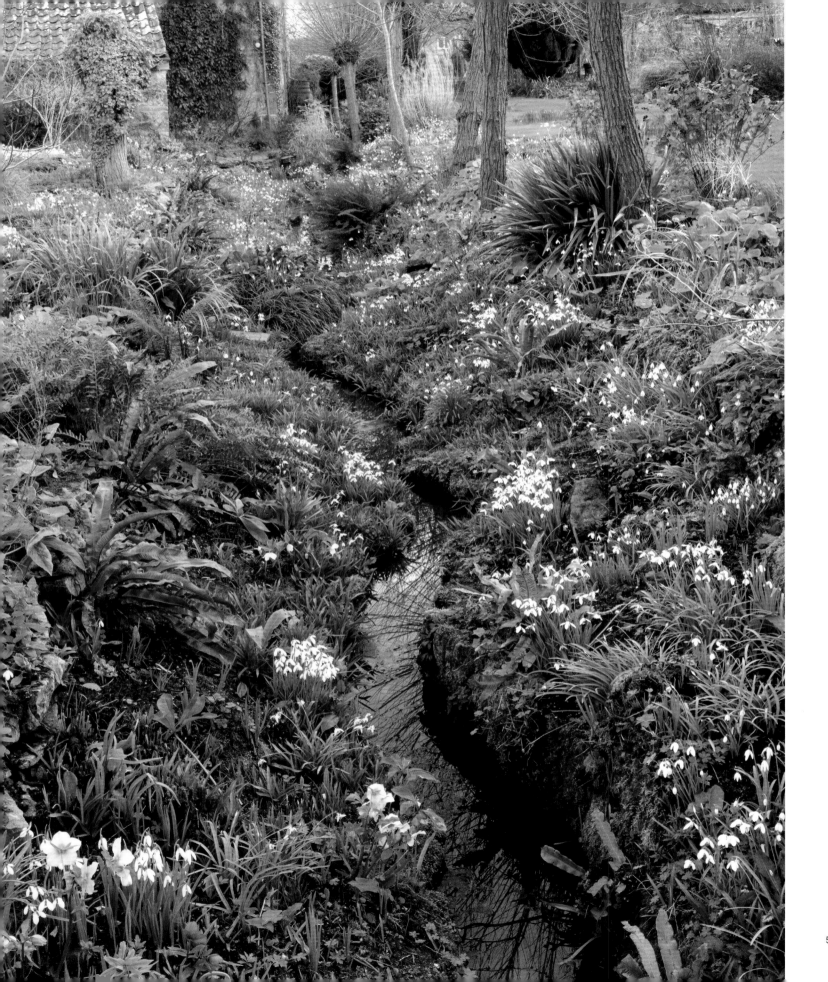

8
Elworthy Cottage
Elworthy

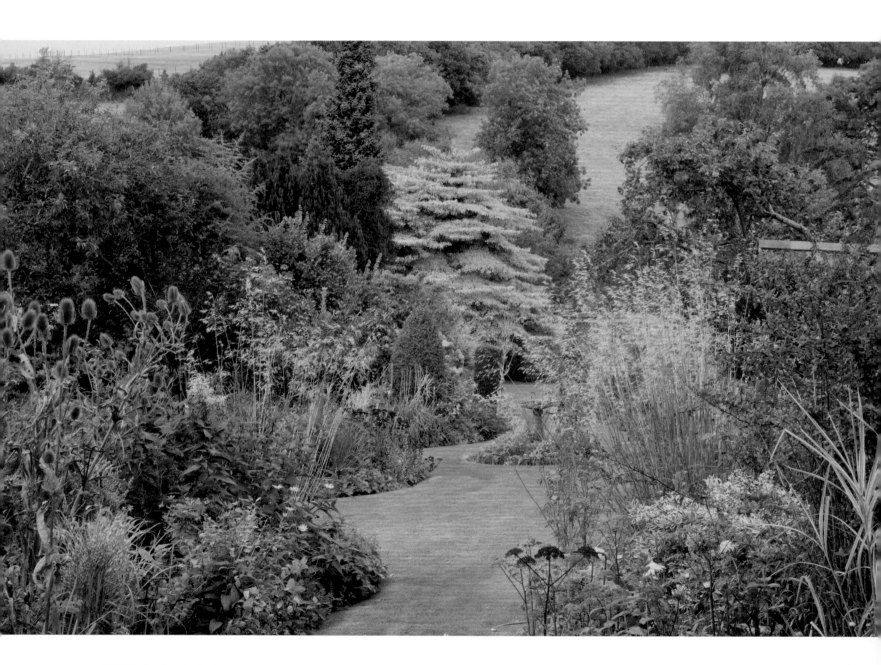

Discreetly folded within the Brendon Hills, at the eastern edge of the Exmoor National Park, Elworthy Cottage is a masterclass in cottage gardening, and has been a destination for discerning plant hunters for thirty years. Owners Mike and Jenny Spiller are highly respected plant breeders of unusual perennials and are familiar faces at specialist plant fairs around southern England, but to really appreciate the glories of their catalogue a visit to their garden and adjoining nursery is a must.

None of this was on the cards when the couple moved to this idyllic rural location in 1976 so that Mike, an engineer, could take up a new job as a highways surveyor. Jenny was working as a teacher, but wanted to keep goats so they needed a house with land. The cottage, formerly two farmworkers' dwellings, had been converted in the 1960s ('badly', according to Mike. 'They stripped out all the period details and buried the rubble in the garden'). However Jenny liked the land and fell in love with the picturesque stone privy that stood in the middle of it.

Although the Brendon Hills are more domesticated than Exmoor's westerly moorlands, Elworthy village is 183m/600ft above sea level and several degrees colder than nearby villages. Mike and Jenny's 0.4-hectare/1-acre garden compounds this by being on a north-facing slope that catches the nor'westerlies from the Bristol Channel, 8 kilometres/5 miles distant. 'Not the easiest prospect', admits Mike, 'and it can be hard to bear when the garden is white with frost while the hill opposite is brilliant green.' But despite the builders' rubble, the soil is good loam, improved over the years with copious quantities of compost and leafmould.

There was no garden to speak of when they arrived. Mike and Jenny were busy with a young family and developed the garden bed by bed, pivoting the overall design around the stone shed. Island beds and borders were marked out using a lawnmower: 'We did try using a hosepipe but a mower is better because you can get quite fine adjustments', says Mike, ever the practical engineer. One bed stayed as long grass because it looked so good, with camassias and primroses (*Primula vulgaris*) allowed to 'run riot' through it.

Neither Jenny nor Mike was knowledgeable about plants initially but following a revelatory visit to the open gardens weekend at nearby Stogumber village, where she met one of the garden owners, Jenny joined the Hardy Plant Society on the garden owner's advice and began raising plants from seed. It was a turning point in her life as a gardener.

As the garden expanded the goats were moved to more distant pastures, and Jenny was able to indulge in her burgeoning love of pollinator-friendly cottage plants: 'simple plants that are not highly bred, and that are still closely related to wild flowers', as she describes them. The garden takes its lead from this naturalist plant palette, and it seems to respond intuitively to the surrounding countryside. It is planted for year-round interest. Jenny and Mike are out every day, photographing star performers of the moment, be they hellebores (*Helleborus*) and lungwort (*Pulmonaria*) in early spring, black cow parsley

'A cottage garden is one where plants are given the freedom to grow where they want to grow.'
JENNY SPILLER

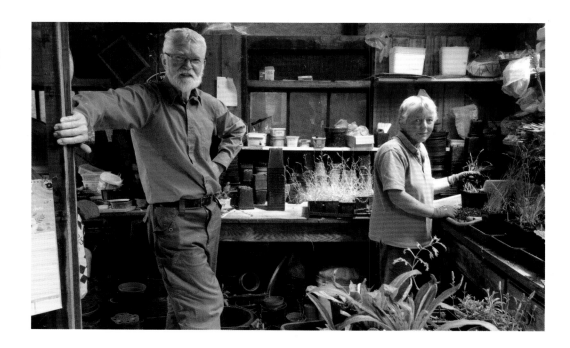

LEFT The subtle interplay between garden and landscape becomes clear when observed from Mike and Jenny Spiller's 'evening bench'.
RIGHT When not working outside in the garden, Mike and Jenny are likely to be found in the potting shed.

(*Anthriscus sylvestris* 'Ravenswing') in late spring, the porcelain-white bells of broad-leaved bellflower (*Campanula latifolia*) in high summer, or wind-whispering grasses and sun-burnished acers in autumn.

The right plants in the right place

The nursery evolved along with the garden, and Mike and Jenny were among the pioneers of the herbaceous perennial renaissance in the 1980s. Jenny started by selling a few fuchsias, but quickly became enthralled by the process of propagation. 'I just love it', she says. 'If I see a seed head that looks interesting, I will sow the seeds or take a cutting.' By the mid-1980s Jenny was selling at Dunster County Fair and had returned to Stogumber Open Gardens, where she remembers long queues forming outside her stall. 'You could count on one hand the number of people growing unusual herbaceous plants back then', recalls Mike.

Jenny established Elworthy Cottage Plants in 1990 and the nursery has since become a byword for good-quality plants. Elworthy's bracing climate means that 'if it grows here it will grow anywhere', says Mike. Jenny's covetable plants are shown off in their garden setting and most – instant gratification at its best – can be purchased on the spot from the nursery.

The garden's opening days under the National Garden Scheme reflect the range of plants, which span from snowdrops (*Galanthus*) in late winter through to late summer. Elworthy's snowdrop collection runs to more than 200 cultivars, including honey-scented *G.* 'S. Arnott' and the home-grown *G.* 'Elworthy Bumble Bee', an early double with attractive, swept-back 'outers'. *Galanthus rizehensis* 'Margaret Billington', with four 'outers' instead of the usual three, is another Somerset variety, originating from Porlock, and is one of the rarest the Spillers stock. 'It's these tiny differences that make snowdrops so fascinating', says Jenny.

Cranesbill (*Geranium*) are another specialty. The doyenne of cottage gardening, Margery Fish, famously advised: 'if in doubt, put in a geranium', and Jenny's expansive collection confirms such wisdom. Her own introductions include *Geranium* 'Elworthy Eyecatcher' (a chance seedling of 2001 whose bright pink spring flowers are preceded by an almost cream-variegated foliage) and *G. nodosum* 'Blueberry Ice' (a plant with striking, white-edged, bright blue flowers that Jenny spotted at a plant fair simply labelled 'Nodosum seedling'). Her favourite is *G. pratense* 'Plenum Violaceum', an old double variety, whose pretty, pompom, violet flowers bloom all summer.

Somerset is the birthplace of the lauded *Geranium* 'Rozanne' (which in 2013 was named RHS Chelsea Flower Show Plant of the Centenary for the decade 1993–2002), and it turns out that Elworthy may have played a part in its conception. Donald Waterer, the Kilve nurseryman who raised 'Rozanne', was a customer and Jenny suspects that 'Rozanne' might have been an offspring of one of the many cranesbills he purchased from Elworthy.

A garden with a free spirit

The Spillers are great advocates for allowing plants to associate naturally. They reckon that about half the garden is 'planted' in this way and, whether by design or happy accident, there are points of interest at every turn.

In the drive, self-seeded pheasant's tail grass (*Anemanthele lessoniana*), skimmia and *Euphorbia characias* subsp. *wulfenii* create a gutsy grouping, while *E.* 'Golden Foam' bubbles up at will through the Rock Garden, adding a twist of lime to a cocktail of pink cranesbills. 'It goes well with everything', says Jenny of 'Golden Foam'. 'I use it to soften the colours between plants.'

Viola 'Hudson's Blue' set against the acid-yellow of lady's mantle (*Alchemilla mollis*) makes another lovely pairing, as does the gentle mauve flowers of *Geranium* 'Elworthy Dusky' beside a serendipitous red orach (*Atriplex hortensis* var. *rubra*). In the woodland area on the far side of the garden, Jenny has teamed white-flowered, shade-loving *Geranium nodosum* 'Silverwood' with *Lunaria rediviva* 'Partway White', an unusual perennial honesty whose pale lilac flowers have the advantage of being scented.

At Elworthy the overall colour palette is deliberately soft, with the hot colours of rust-red day lily *Hemerocallis* 'Tejas' and *Cotinus* 'Grace' confined to a separate bed. Twin borders, planted in a yellow, white and blue scheme, create an important axis in the garden, and make good use of the pure white blooms opening from cream buds of *Leucanthemum × superbum* 'Elworthy Sparkler' ('an excellent plant in drought conditions', notes Jenny. 'It does not flop').

The view from Mike and Jenny's favourite evening bench at the top of the garden looks down through these borders, which lead the eye down the hill, past the terracotta roofline of the shed to the stately *Cornus controversa* 'Variegata' on the lower lawn, and on up to the facing hill, dotted with grazing sheep and bounded by a row of mature beech (*Fagus*) trees giving the impression of a hanging wood. It is a vista that encapsulates the garden's superb plantsmanship and light touch design.

RIGHT Whatever the season, Jenny Spiller's generous approach to planting pays dividends, with beds packed with interest, texture and colour.

Forest Lodge

Pen Selwood

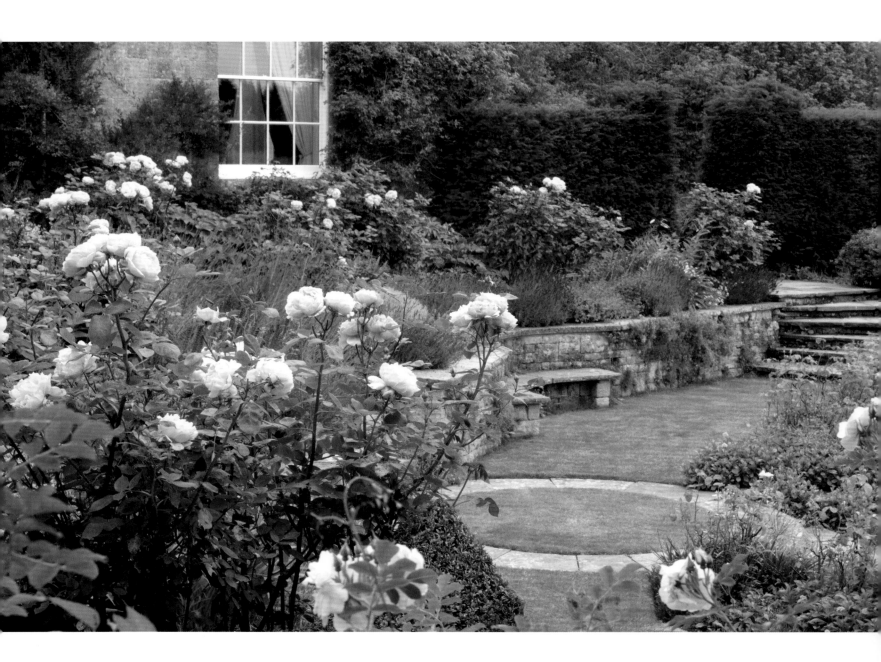

THE VILLAGE OF PEN SELWOOD lies on the eastern edge of Somerset, where it meets Dorset and Wiltshire, in an Area of Outstanding Natural Beauty. This densely wooded landscape has been a focus for human activity since the Bronze Age. Its high ground is littered with ancient fortifications and just outside the parish boundary lies Egbert's Stone, where King Alfred is believed to have massed his troops prior to his historic victory over the Danes at the Battle of Edington in 878. Thankfully, Pen Selwood is more peaceful these days, and nowhere more so than at Forest Lodge, the glorious 1.2-hectare/3-acre garden Lucy Nelson has created from scratch.

Lucy and her husband James moved here from Dorset in 1996, in search of more land and better riding country. Lucy is a noted breeder of performance horses, and Forest Lodge, which was built as a hunting lodge for the Earl of Ilchester in the early nineteenth century, offered kilometres of bridleways and good grazing.

From the start the garden was Lucy's project: 'I had made one garden before and both my mother and aunt were gardeners', she explains. With that experience behind her, and recognizing the importance of good bones in a garden, Lucy enlisted designer Michelle Prior to help with the initial layout. On Michelle's advice the steeply sloping land behind the kitchen facade was relandscaped with terraces leading down to a circular 'amphitheatre' lawn, set out at a diagonal to the house. Perimeter deer fencing was another expensive but

essential preliminary, and the existing 'puddle' of water was replaced by a generously proportioned, spring-fed pond.

When it came to design ideas, Lucy admits she has barely left the county. 'Somerset's gardens have been a great inspiration to me', she says, and that is little wonder, because Lucy knows the county well. She recently served as its high sheriff (an ancient, non-political, royal appointment dating from Saxon times) and still serves as a deputy lieutenant.

Country house vernacular

The landscape garden at Stourhead, just over the border in Wiltshire, was an obvious reference point for Lucy (not least because Forest Lodge shares Stourhead's acidic greensand soil). But oft-visited Somerset gardens such as Tintinhull, East Lambrook Manor (see page 48) and Nori and Sandra Pope's colour-themed garden at nearby Hadspen House (now called The Newt in Somerset, see page 110) also informed her approach. Hadspen's design has since been superseded (although it lives on in the Popes' book *Colour by Design: Planting the Contemporary Garden*).

However it is the influence of Hestercombe Gardens (see page 78) that resonates most strongly at Forest Lodge. Lucy had studied the work of Edwin Lutyens and Gertrude Jekyll and felt that their unpretentious style was well suited to her Somerset garden. Lutyens's low-key country house vernacular provided the cue for a sympathetic new extension

LEFT David Austin roses throng the Terraced Garden, and are chosen for their reliability and beautiful flower forms.
RIGHT A river of bellflowers (*Campanula*) cascades down the curved terrace steps to the circular amphitheatre lawn.

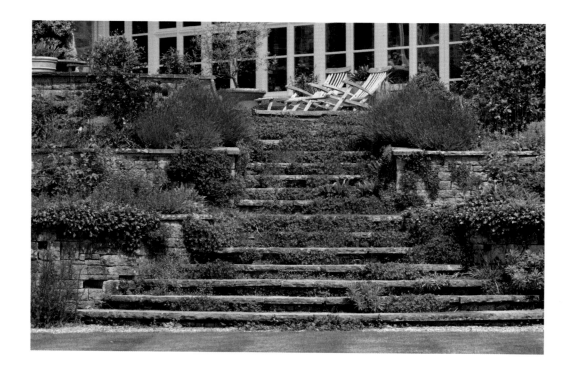

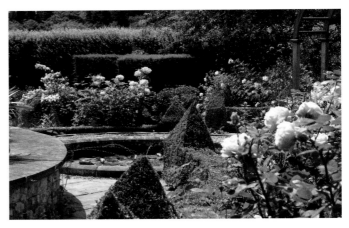

at Forest Lodge, designed by Lucy's brother-in-law, architect Martin Llewellyn, while the stone walls and intersecting circle motifs of the formal Terraced Garden reference Hestercombe more specifically.

Lucy works closely on the terrace planting with head gardener Mandy Fowler, who has tended the garden for the past fifteen years. 'Mandy has great skill in putting things together', says Lucy, 'and we have an ongoing debate between "form" and "planting".' To this end they have added more flowers alongside the yew (*Taxus*) and hornbeam (*Carpinus*)

topiary, and Mandy has also introduced grasses such as Mexican feather grass (*Nassella tenuissima*) and *Calamagrostis* × *acutiflora* 'Karl Foerster', for a more contemporary accent. 'They contrast well with the clipped forms', she notes, 'and add movement.'

In the Kitchen Terrace, the box (*Buxus*) parterre effervesces with salvias, *Geranium* × *magnificum* and vigorous roses such as *Rosa* 'Ferdinand Pichard', *R.* Olivia Rose Austin and *R.* Brother Cadfael. Locally sourced salvias include intensely blue *S.* 'Blue Note' and the sugar-pink *S. greggii* 'Stormy Pink'. 'The salvias love the sun and sand here', observes Mandy, making the garden sound like the perfect holiday destination.

Restraint is the key note on the Drawing Room Terrace, where the cool grey Chilmark stone of the house is warmed by the apricot blooms of the old climbing *Rosa* 'Desprez À Fleur Jaune'. Square brackets of clipped yew enfold mirror borders containing an elegant combination of pyramid yew topiaries, peachy pink *Rosa* Sweet Juliet and opalescent-pink *Salvia* × *jamensis* 'Peter Vidgeon'. Later in the season these will

ABOVE The typically generous, romantic planting at Forest Lodge includes the drawing room facade (top left), hung with *Wisteria floribunda* f. *alba* 'Shiro-noda' and *Rosa* 'Desprez À Fleur Jaune', and around the circular lily pond (above right) on the Kitchen Terrace.

OPPOSITE In the Orchard can be found wildflower planting, for which Mandy Fowler has been naturalizing resilient perennials such as ragged robin (*Silene flos-cuculi*), ox-eye daisies (*Leucanthemum vulgare*) and meadow cranesbill (*Geranium pratense*).

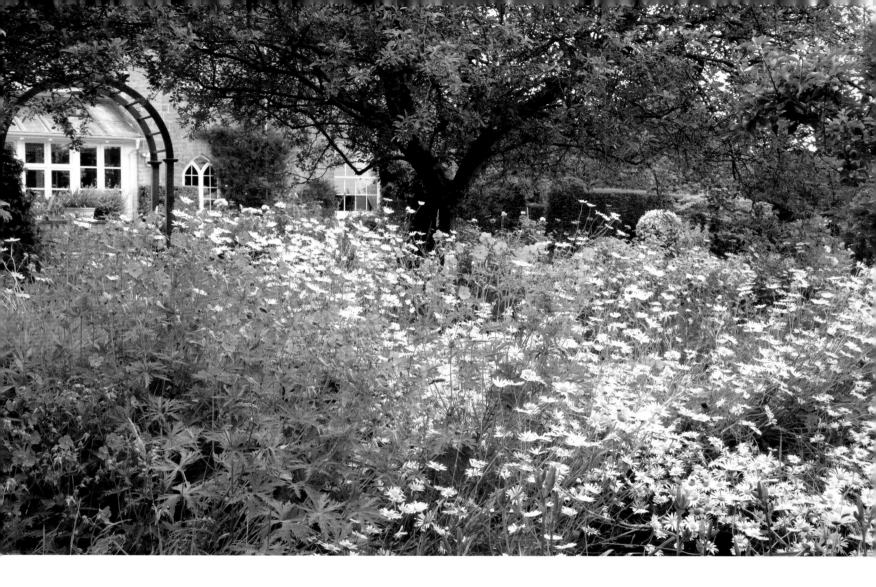

be joined by deep blue agapanthus and lilac *Veronicastrum virginicum* 'Fascination'.

Leading off from the Kitchen Terrace is the Orchard, managed as a wildflower meadow, where Mandy has planted a succession of bulbs beneath *Malus hupehensis* and the central quartet of *M. transitoria*. The long season of interest starts with snowdrops (*Galanthus*), crocus and *Tulipa sylvestris*, and continues through summer with montbretia (*Crocosmia*) and cranesbills (*Geranium*) among the perennials naturalizing in the grass.

Through a stone doorway in the Orchard wall there is a return to formality, with a stainless steel rill by the award-winning sculptor David Harber. The rill was a retirement present to James. 'The company asked him what he wanted, and I said "a rill" ', recalls Lucy. The pleached hornbeam *allée*, which flanks it, is precision-pruned every autumn by local tree surgeon David Harness.

A group of cloud-pruned variegated hollies (*Ilex*) announces the start of the Woodland Walk, which skirts the pond. This area recently underwent a dramatic identity change, when the conifer plantation in the neighbouring field was felled. The increased light levels prompted a rapid relocation of shade-lovers such as trilliums and *Podophyllum versipelle* 'Spotty Dotty'; conversely the *Rosa* 'Bonica' that Mandy moved here from elsewhere in the garden is thriving, alongside self-seeded *Geranium nodosum* 'Svelte Lilac'– a textbook case of 'right plant, right place'.

Amid the horticultural musical chairs, the rhododendrons have stayed put. They relish the acidic greensand, and Lucy's careful selection ensures an extended season of interest, starting with the early pink variety *R*. 'Christmas Cheer' to the latest, *R*. 'Polar Bear', whose fragrant white blooms appear in early summer.

Flowering trees

Away from the formal terraces, the garden embraces its natural hillside terrain, with large swathes of long grass and loose plantations of trees and shrubs. Being an avid reader of

RIGHT Lucy Nelson, here with assistant gardener Ollie Dowling and head gardener Mandy Fowler, owns Forest Lodge with her husband James.

OPPOSITE Trees create year-round interest and atmosphere at Forest Lodge, with their bright spring foliage and flowers and their glowing autumn colour. The pleached hornbeam hedge adds a note of formality and is underplanted with evergreen and fragrant sweet box (*Sarcococca*).

'Compassion is my watchword in life.'

LUCY NELSON

gardening books and journals, Lucy is fascinated by flowering trees and has put together a well-researched collection that spans the year, from late autumn-flowering *Camellia sasanqua* to early winter-flowering witch hazels (*Hamamelis*).

Dogwoods (*Cornus*) are well represented, as both Mandy and Lucy love this genus; a recent addition includes *C.* × *elwinortonii* Venus, whose blowsy, creamy white bracts look wonderful in late spring alongside the white camassias that have been naturalized nearby.

Some of the trees were suggestions from Mandy's brother, who used to run a plant nursery in New York State that shared a similar soil type to Forest Lodge. Thanks to his input this Somerset garden includes the stateside native American yellowwood (*Cladrastis kentukea* syn. *C. lutea*), as well as uncommon specimens such as *Enkianthus campanulatus*, an acid-loving shrub native to China, whose virtues include cream and pink flowers in late spring and vibrant foliage in autumn.

Forest Lodge has an abundant supply of natural springs and a spring-fed Bog Garden forms a centrepiece to the informal garden, where a 'river' of *Geranium* 'Rozanne' amplifies the trickle of water as it flows down to the pond. The towering stand of arum lilies (*Zantedeschia*) flowers from early spring until first frost, its calm, green and white presence contrasting with deep red acers, the acid-yellow foliage of Indian bean tree (*Catalpa bignonioides*), vibrant orange geums and self-seeded offspring of *Astrantia* 'Hadspen Blood'.

The compassionate gardener

For Lucy, her well-stocked garden is an education and it is she who researches and sources the plants. New purchases such as the fragrant flowering shrub *Calycanthus* 'Venus' are assessed in the Kitchen Garden before being planted out in autumn by Mandy and assistant gardener Ollie Dowling.

The working area is also a cutting garden and is home to Lucy's favourite rose, *Rosa* 'Compassion'. 'Compassion is my watchword in life', explains Lucy, who uses natural horsemanship to train her young horses and is active in the voluntary sector, having co-founded the baby charity Tommy's more than thirty years ago. She is also closely involved with the Somerset Community Foundation and takes great pleasure in using her garden to raise funds for good causes such as the National Garden Scheme (NGS) and local mental health charities, whose clients are welcome to walk, draw or just relax in the garden. 'It's a way I can share it with people', says Lucy, 'and the garden is very calming and therapeutic.'

10
Greencombe Gardens
Porlock

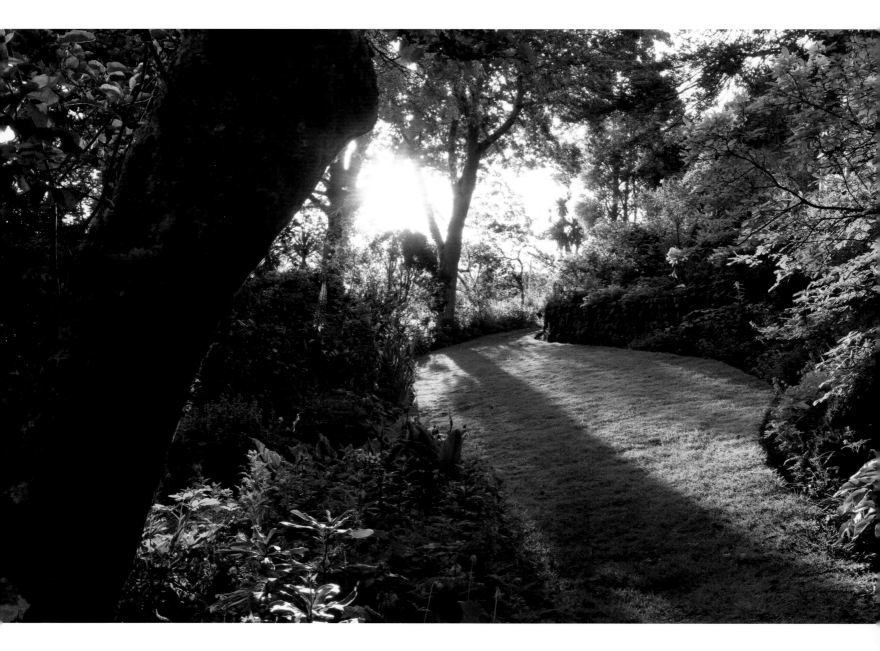

VISITORS TO GREENCOMBE would do well to heed the 'Look up, look down, look back' sign propped up amid the ferns and periwinkle (*Vinca*) by the front door. The enchanting woodland garden created by Joan Loraine between 1966 and her death in 2016 is horticultural armchair travel at its most immersive. Poised on a 1.4-hectare/3½-acre strip looking north over Porlock Bay, Greencombe's global treasure chest encompasses four National Plant Collections and has seasonal interest at every turn, from forest floor to tree top.

Greencombe's garden was initially set out in the 1940s by Horace Stroud, a Minehead shopkeeper whose sense of spatial design (honed, he claimed, by dressing windows) proved invaluable when it came to terracing the steeply sloping site below Porlock Hill.

Horace laid out the grand piano-shaped main lawn and incorporated the neighbouring woods ('First', 'Middle' and 'Far') into the garden, sourcing hundreds of rhododendron and azalea cuttings from Cornwall to add to Greencombe's native trees. He also added the pond and the lower lawn, where visitors can savour a panoramic view that sweeps from Hurlstone Point to the grey shingle crescent of Bossington beach below and, on a clear day, across the Bristol Channel to the Welsh coast.

Horace provided the bones of the garden, but it was Joan Loraine who gave it soul. A self-taught gardener, Joan became an expert plantswoman through her profound engagement with Greencombe. 'She was a formidable woman', remembers Joan's American nephew Rob Schmidt. 'When she had her mind set on a given endeavour she would accomplish it, one way or another.' Joan's neighbour, the noted horticulturalist Norman Hadden, was an important source of encouragement, and many of the unusual cuttings he gave her, such as his home-bred *Cornus* 'Porlock', still thrive.

During the course of gardening on Greencombe's challenging site (buffeted by wind, lacking a stream, essentially soilless and with low light levels in winter), Joan developed a philosophy of 'intrinsic' gardening and embraced organic methods. Her holistic approach resulted in a garden that belongs utterly in its surroundings, with a look of 'quiet inevitability' about its planting.

Joan was a firm advocate of mulching. Managed as a closed system, Greencombe generates up to 30 tonnes of compost and leafmould a year and this, applied over the decades, has encouraged strong root systems while helping to retain moisture and suppress weeds. The stuff of horticultural legend, Greencombe's rich chocolate-brown leafmould is made in a series of compartments carved into 'the gut' of the medieval deer-leap, which forms the garden's lower boundary.

Lawn levelling and stump removal on a massive scale were early challenges, and while working among Greencombe's soaring oaks (*Quercus*) and sweet chestnuts (*Castanea sativa*) Joan evolved her idea of 'vertical gardening'. Innumerable

LEFT The flowing contours of the lawn help foster the garden's look of 'quiet inevitability'.
RIGHT Framed by a 'guardian' oak, Greencombe's borrowed landscape extends across Porlock Marsh to the Bristol Channel.

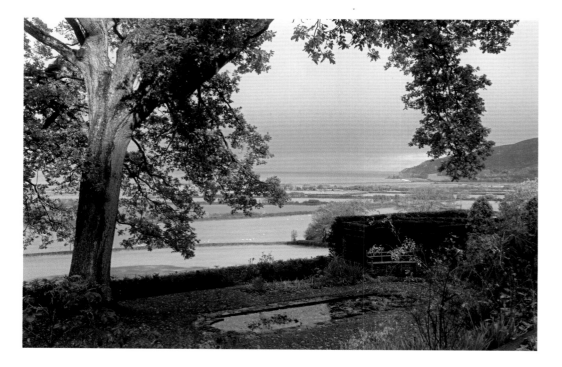

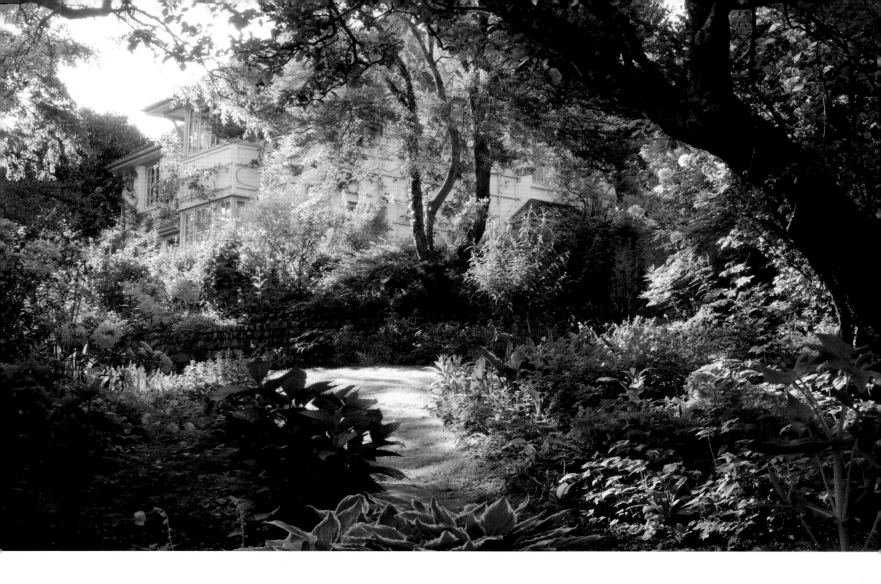

ABOVE Greencombe house, seen here from the lower lawn and through a veil of foliage, was built in 1934.

RIGHT Joan Loraine relished the versatility of climbing and rambling roses, enjoying their ability to scale heights as well as their fragrance.

OPPOSITE TOP The house is hung with Japanese wisteria (*W. floribunda* 'Multijuga'), whose extravagant racemes are 50cm/20in or more long.

OPPOSITE CENTRE A trio of flame-coloured maples (*Acer palmatum* 'Dissectum') create focal points in the main lawn.

OPPOSITE BOTTOM In late spring Greencombe's borders radiate colour and interest from its global collection of plants.

Look up, look down, look back. Ask what you want to know. The best way round – up steps . . . past house . . . across lawn . . . and the world is yours.

clematis and roses scramble through trees and shrubs, and up the sides of the house and across the garage roof. Joan was fond of roses ('I fall asleep thinking of roses', she once wrote), and planted dozens of ramblers, urging *Rosa* 'Paul's Himalayan Musk' high into a Portuguese laurel (*Prunus lusitanica)* to add a vital extra dimension to the garden.

Finding plants suitable for the woodland terrain was fundamental to Joan's 'intrinsic garden'. Magnolias, azaleas, rhododendrons and hydrangeas thrive in Greencombe's acid soil, creating a psychedelic pageant of colour from shocking pink *Rhododendron arboreum* in early spring to the pure colours of Japanese Kurume azaleas in mid-spring, moving through to Satsuki azaleas in their midsummer palette of pink and late summer hydrangeas in vivid blues and pinks, and ghostly white.

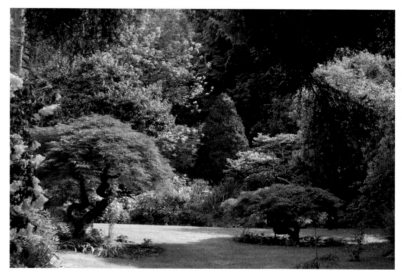

The narrow mossy paths that wind along Greencombe's wooded contours lend a fairy-tale quality – and innumerable opportunities for 'close to the eye' planting. Joan's quest for woodland-edge plants led her to the acid-loving gaultheria, shield fern (*Polystichum*) aka 'thumbs-up ferns, blueberries (*Vaccinium*) and dog's-tooth violets (*Erythronium*), which form Greencombe's four National Plant Collections.

Joan first saw dog's-tooth violets in Norman Hadden's garden and was instantly smitten. Her collection of these enchanting mountain lilies is one of Greencombe's early spring highlights, and it is arranged geographically with European *E. dens-canis* in First Wood, *E. japonicum* in Middle Wood and North American species such as lemon-yellow *E. oregonum* in Far Wood.

A new chapter

Since Joan's death in 2016, her legacy has been in the safe hands of Rob and his wife Kim-Nora, who run Greencombe as a trust. Their return from the United States heralded a new chapter in the garden's story. Educated in Britain, Rob spent school holidays at Greencombe, gardening alongside Joan and learning the 'basic operation' of the garden.

Knowing that they would one day be custodians of Greencombe, Rob and Kim-Nora studied horticulture when they were living in New York, while Rob pursued a career in information technology ('a different world'). They also

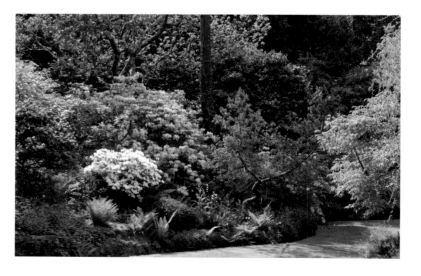

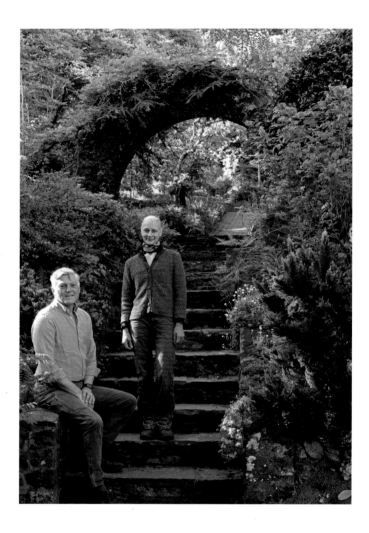

'Horticulture changes all the time', says Rob, 'so Kim-Nora and I represent an injection of fresh knowledge in the garden.' As a keen forager and conservationist, Kim-Nora comments: 'I'm in my element here. I'm always looking for things to identify as I walk around.'

Having focused their initial efforts on maintenance, the couple are beginning to implement their own ideas while continuing to strive for the 'inevitable look'. Joan would be supportive of change, Rob feels: 'She was always doing crazy new things in the garden!'

'Inevitable' areas for redevelopment are opening up all the time. 'We've lost a number of chestnuts recently to high winds', says Rob, pointing out a clearing where more *Magnolia campbellii* are planned, and where self-seeded echiums, foxgloves (*Digitalis*), *Rhododendron protistum* and soft tree fern (*Dicksonia antarctica*) are already springing up. 'It's wonderful to see light appearing and the azaleas blossoming more vigorously in response.'

In line with Greencombe's sustainable ethos, the fallen chestnuts have been planked to make a table in the Green Room, where visitors can pore over Joan's planting plans. The tiny chapel in Far Wood is also made from Greencombe timber, although its roof shingles are pine from Romania, a country with which Joan had close ties, having led Porlock's relief effort to the village of Ursoaia in the 1990s. The chapel's presence is a surprise to many visitors, but reflects Joan's deeply held Catholic faith and invites a moment of prayer or contemplation.

Rob and Kim-Nora are hands-on each day in this magical but labour-intensive garden in which they are assisted by long-term gardener Jon Grant and by part-time help and volunteers. Power tools are kept to a minimum, enabling each of them to garden quietly even when there are visitors. In late summer, sweeping chestnut catkins from the woodland floor is a major undertaking; so too is the essential task of deadheading and pruning rhododendrons and camellias. Leaf collection is a winter job using corn brooms and rakes, but there are compensations, explains Rob: 'There's a huge amount of blossom. The camellias start blooming in early winter, and there are wonderful yellow flowers such as mahonia and *Chimonanthus praecox*.'

And their biggest discovery since taking on Greencombe? 'The darkness', responds Rob, without hesitation. The sun leaves the garden in late autumn, and its first momentary reappearance in late winter is cause for a celebratory tradition. 'When the sun first hits the base of the "guardian" oak on the lower lawn we run out with our sherry glasses already primed to toast it', says Kim-Nora. Another year at Greencombe is ready to begin.

accompanied Joan on her later botanizing trips around the world, seeing dog's-tooth violets growing wild in north-west America and, closer to home, travelling to Paignton Zoo to visit its National Plant Collection of buddleja.

Despite Rob's familiarity with it, coming to live at Greencombe has been a learning curve. 'Joan's letters to me on intrinsic gardening at Greencombe have been useful', he says. 'It's an individual's garden, and Joan emphasized that decision-making such as moving plants or pruning should come from one person. I'm much taller than Joan, so I'm pruning now to my height.'

ABOVE Rob and Kim-Nora Schmidt are here pictured in front of the moon arch built by Horace Stroud, with the Kitchen Garden glimpsed beyond.
OPPOSITE There is a deep enchantment to Greencombe's woods, whose luminous colour and transcendent beauty have been known to move visitors to tears.

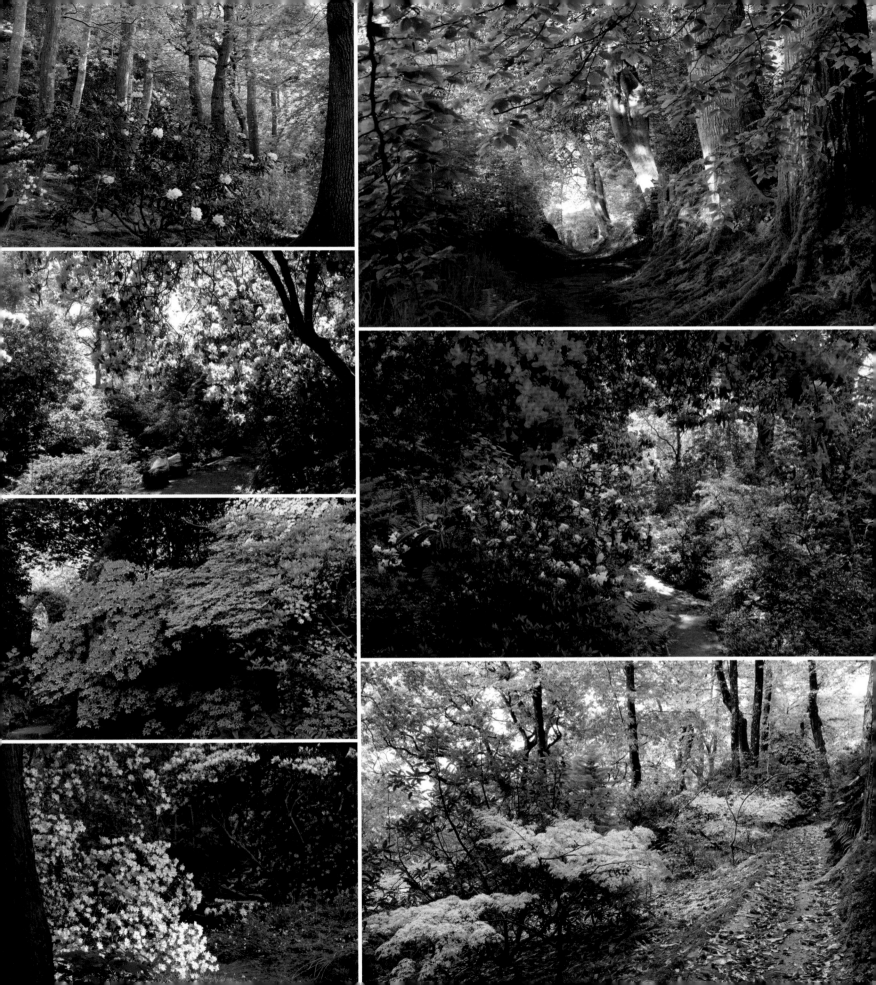

11
Hauser & Wirth Somerset
Bruton

New York, London, Zurich, Los Angeles, Hong Kong, Bruton. A decade ago a dilapidated farm outside a small town in Somerset might have seemed an unlikely addition to Manuela and Iwan Wirth's international portfolio of art galleries. Today, with visitors from all over the globe, Hauser & Wirth Somerset is firmly established on the art world map and, thanks to its Piet Oudolf garden, it is a must-see for garden lovers too.

The reinvention of Durslade Farm in Bruton dates to 2009, when the Wirths purchased the property. After consultation with the local community, they began to transform it into an arts centre, marrying historic farm buildings with new gallery spaces by architect Luis Laplace. Experimental at the time, the Wirths' concept now brings world-class contemporary art to a rural setting, with the added draw of a restaurant serving sustainably farmed food from the Wirths' own farms.

Commissioning Piet Oudolf to create a garden there was an inspired decision. As the garden writer Noel Kingsbury has observed: 'Piet plants as an artist paints', and Oudolf Field at Hauser & Wirth Somerset is both a work of art in its own right and a source of inspiration for the gallery's artists in residence. The American artist Mike Glier has returned over successive seasons, capturing not only the garden's physical beauty in paint, but its intangible qualities too – the sound of swallows swooping overhead and even the noise of the lawnmower.

With an open brief ('Iwan and Manuela gave me absolute freedom, with no compromises'), Piet designed three distinct spaces: a minimally planted arrangement in the farmyard; a cloister; and a larger garden in the field behind the gallery. On seeing the site for the first time in 2012, Piet immediately co-opted the field's entire 0.6 hectares/1½ acres for a herbaceous perennial meadow in his signature style, honed over many years in his own garden in the Netherlands, and at the plant nursery he ran with his wife Anja.

LEFT Enclosed by mixed native hedges, Oudolf Field has developed a powerful sympathetic magic with the wider landscape.

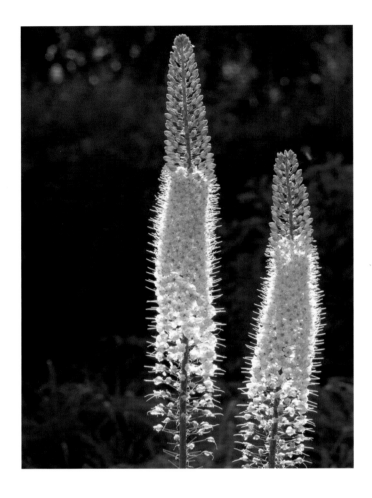

In keeping with the Wirths' commitment to sustainability, all the garden's 26,000 perennial plants were UK grown by Chris and Toby Marchant of Orchard Dene Nurseries. Getting that many plants in the ground was another big undertaking. Every plant was placed meticulously according to Piet's 1:100 scale plans, conjuring a garden that feels spontaneous: 'a landscape that you would dream of, but never find in the wild'. Following the wet winter of 2013 planting was delayed until spring, and was immediately followed by a drought. Head gardener Mark Dumbelton's Herculean watering efforts ensured that the fledgling garden survived and was mantled in late summer colour for the official opening in September 2014.

The seventeen gently contoured beds that make up the Field flow in a rhythmic dance to a modern-day eye-catcher – a futuristic fibreglass pod designed by Smiljan Radic as the 2014 Serpentine Gallery Pavilion. The individual beds are small enough to 'reach with your eyes', as Piet puts it, and the paths that weave between them likewise encourage visitors to experience the planting in the round. 'I like gardens you can walk through', says Piet, 'so there is a lot of walking space, and you can see from all angles.'

The layered planting reflects Piet's philosophy of using all aspects of a plant over its lifetime– its foliage, stems, flowers and seed heads – to create interest across all four seasons. His holistic approach is also a meditation on time and mortality: 'What it takes humans a lifetime to experience, a plant will experience in its own yearly life cycle. In that sense, gardening is a microcosm of life', comments Piet.

New perennials

The central perennial meadow beds are 'matrix planted', using a single species as the dominant plant, into which other plants are naturalistically blended. *Sporobolus heterolepis* (a prairie grass native to North America's Great Plains) is the feature species here, woven with mid-height perennials such as *Amsonia hubrichtii* and Carthusian pink (*Dianthus carthusianorum*) and grasses such as *Festuca mairei* and *Molinia caerulea* subsp. *caerulea* 'Moorhexe'.

Block-planted beds top and tail the sporobolus meadow, striking a more emphatic note. Chunky stands of *Symphyotrichum* 'Little Carlow', *Echinacea purpurea* 'Fatal Attraction', *Helenium* 'Moerheim Beauty' and swathes of

The Cloister Garden is as contained as Oudolf Field is open. It is a *hortus conclusus* at the heart of the gallery, its contemplative mood underscored by a soothing carpet of the clump-forming evergreen grass *Sesleria autumnalis* intermingled with *Kirengeshoma palmata*. In spring the sesleria is stippled with the clear mauve flowers of shooting star (*Dodecatheon meadia*) and the soft pink starbursts of *Allium tripedale*.

A meditation on time

Oudolf Field is deceptively simple. Three planting 'stories' underpin its design: a pond and wetland area; a robust perennial meadow; and a grass meadow with perennial planting.

Born of years of trialling garden-worthy plants, and observing plants in their native habitats, Piet's plant selections in the Field at Durslade read like an autobiography. They include vibrant pink *Betonica officinalis* 'Hummelo', *Salvia* × *sylvestris* 'Dear Anja' and *S. verticillata* 'Purple Rain', the chance seedling that started Piet's interest in breeding new perennials in the 1980s.

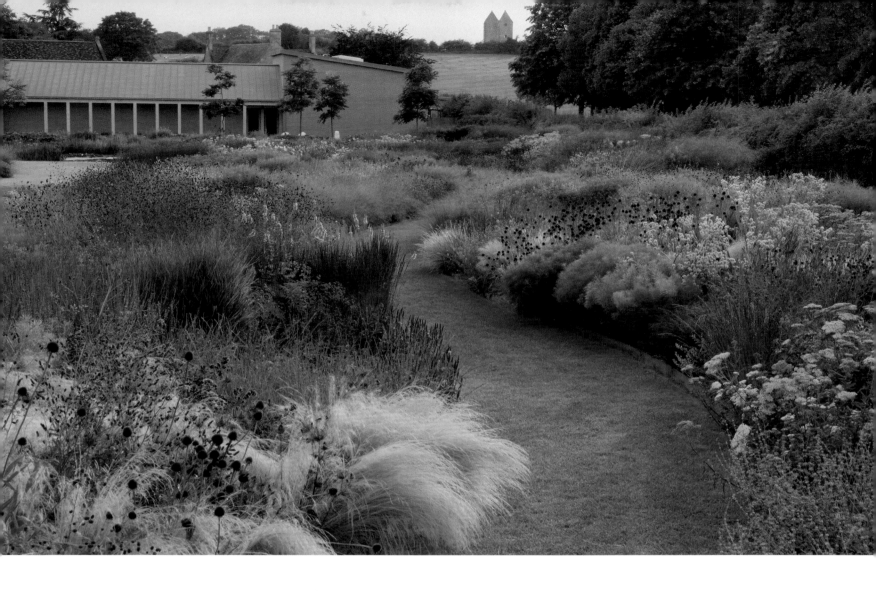

OPPOSITE When backlit in late spring, the apricot flower spikes of *Eremurus* 'Cleopatra' take on a glowing intensity.

ABOVE The Dovecote, a centuries-old Bruton landmark, makes a picturesque eye-catcher from the 'Pavilion end' of Oudolf Field.

LEFT In a garden defined by its use of herbaceous perennials, the group of Kentucky coffee trees (*Gymnocladus dioicus*) outside one of the new galleries designed by Luis Laplace adds a touch of exoticism; they associate well with the changing sculptures.

Japanese anemones (*Anemone × hybrida*) add drama and late summer colour, while grasses such as *Deschampsia cespitosa* 'Goldtau' and *Panicum virgatum* 'Shenandoah' begin to turn autumnal shades of bronze, brown and caramel.

Robust perennials such as *Thalictrum* 'Elin', *Eupatorium maculatum* Atropurpureum Group and the soaring white spires of *Actaea simplex* 'Prichard's Giant' amplify the sense of enclosure in the corner and side beds, creating a frame within the frame of surrounding mixed hedging.

His name above the door

It's one thing to install a new garden; it's quite another keeping it true to the designer's intentions as it develops. 'All my work depends on gardeners, one hundred per cent', acknowledges Piet. Fortunately Mark has proved to be a perfect fit. Although an engineer by training, his horticultural background in nurseries has given him an encyclopedic knowledge of plants and an intuitive understanding of Piet's plant-led approach: 'I respect that it's his name over the door – you have to be aware it's not your garden.'

Mark relishes Piet's annual visits to the garden, and the opportunity to walk around with him. 'Piet doesn't tell you what to do, you learn!' says Mark. 'You start to pick up on the things he likes.'

The apparently effortless naturalism in Oudolf Field relies on Mark's intelligent interventions. To maintain the right balance between form and colour he has evolved an exacting regime, pruning plants such as *Doellingeria umbellata* (syn. *Aster umbellatus*) to delay flowering time, and others to control height, 'so you get a nice rhythm in the borders', he explains.

Bed renovation takes place over autumn and winter. As the garden is open to the public six days a week this is done piecemeal; with no traditional garden 'rooms' to disappear into, the gardeners – and their work – are always on display. 'There's nowhere to hide', notes Mark.

But with responsibility comes the privilege of seeing the garden as Piet intended, evolving daily over the seasons and in different light conditions. 'Autumn is my favourite time', says Mark, 'just as summer's ending, when there a few late-flowering asters, lots of seed heads and the grasses are really prominent. Even though you have less out in terms of flowers, it seems more.'

Visitors, and particularly lucky locals who see it regularly, are also the beneficiaries of this generous spirited garden; freely open to all, it rewards with fresh insights every time.

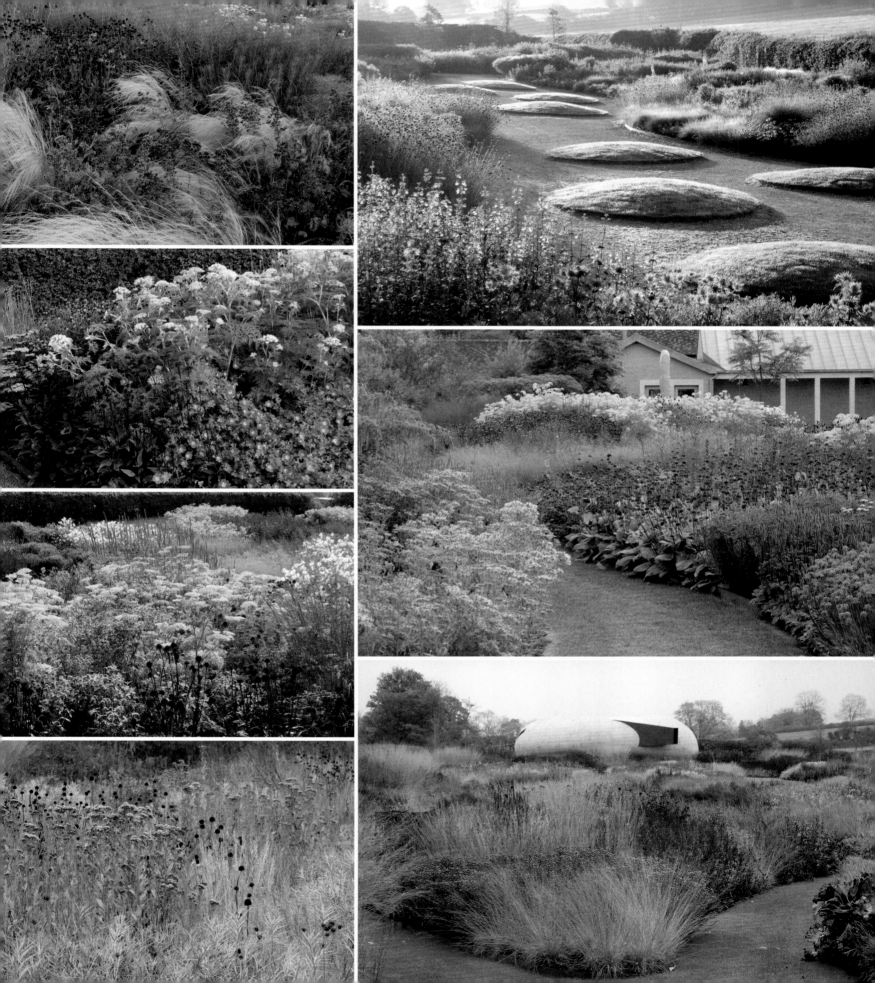

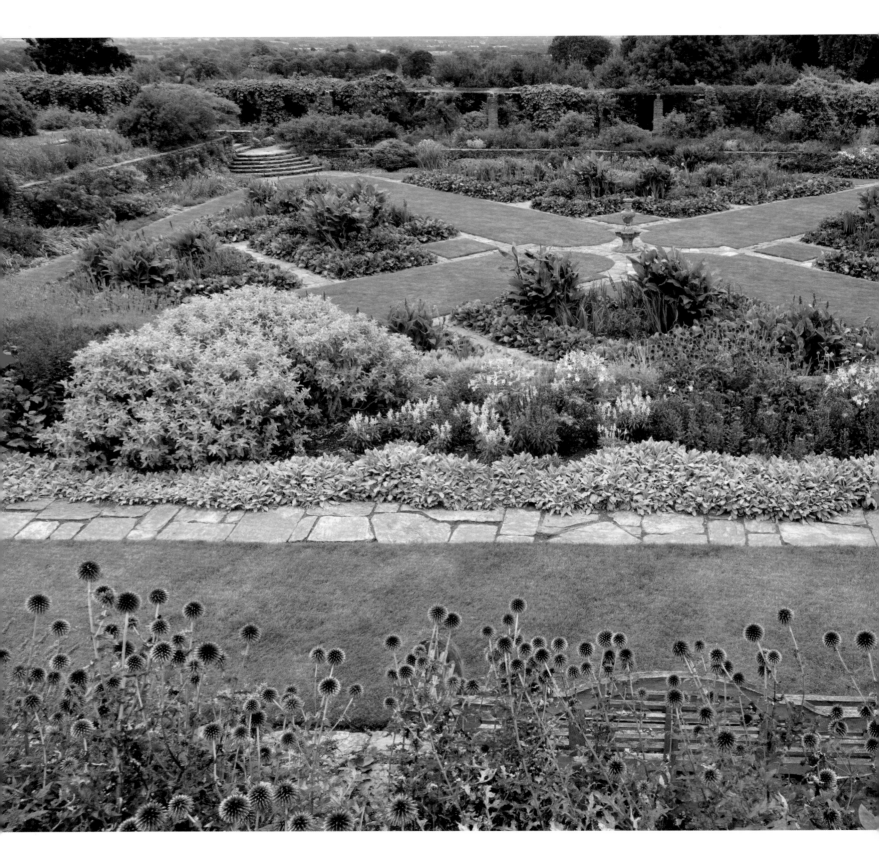

12
Hestercombe
Cheddon Fitzpaine

JUST A FEW KILOMETRES from the county town of Taunton, on the southern slopes of the Quantock Hills, lies Hestercombe – Somerset's flagship garden. Its combination of three distinct historic gardens, extending to some 20 hectares/50 acres, and the stirring story of their restoration, has made it a compelling destination since it opened to the public – and their dogs – in 1997.

Each of Hestercombe's gardens bears witness to a different century in its history: an eighteenth-century landscape garden; a Victorian shrubbery and parterre; and an Edwardian garden designed by Sir Edwin Lutyens and Gertrude Jekyll. The recent discovery of a fourth 'lost' garden on the estate – a rare Elizabethan water garden – only adds to Hestercombe's horticultural largesse. (Sadly the medieval garden belonging to 'the Lord of Hestercombe', mentioned in a thirteenth-century document, is unlikely to come to light.)

The landscape garden was the work of Coplestone Warre Bampfylde (1720–91), who inherited the estate in 1750. An accomplished gentleman–artist, Bampfylde spent the next thirty-six years remodelling the steep valley ('combe') behind the house into a living recreation of the idealized 'landskips' painted by seventeenth-century artists such as Claude Lorrain, Salvator Rosa and Gaspard Dughet.

Following a circular route around the valley, moving from shady groves to open, light-filled spaces, visitors arrived at a succession of picturesque halts, from which they could admire meticulously orchestrated vistas across the combe or over the Vale of Taunton. Each was a miniature stage set designed to evoke a different atmosphere: an exotic Chinese seat, a Doric temple, a brooding mausoleum.

Owned by the Warre family since 1391, Hestercombe was sold in 1872 to Viscount Portman, an MP and a long-serving lord lieutenant of Somerset. He promptly set about remodelling the house in the fashionable Italianate style of the day, and he

LEFT A bench by Sir Edwin Lutyens on the Grey Walk makes the perfect vantage point from which to appreciate the way in which Gertrude Jekyll's planting scheme for the Great Plat softens and harmonizes Lutyens's geometric design.

added a formal parterre overlooking the panorama of the Vale of Taunton.

In 1903, following an introduction from *Country Life* editor Edward Hudson, Portman's grandson Teddy and his wife Constance commissioned the eminent architect Sir Edwin Lutyens to lay out two further formal gardens and a classical Orangery on the sunny hillside below the Victorian Terrace. Construction of the Great Plat and Dutch Garden involved a huge earth-moving operation, and took five years to complete.

Lutyens's long-standing collaborator Gertrude Jekyll designed the planting, and their work together at Hestercombe is considered among their finest achievements. The interplay between Lutyens's formal framework and the colours and textures of Jekyll's planting is a combination that has proved influential, not least within Somerset (see Forest Lodge page 60, Kilver Court page 92 and The Newt in Somerset page 110).

In 1908 Lutyens added the Daisy Steps to link his Formal Garden with the Landscape Garden – the fleabane (*Erigeron*

karvinskianus) that cascades down the steep flight of steps is Hestercombe's signature plant.

The garden's fortunes took a downward turn during the Second World War, when Hestercombe was sold to the Crown Estate, which managed the Landscape Garden as commercial forestry. The original eighteenth-century trees were felled for timber, and the lakes drained; Bampfylde's creation began to disappear beneath dense coniferous woodland and brambles.

After the war Hestercombe became the headquarters of the Somerset Fire Brigade, and in the 1970s the Lutyens garden, by now owned by Somerset County Council, came within one vote of being turned into a parade ground for firemen. Thankfully, instead of tarmacking the garden, in 1973 the council began to restore it, a process spurred on in part by the chance discovery of a set of Jekyll's original plans in a potting shed.

The right man in the right place
Hestercombe's second lucky break came in 1991, when dairy farmer turned conservationist Philip White was working for

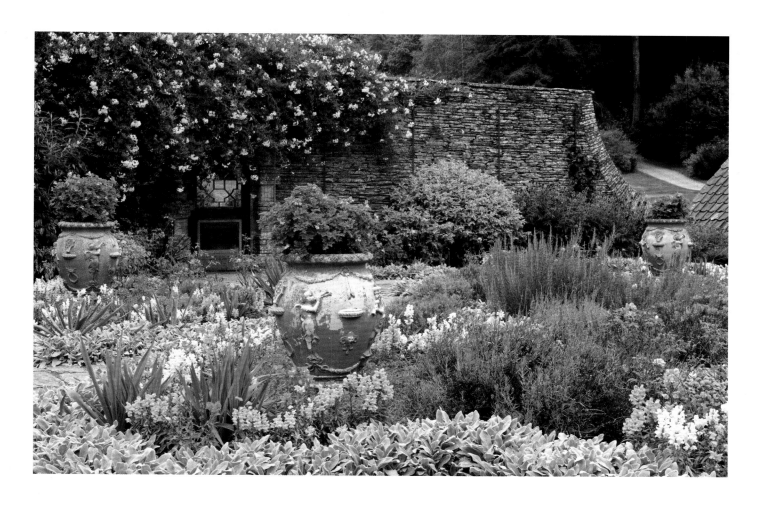

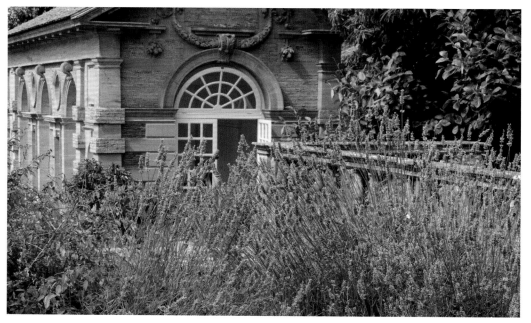

OPPOSITE While the standard 'White Pet' roses on the Victorian Terrace are a constant, the bedding scheme is changed every summer and autumn – each scheme using 7,000 plants.

ABOVE Lavender, yucca and lambs' ears (*Stachys byzantina*) provide the backbone of the Mediterranean grey scheme in the Dutch Garden, supplemented in summer by annuals such as floss flowers (*Ageratum*), snapdragons (*Antirrhinum*) and heliotropes, as specified by Gertrude Jekyll.

LEFT Taking its inspiration from Sir Christopher Wren's baroque architecture, Sir Edwin Lutyens's Orangery uses golden yellow, local Hamstone to sumptuous effect.

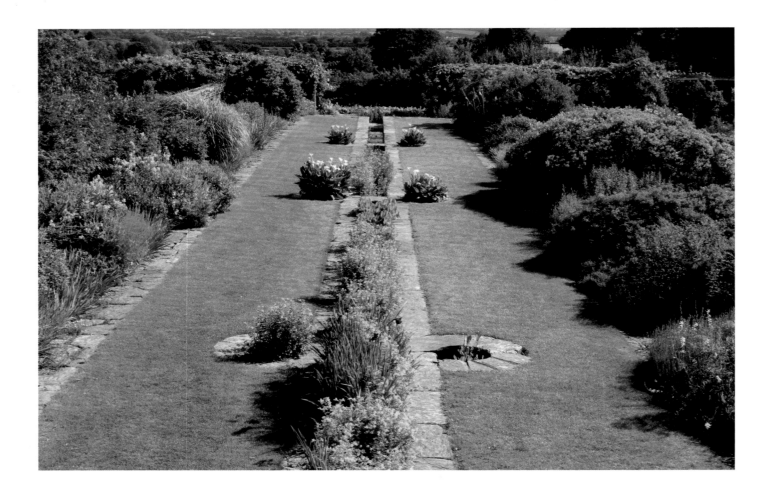

ABOVE The East Rill is planted with arum lilies (*Zantedeschia*), yellow monkey flowers (*Erythranthe guttata*) and blue *Iris ensata*, and its grassy terrace is lined with perennials and shrubs including *Veronica brachysiphon*.

RIGHT With no extant planting plan for the Pergola, the current scheme was researched by Hestercombe's archivist Kim Legate when the structure was restored in 2004 and includes roses such as 'The Garland', 'Evangeline' and 'Jersey Beauty'.

OPPOSITE Planting holes in the drystone wall between the Grey Walk and the Great Plat allow drought-tolerant plants to cloak the vertical surface with flowers and foliage.

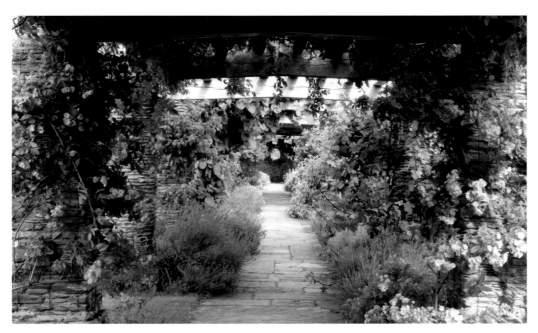

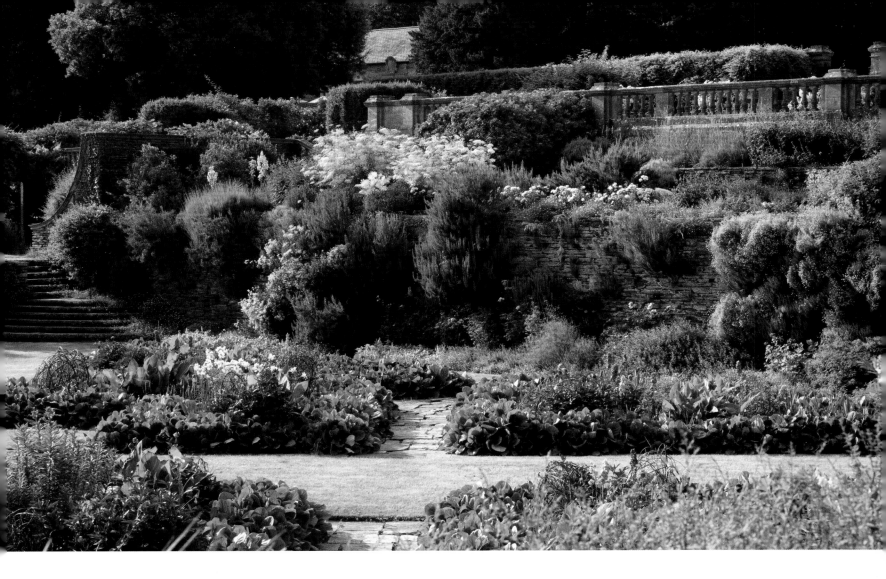

the Somerset Wildlife Trust (which was then based at the estate). Walking around on his lunch breaks Philip spotted the telltale signs of the lost garden. 'You could just make out the silted up lakes, the broken brick leat that had once fed the now-derelict waterfall and the tumbled-down pillars of a temple', he recalls. 'I became consumed by the idea of restoring the landscape to its original glory and that if I did not undertake this challenge then no one else would.'

Initially Philip's was a lone voice in the wilderness, but in 1995, driven by a sense of destiny, he started the restoration, bravely remortgaging his house to pay for tree clearance and lake dredging. Miraculously the Arcadian vistas, as recorded in Bampfylde's paintings, began to re-emerge.

Hestercombe was established as a charitable trust in 1997, and as more external funding has become available the restoration has gathered pace. One by one the eighteenth-century follies have risen from the ground, and the complex hydraulic system repaired so that water once more runs freely along the leat and tumbles down the Great Cascade.

Twenty-five years after it first began, Hestercombe's renaissance shows no signs of slowing down.

Philip's vision for the restoration process has been pioneering. The foundations of lost features such as the Witch House and the Octagon Summerhouse have been conserved *in situ* and the buildings reinstated using meticulous archival detective work, led by Philip and Hestercombe's dedicated archivist Kim Legate. The latest to be unveiled is the Sibyl's Temple, a perfect little stone rotunda, based on a similar structure at Batheaston, which Bampfylde would have known.

No detail is too small for Philip, who is a stickler for the principle of 'reversability'; when a Bampfylde sketch of the Gothic Alcove was discovered at the British Museum, the restored feature at Hestercombe was altered appropriately.

RIGHT Hestercombe's gardening team, here beside the Pear Pond in the Landscape Garden, combines countryside management skills with horticultural expertise. From left to right: Grace Grantham, Claire Greenslade, Ben Knight, Gabrielle Miller-Cahill, Jenny Ockenden and Libby Harri. OPPOSITE Sir Edwin Lutyens's Daisy Steps (top left) lead the visitor back in time and to Bampfylde's Landscape Garden, where exquisitely composed vistas and eclectic narratives unfold with languid ease along meandering pathways.

The recent discovery of watercolour paintings showing delphiniums in Jekyll's garden at Munstead Wood also prompted a rethink in the Great Plat, as head gardener Claire Greenslade explains: 'From the painting it looked as if the delphiniums had white centres, and there were definitely two shades, and we'd always had just one type as a blanket. So now we use two varieties, 'Blue Nile' and 'Pericles'.'

Claire and Kim devise the biyearly bedding schemes in the Victorian Terrace: 'We look at nineteenth-century pattern books and contemporary plant catalogues to see what would have been available and try to get it as close as possible with what's available now.'

Claire's previous career as a textile designer and stained-glass artist has been invaluable in helping her to manage Jekyll's painterly planting schemes. Over her ten-year tenure at Hestercombe she's become expert at intuiting Jekyll's intentions. 'Jekyll's approach was "more is more" ', comments Claire, 'so for her garden we make sure we have lots of fillers like snapdragons, heliotrope and ageratum. We also keep pots of things like gypsophila and perennial sweet pea on standby to supply interest when plants go over.'

Caring for the past

With oversight of all Hestercombe's historic gardens, Claire's role is a varied one. Her six-strong gardening team is split between Landscape and Formal Gardens, with additional support from loyal volunteers.

In the Landscape Garden volunteers help with stone walling and managing the omnipresent laurel (*Prunus laurocerasus*), which Bampfylde used to deliberately obscure some views and create dark areas. In the Formal Garden volunteers help with the 'Forth Bridge' task of edging the grass plats and keeping the paving cracks free of weeds – essential for maintaining Lutyens's sharp geometry, as depicted in contemporary photographs. Also in the Formal Garden in autumn they are busy with propagation: 'we take lots of semi-ripe cuttings of short-lived plants like santolina and lavender', says Claire. Mulching and pruning are big winter jobs: 'we've got lots of roses, so the rose pruning goes on forever!'

Claire and her colleague Ben Knight, the Landscape Garden supervisor, walk around the Landscape Garden once a month and also do this regularly with Philip. 'View pruning' is done two or three times a year and is particularly important for Bampfylde's masterstroke, the Capriccio View, which when one stands in the right place magically unites the Gothic Alcove, the Witch House and the obelisk of the Mausoleum in a single vista.

Even as Hestercombe celebrates the 300th anniversary of Coplestone Warre Bampfylde's birth in 2020, its modern-day custodians continue to build on his legacy. From opening up the Victorian drive to pedestrians and cyclists, and to Philip's dream of commissioning a twenty-first-century garden in the 'secret' West Combe, Hestercombe looks as much to the future as it does to the past. 'There's a lot still to do', says the indefatigable Philip. 'It's an exciting time.'

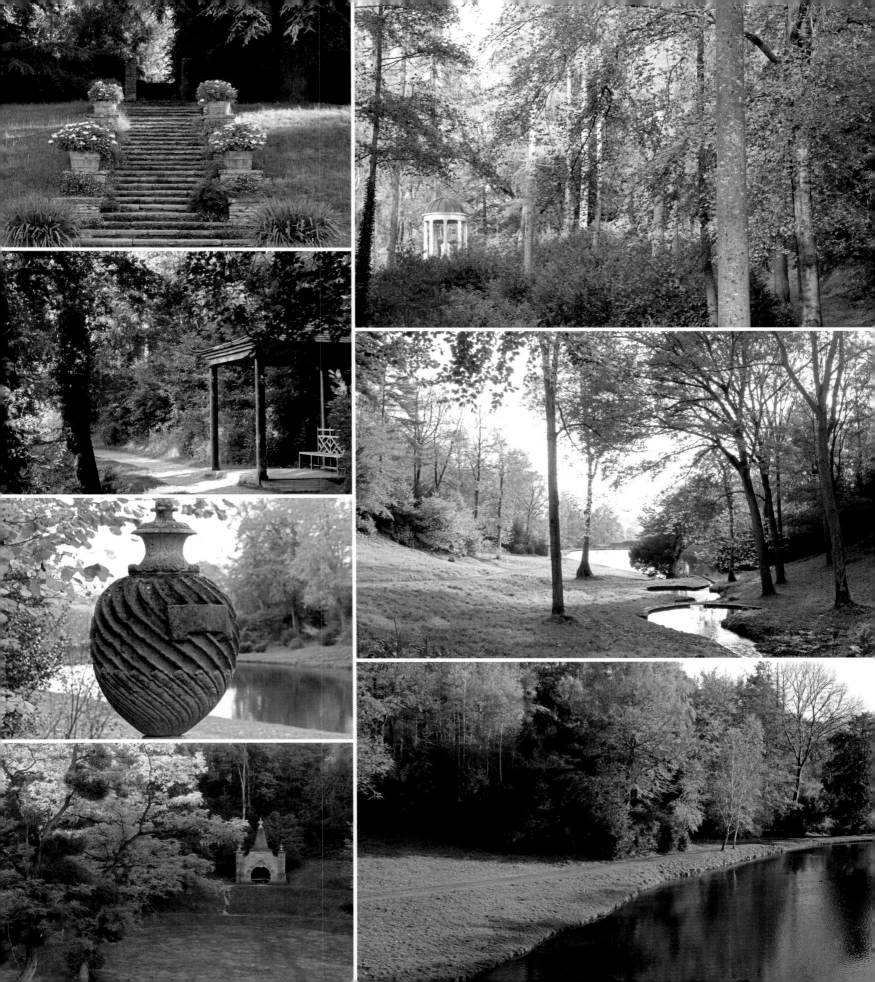

13
Iford Manor
Iford

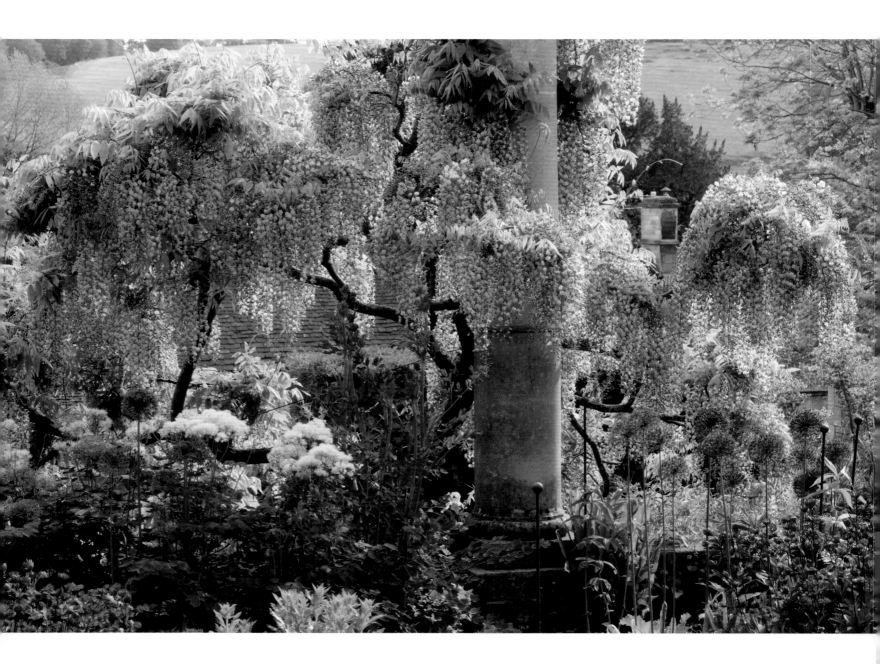

IFORD MANOR IS OFTEN described as 'other-worldly' and even in the early decades of the turbulent twenty-first century it retains the air of a place apart. The home of the architect and garden designer Harold Ainsworth Peto between 1899 and his death in 1933, Iford is his most iconic personal creation, a peaceful English garden infused with a nostalgia for classical and renaissance Europe, but whose many layered history reaches far beyond the Edwardian era in which it was created.

Perhaps Iford's ambivalent location, on the last hill in the Cotswolds and straddling the county line between Wiltshire and Somerset, accounts for its enigmatic aura. The river Frome, which winds past the house, was the county boundary in Saxon times, and Iford has been settled since the Romans. Where the Romans settled, medieval monks and millers followed, and in the fifteenth century the Iford Valley was an industrial hub, whose water-driven fulling mills and cloth factories generated great wealth for Iford Manor's owners the Horton family.

It was the Gaisford family, three generations of which owned Iford Manor between 1777 and 1858, who laid the foundations for the current garden and planted the hanging wood. The great *Wisteria sinensis* that still cascades down the Georgian facade of the house dates from this time – and is thought to be one of the oldest specimens in the country. The Gaisfords also set out a long lawned terrace below the hanging wood – a feature that, along with Iford's tangible sense of human history, captivated Peto when he first saw the property in 1898, purchasing it the year after.

Having stepped down from his successful architectural practice in London in 1892, to pursue a growing interest in gardens, Peto was searching for an English manor house where

LEFT Wisteria is one of Iford's signature plants; here the sinuous branches of a specimen on the Great Terrace are a sculptural presence in their own right.

BELOW Harold Peto added the Ionic colonnade to the Great Terrace c.1907; it is one of numerous listed structures in the garden.

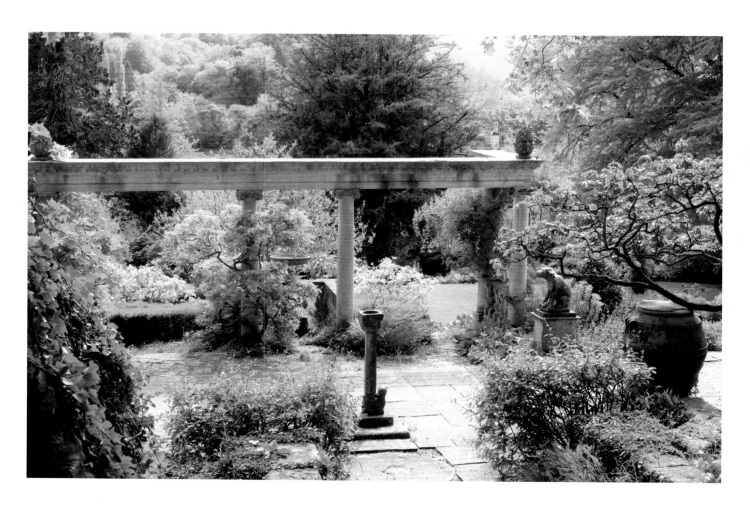

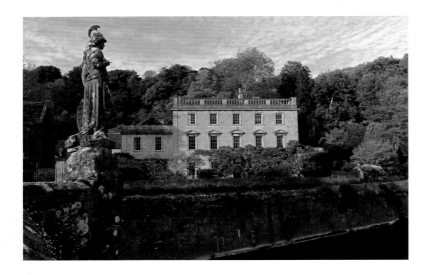

'*If we want things to stay as they are, things will have to change.*'

GIUSEPPE TOMASI DI LAMPEDUSA,
THE LEOPARD

he could make a garden for himself. By then he was in his mid-forties.

He had spent the previous decade travelling the world looking at gardens, admiring particularly those with 'a historic feeling […] and visible signs that men have loved it and made the most of it in times gone by.' No wonder Iford appealed and in 1899 Peto moved in. Over the next fourteen years he worked intensively on the garden, while also embarking on a productive second career as a garden designer, in England and in the south of France.

The perfect balance

For Peto a garden had to contain the right combination of architecture and plants. 'Old buildings or fragments of masonry carry one's mind back to the past in a way that a garden entirely of flowers cannot do', he wrote in *The Boke of Iford*. At Iford Manor he used the antique architectural oddments that he had amassed on his travels to create the dream of an Italian hillside in a rolling West Country valley.

Focusing his main efforts on the Great Terrace, Peto paved the eighteenth-century grassy walk, lining it with enormous oil jars from Nice and ancient Greek and Roman sarcophagi. He commissioned local stonemasons to construct classical colonnades and two Italianate garden rooms, the Casita and the Cloisters. Peto also closed one end of the long vista with a Roman-inspired, semicircular stone seat, the other with an eighteenth-century stone gazebo, which originally stood overlooking the river in the Walled Garden.

The Romanesque-style Cloisters were completed in 1914, an architectural jewel box where Peto could display the rest of his

LEFT TOP From its vantage point on Iford Bridge, the statue of Britannia has looked out over the river Frome since being placed there by Harold Peto in 1910.
LEFT CENTRE Peto's unfinished Japanese Garden was completed by John Hignett in the late twentieth century.
LEFT BOTTOM The Puzzle Garden was laid out in 1997 and used 'Iford box' for its chequerboard design.
OPPOSITE The architecture of the Cloisters may be medieval Italian in style, but the view is pure Somerset.

'antique fragments'. Among the plaques and relief sculptures, an inscription declares the building to be 'a haunt of ancient peace', a quotation from Alfred Lord Tennyson's poem 'The Palace of Art' that has become something of a motto for Iford.

By 1917 Peto considered his creation complete enough to write about its evolution in *The Boke of Iford*, but his tradition of welcoming the public to Iford dates from before then, with evidence that groups were visiting from as early as 1910. In the 1920s the garden was opened to raise funds for a nurses' charity, an early forerunner of the National Garden Scheme (for which the garden still opens once a year).

A family project
Iford remained in the Peto family until 1965, when Elizabeth Cartwright purchased it and began restoring the garden. 'It had slipped, literally and metaphorically', she says, the garden being located on a geological fault line. One of her first tasks was to deal with the colonnades on the Great Terrace, which had collapsed in a storm.

Like Peto before her, Elizabeth fell in love with Iford, even though 'people said I was mad to take it on', she recalls. Having grown up at Aynhoe Park (whose landscape was designed by Capability Brown), she was familiar with the challenges of historic gardens, and the subtle decisions needed to achieve 'continuity, not stasis'. Aynhoe gardener Leon Butler became her valued head gardener at Iford, and over the years Elizabeth also called in expert 'guiding hands' such as Lanning Roper and Penelope Hobhouse to help with planting design.

A descendent of the Chigi family, Elizabeth has also been able to add to Iford's Italian artefacts – the terracotta planters that look so at home in the box (*Buxus*) parterre by the Casita came from Villa Vico Bello, a Chigi residence near Siena.

In 1979 Elizabeth married John Hignett, for whom Peto's garden became a vocation. A talented engineer, John managed to find ingenious ways of remedying the effects of subsidence and has patiently kept original plants going, another link between past and present. 'Peto liked using old varieties such as *Rosmarinus officinalis* [now renamed *Salvia rosmarinus*]

RIGHT Iford is above all a family home, loved and enjoyed by three generations of the Cartwright-Hignett family.
OPPOSITE Harold Peto's love of antique statuary permeates the garden; notable pieces include a cast of the Capitoline Wolf (below left) taken from the original in the Capitoline Museums in Rome, and a life-size bronze statue of the Dying Gaul (top right), which tops the entrance to the Walled Garden on Iford Lane.

and *Lavandula angustifolia*', John notes. 'They have longevity and age elegantly.'

After fifty years at the helm, Elizabeth and John have retired from running Iford, having recently passed the baton to their son William Cartwright-Hignett and his wife Marianne. 'It's all about getting the timing right', explains Elizabeth. 'You want to do it while the older generation is still around to offer support and insight. Iford is a family project.'

The story continues

The next generation come to 'project Iford' with every bit as much commitment and passion as the previous one. The young Cartwright-Hignetts are putting into place a long-term strategic plan to ensure a sustainable future for the garden and to safeguard its special atmosphere. A new visitor centre and café are being built in old agricultural buildings, and the Cloisters and gazebo have been comprehensively restored, following major underpinning to put in place foundations where previously there were none.

William and Marianne are also following past example by having appointed a new head gardener to revitalize the garden, working alongside them to realize their ambitions. Formerly head gardener at Sissinghurst Castle (and before that Bodnant and The Courts), Troy Scott Smith is a gardener with a rare empathy for old gardens and a talent for reinfusing their souls. 'He is', beams William, 'a phenomenal fit for Iford.'

Troy has known the garden for years since his first head gardenership at The Courts (8 kilometres/5 miles distant). He relishes his brief at Iford, noting: 'A garden isn't a static thing, and that's one of its joys. But the nature of the change is important, understanding the place, how it fits into the landscape, the intentions of its various owners, and then to try and bring all that together while also thinking about its present use and the future.'

Propagating from original Peto plants is one of Troy's immediate priorities ('some plants are iconic to a place') and so too is the task of opening up the eighteenth-century woodland rides, allowing visitors to experience more of Iford's landscape. Only weeks into his tenure, he's already scarified the orchard in preparation for a wildflower meadow, and has cleared the bank above it for a planting of Japanese cherry (*Prunus*) trees, gifted to Iford as part of the Sakura Project, a cultural exchange between the UK and Japan.

William and Marianne are excited about the developments they have set in motion, which will include music and other events, and a volunteer programme. With Troy's input, and Elizabeth and John's support, William and Marianne are writing the latest pages in 'The Boke of Iford', but they are well aware of the privilege and responsibility that come at this pivotal moment. 'Iford was almost lost once before and we want to ensure that can never happen again', they say. 'We are just a chapter in a very long history.'

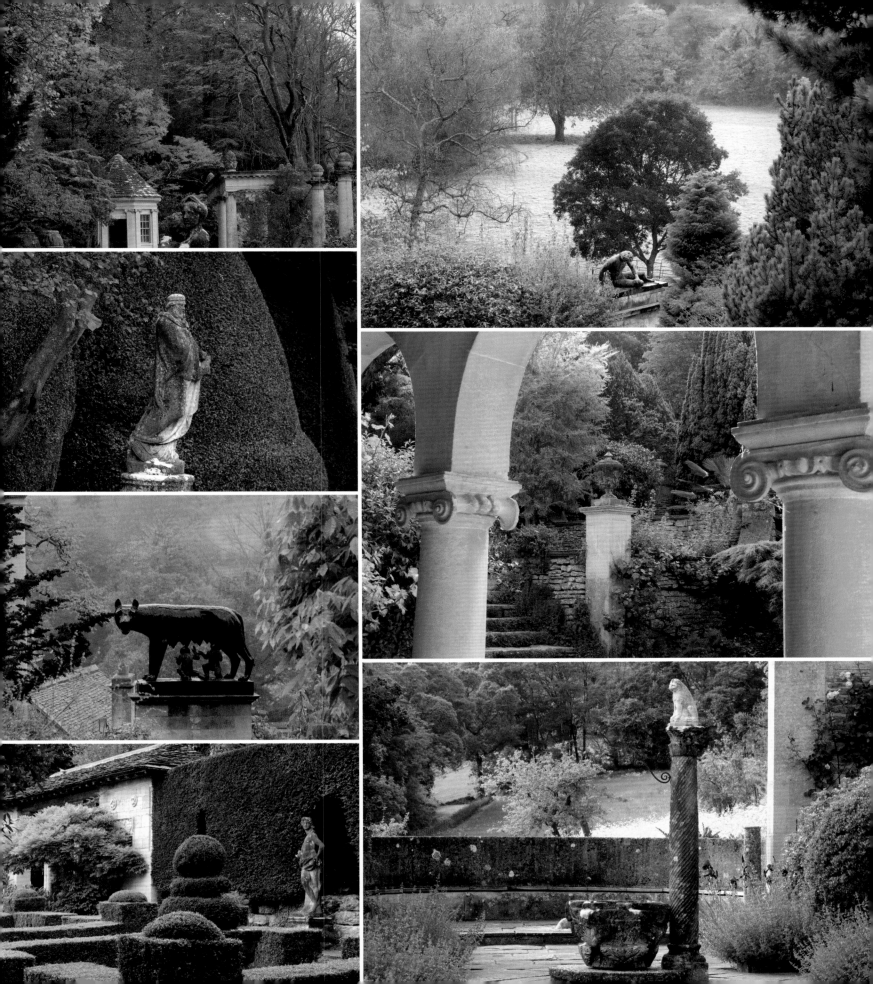

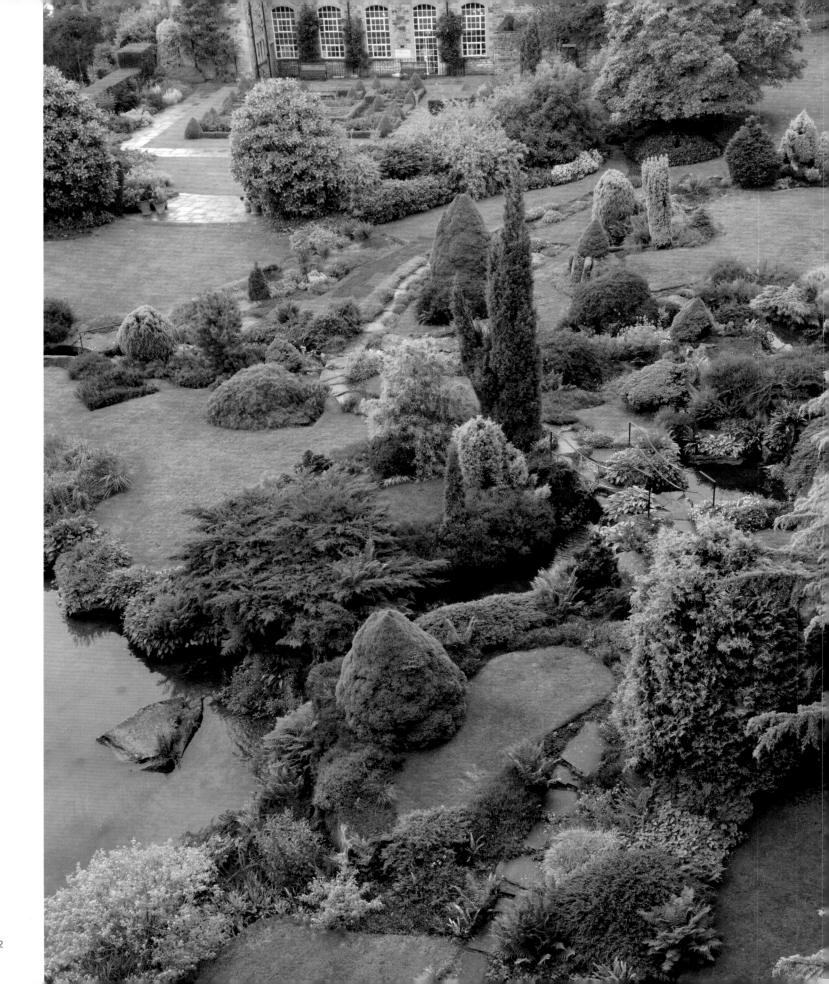

14
Kilver Court
Shepton Mallet

FASHION, FARMING, FOOD, hospitality and gardening – Roger Saul's quicksilver entrepreneurial flair has embraced them all since founding iconic British brand Mulberry in Somerset in the 1970s. At Kilver Court Designer Village he has distilled them into a destination where shoppers encounter distinctively British brands, dine on spelt dishes made from grain farmed on Roger's Sharpham Park estate, and stroll around 1.4 hectares/3½ acres of gardens set against the unforgettable backdrop of Charlton railway viaduct.

Kilver Court's buzzy ambience today is a far cry from when Roger bought the site in 1996, to set up a new headquarters for Mulberry. The old industrial complex – once the heart of Shepton Mallet's textile quarter and latterly part of the town's cider and beer brewing enterprises – had scope but had been unsympathetically converted into numerous offices. Restoring it became a passion project for Roger who, Somerset born and bred, has always kept close ties to the county.

The garden was also daunting – but for different reasons. 'It was well maintained but "done" ', recalls Roger. 'Beside the Directors' Suite it was all "corporation roses" in serried ranks.' The lacklustre roses belied the garden's fascinating history, which dates back to the early 1900s, when Sir Ernest Jardine transformed the mill pond beside his lace-making machinery factory into a boating lake and created pleasure gardens (known as 'Jardine's Park'). Here, within an industrial site by the river Sheppey, which had been first a former wool and then a silk mill, his workforce could enjoy their leisure time and grow fresh vegetables.

While textiles fuelled the garden's first incarnation, its second was thanks to Babycham, the sparkling perry created by the Showerings' brewing dynasty in their Shepton cider mills. The huge success of the drink – launched nationally in 1953 – prompted their purchase in the late 1950s of Jardine's Park and mill to accommodate the expanding business.

Managing director Francis Showering and his brother Ralph redeveloped Jardine's gardens, commissioning a huge rock garden as their centrepiece. This was an expanded version of the 1960 Royal Horticultural Society (RHS) Chelsea Flower Show Gold Medal winning design by George Whitelegg. Whitelegg

LEFT The photographer's privileged view from the Charlton Viaduct, 14m/45ft above ground level, reveals the bones of the garden. The pair of *Magnolia grandiflora* by the parterre were sourced from Italy by Kilver Court owner Roger Saul.

RIGHT Built of contrasting limestone masonry and brick, the viaduct's arches create huge windows that frame the garden at Kilver Court.

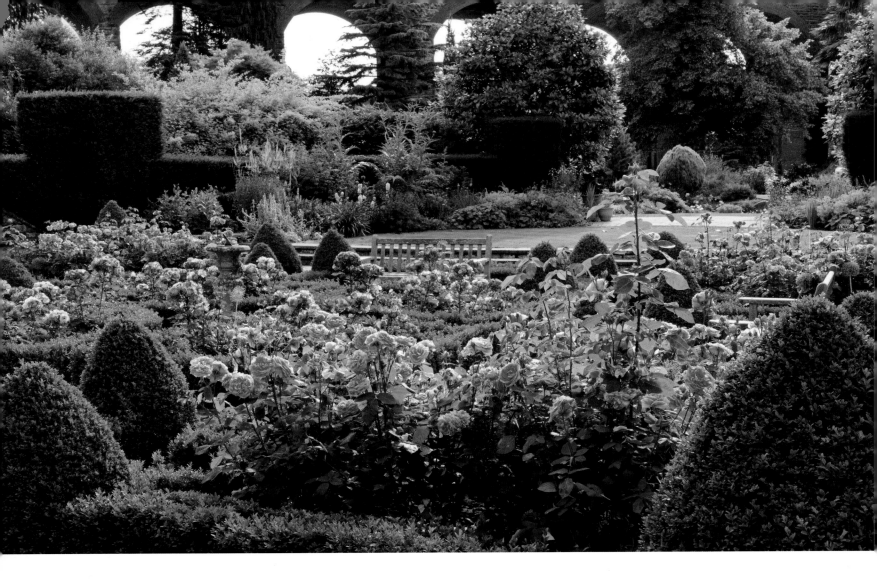

— whose Chelsea Flower Show creations helped popularize rock gardens in the mid-twentieth century — oversaw construction, transporting sandstone slabs from the Forest of Dean to site on the back of Babycham lorries. The Showerings also installed the huge herbaceous border that stretches behind the viaduct, and the thatched duck house on the lake.

Design inspiration

By the time Roger Saul arrived, the 'garden that Babycham built' was ready to be revitalized and begin its third act. Having already made two gardens in Somerset — at Sharpham

ABOVE Taking its cue from the garden at Les Invalides, the Rose Parterre brings a touch of Parisian chic to this Somerset garden.
OPPOSITE TOP Deftly woven colour schemes in the herbaceous borders by the Rose Parterre reveal Roger Saul to be a skilful plant designer.
OPPOSITE CENTRE AND OPPOSITE BOTTOM Rolling fields form the backdrop to the Colour Border, in bucolic contrast to the industrial architecture that it faces.

Park, his home since the mid-seventies, and at Charlton House, the hotel he set up in the 1990s — Roger was equipped for the challenge, and embraced the project with trademark energy. 'But Kilver is very different to Sharpham', Roger explains. 'Sharpham is a quintessential English garden with garden rooms and a Tudor house as a backdrop; Kilver is more of a landscape garden.'

First to go were the regimented hybrid tea roses, which were replaced by a box (*Buxus*) parterre inspired by the garden at Les Invalides in Paris. 'I used to stay near there when I was doing the Paris shows with Mulberry, and I've always loved its topiary', says Roger. 'Looking down at the garden from the Directors' Suite, I wondered could I do something like that here?'

The answer was emphatically yes, and the result is an elegant composition in which the drumstick flower heads of *Allium hollandicum* 'Purple Sensation' blaze a trail for a pretty pairing of *Rosa* 'Blue For You' and the English shrub rose *R.* Gertrude Jekyll. The latter is a revealing choice, since Roger's early gardening exploits were informed by Jekyll's books and

her designs at Hestercombe House (see page 78). 'I admire her sweeps of perennial plants and colour. For me she is the most influential garden designer of the last 150 years, without question', says Roger.

For the yew- (*Taxus-*) backed borders that enclose the parterre Roger took his inspiration from pre-Raphaelite paintings and William Morris designs, assembling a sumptuous palette of wine dark purples and deep blues, with highlights of red and gold, centred around *Cotinus coggygria* 'Royal Purple'. 'At the time, I was having lots of fun designing fabrics for Mulberry Home and it had an influence on the garden too', he explains. Later in the season, the fiery foxtail lily *Eremurus* × *isabellinus* 'Pinokkio' adds drama and verticality, while dahlias such as flame-red *Dahlia* 'Maxime' create colourful sweeps that would surely meet with Jekyll's approval.

The colour border

More recently Roger has focused his attention on the 100-metre/100-yard herbaceous border, which had become badly overgrown. Overhauling a border on this scale is no small undertaking, and planning took more than a year while Roger explored ideas, eventually deciding on a colourist scheme, influenced by Nori and Sandra Pope's pioneering plantsman's garden at nearby Hadspen House (now The Newt in Somerset, see page 110), which he greatly admired.

Opting to use foliage colour rather than flowers as the main feature added an extra challenge, but once the design on paper came together it was an exciting moment says Roger: 'I realized it would work.'

Digging out the 1960s' border took six months but was also an opportunity to reshape its angular lines, with a curvaceous new profile designed to echo that of the viaduct as it crosses the Sheppey Valley. The new border required more than 3,000 plants, which were laid out in colour-coded sections, with Roger directing the gardeners by walkie-talkie from the top of the viaduct, 14m/45ft above the garden.

The ensuing border 'reads' from left to right, grading from the yellows and golds of *Lysimachia punctata* Golden Alexander to shades of green and chartreuse, and on to bronzes such as *Heuchera* 'Marmalade', to the deep purple of *Sambucus nigra* f. *porphyrophylla* 'Gerda' and *Pittosporum tenuifolium* 'Tom Thumb' before brightening into the blues and silvers of sea holly (*Eryngium*), Russian sage (*Perovskia atriplicifolia*) and *Artemisia ludoviciana* 'Valerie Finnis'. The border culminates in a Bog Garden near the river Sheppey, where rodgersia, astilbe, hostas and gunnera show their appreciation of the damp conditions by producing luxuriant foliage and flowers.

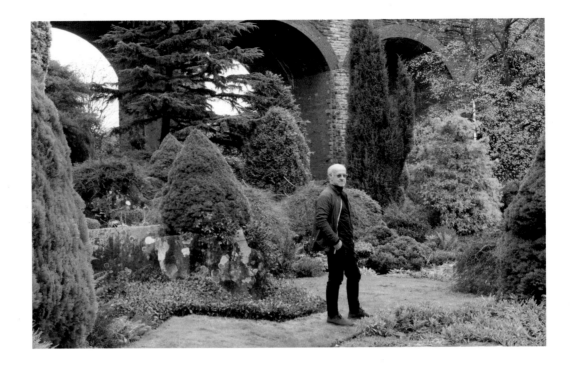

RIGHT The Charlton Viaduct makes a dramatic sculptural backdrop to the Rock Garden, here being enjoyed by Kilver Court's owner, Roger Saul.
OPPOSITE As befits its origins in the RHS Chelsea Flower Show, the Rock Garden is pure horticultural theatre; being underpinned by an eclectic mix of conifers and evergreens, it takes centre stage whatever the season.

Underneath the arches

A masterpiece of Victorian engineering, Charlton Viaduct opened in 1874 as part of the Dorset & Somerset Railway. It no longer carries trains but remains a powerful reminder of Somerset's industrial past, when the Mendip Hills were as much known for their coal mines as they were for their sheep and dairy farms. From a garden design perspective, however, the viaduct's massive scale needs careful handling. 'You can't compete with it', says Roger, 'you have to reflect it.'

The viaduct's sculptural presence also throws up some horticultural challenges, casting deep shadows and funnelling the prevailing wind through its arches. Tender plants such as aeonium and helichrysum are overwintered in a polytunnel 'underneath the arches' and the gardening team wrap the soft tree ferns (*Dicksonia antarctica*) and bananas (*Musa*) to insulate them from the cold.

A rare survivor

Roger is a conscientious custodian of the historic Rock Garden, which is a rare survivor of a style that fell far from grace in the mid-twentieth century after decades of popularity. Amid the craggy rockscape, the rushing cascades designed by Whitelegg bring a festive exuberance to the heart of the gardens – a reminder of the days when a sight of them would be a highlight for holidaymakers travelling by train to the seaside resort of Bournemouth.

'I love creating things.' ROGER SAUL

Roger and the two-strong gardening team have been fine-tuning the mature planting, gradually removing superfluous conifers and adding foliage contrasts such as ruby-leaved *Acer palmatum* 'Garnet' and its coppery cousin *A.p.* 'Ornatum'. Following recent consultation with RHS alpine expert Peter Goodchild, further interventions are planned, and the three overgrown × *Cuprocyparis leylandii* that are encroaching on a swamp cypress (*Taxodium distichum*) have been earmarked for removal.

The designer's eye

Roger's gardening style is as eclectic as his fashion ethos. On the far bank of the lake, the charming rustic wooden bridge that hops over the leat was inspired by one of Roger's favourite hotels, Endsleigh in Devon, while the tree stumps in the nearby Stumpery were found at Shepton Mallet Antiques & Collectors Fair.

'Fashion is a layering process', Roger explains. 'I'm always looking for "wow" in different areas, and to balance the new collection with the security of what has gone before.' At Kilver Court, he has taken his unique design sensibility into the garden, building on history and tradition to create a magical space that transcends fashion.

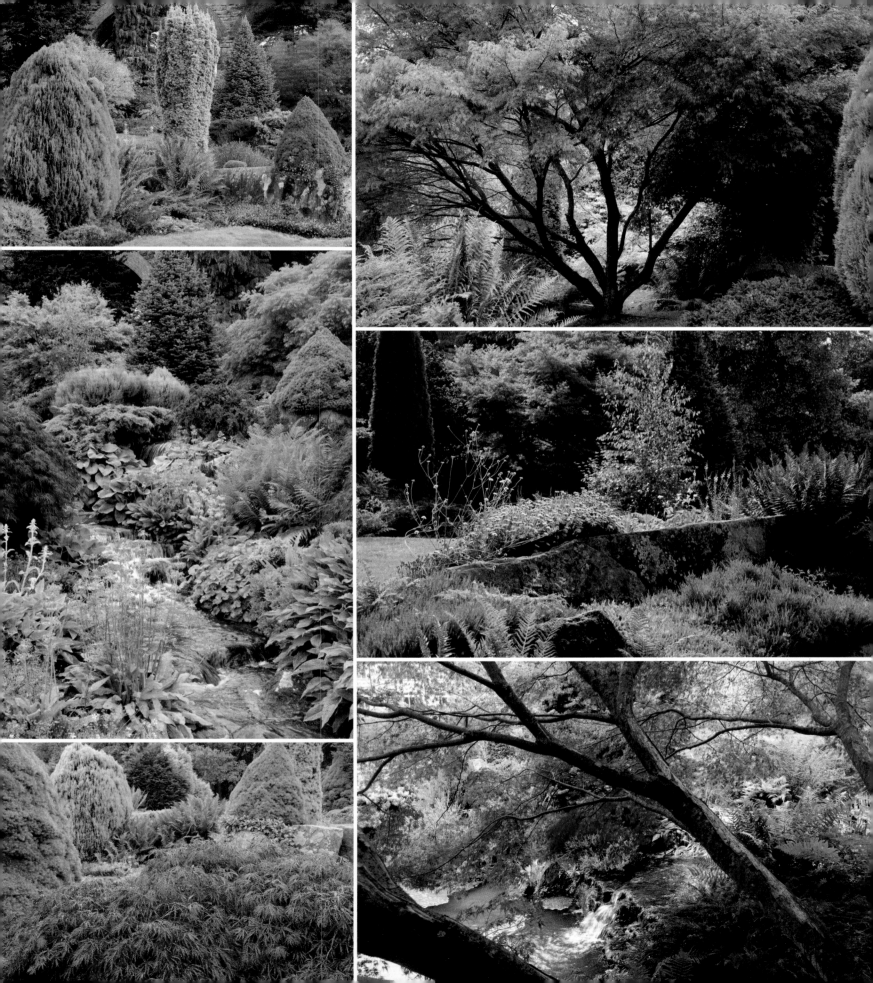

15
Midney Gardens
Somerton

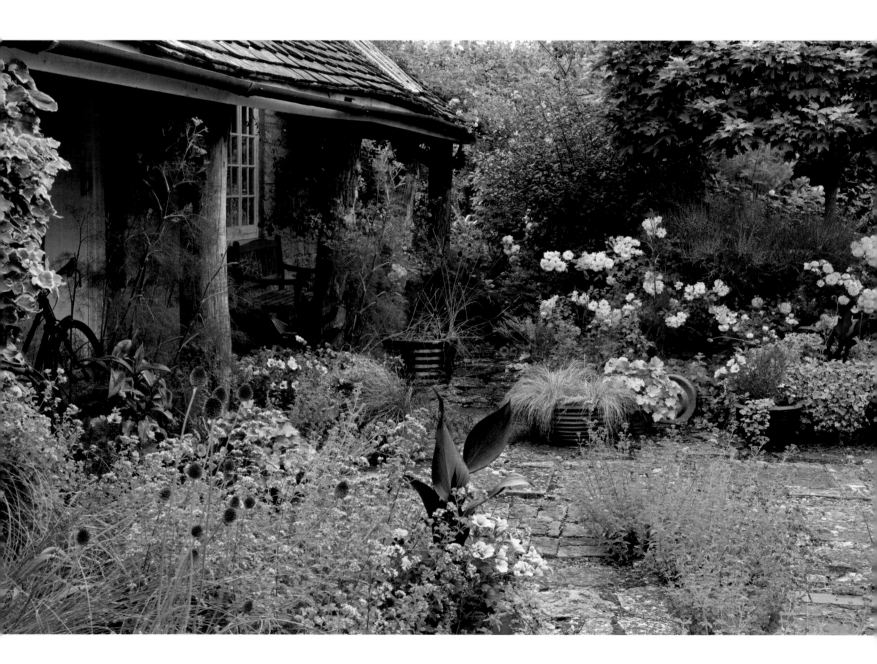

A COMBINATION OF PLANTSMANSHIP, flair for colour and a quirky do-it-yourself ethos makes Midney Gardens one of Somerset's most singular new gardens. Created from scratch in a little under ten years by Dave Chase and Alison Hoghton, Midney Gardens are a testament to what can be achieved with talent and a tight budget.

The gardens lie on the edge of the Somerset Levels about 1.5 kilometres/1 mile south-east of Somerton, the one-time capital of the Saxon kingdom of Wessex. The skyline in this low-lying part of the world is shaped by the gentle contours of the Mid Somerset Hills while the local abundance of fossil-rich Blue Lias stone is reflected in the architecture of the couple's home, a former gamekeeper's cottage.

Dave and Alison moved here from Berkshire in 2009 with the aim of making 'one of the best gardens in Somerset'. Each of them brought different skills to the project. Dave set out the garden, drawing on his experience as a professional landscaper and his tenure at West Green House in Hampshire, working in the gardens developed there by the Australian garden designer Marylyn Abbott. Alison, a personal development trainer, had comparatively little gardening expertise so worked alongside Dave for the first couple of years ('a bit of a trial by fire', she jokes) and now oversees Midney's hospitable ambience (her cakes repay a visit in their own right).

The garden opened to the public in 2012 and just seven years after first breaking soil their ambition was vindicated with Royal Horticultural Society (RHS) Partner Garden status.

Contemporary cottage style

The flat, 0.6-hectare/1½-acre plot had not been initially promising. Having previously hosted a farm shop growing hydroponic watercress, a quarry, a sawmill and a cement works, this keeper's cottage had certainly experienced an industrious past and its garden had become overrun with brambles and decaying outbuildings. However Dave and Alison were struck by its sense of peace and the lovely views to Green Down hill and Dundon Beacon, as well as practicalities such as space for car parking.

The couple set about clearing the site, little realizing what surprises lay beneath the poor soil. On excavating tonnes of concrete infill from the quarry, they discovered a bus whose engine, they were told, once powered part of the sawmill. While the concrete was reused as hardcore to extend the

'I wanted to create a garden and then set it free – it's a funny thing to do, isn't it?'
DAVE CHASE

driveway to Midney Gardens, the quarry was repurposed as a wildlife pond with the bus safely entombed below the pond liner, its presence wittily memorialized by a London Transport bus stop sign.

Guided by a pragmatic 'work with what you have got' philosophy, and an admiration for Gertrude Jekyll and other Arts and Crafts designers, Dave implemented a 'contemporary cottage' design. Colour themes define a succession of rooms in the Plantsman's Garden, while the Kitchen Garden is an experimental potager with themed areas including: a Paradise Garden shaded by quince (*Cydonia*) trees and edged in fragrant

LEFT The dense, 'contemporary cottage' planting on the terrace behind the house makes for relatively easy maintenance – in summer at least.
RIGHT Dave Chase and Alison Hoghton have transformed Midney Gardens since 2009.

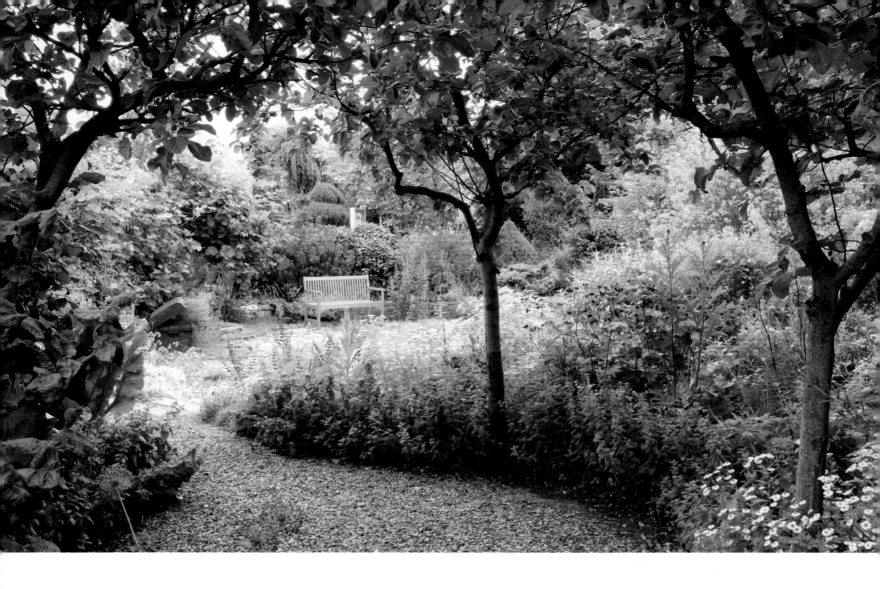

mint (*Mentha*); a Gin Garden with juniper (*Juniperus*) and almond (*Prunus dulcis*) trees; and a tranquil Egyptian Garden with pyramid-plan supports, overseen by a kitschy pharaoh bust. Dave further indulges his passion for growing exotic plants in the World Gardens, a miniature botanic garden housed in one of the old polytunnels.

Informal wildflower planting characterizes the Woodland Walk, which leads past the pond to a small, three-circuit labyrinth. Sited at the far end of the garden where Dave and Alison had noticed particularly calm, grounded energy, the labyrinth references Midney's proximity to the pilgrimage site of Glastonbury, 14 kilometres/9 miles away.

Colour and design

A sense of playful resourcefulness permeates the garden. Some recycling is so ingenious it repays a second look – a high-rise sculpture turns out to have been a wok in a former life. The old tools in the car-park fence reflect Dave's view of Somerset as 'a proper working county where you can still find tumbledown

barns and rusty machinery in hedges'. In the same vein, he has sculpted the garden's surrounding hedges to echo the hills beyond. 'We wanted to create a garden that people would enjoy visiting, and Dave is never short of ideas!' says Alison.

His imaginative designs are particularly evident in the first room in the Plantsman's Garden, which has a seaside theme, with a bathing-hut shed and a cockleshell-shaped, gravel terrace. Reused timbers form a 'breakwater' while the walls and steps are crafted from stone found on-site ('we have not wasted anything in this garden', notes Alison). Dave jettisoned the Clarice Cliff colour scheme he originally intended here in favour of silvery maritime blues and Mediterranean plants such as catmint (*Nepeta*), rosemary (*Salvia rosmarinus*, syn. *Rosmarinus officinalis*), lambs' ear (*Stachys byzantina*) and honeywort (*Cerinthe*).

From this deliberately gentle start, colour builds gradually. A sinuous path links the Plantsman's rooms in roundabout fashion, obscuring and then revealing views, allowing colour themes to emerge gradually. The leisurely pace of the garden

is no accident, as Alison explains: 'it is a small garden and its design helps to slow people down, so they can really see what's there and take their time to enjoy it.'

The colour rooms pivot around a central area where the warm pinks of rock rose (*Cistus*), lupins (*Lupinus*) and nectaroscordum draw the eye before sending it on its way again – to a Fire Garden with flickering flames of *Lysimachia ciliata* 'Firecracker' and *Euphorbia amygdaloides* 'Ruby Glow', and on to a Moon Garden dusky with *Papaver* 'Patty's Plum' and purple sage (*Salvia*), whose metallic foliage chimes with the cast-iron art nouveau Phoebus camp stove placed, somewhat cheekily, here.

In a nearby border Dave pays homage to Sylvia Crowe, an influential mid-twentieth-century landscaper of post-war new towns and civil engineering projects. It has a soft blue, yellow and white scheme and takes its cue from Dave's time spent restoring the Crowe-designed garden at Hailey House in Oxfordshire in the mid-1990s. 'It was the first time I had worked on a garden by a named designer', recalls Dave, 'and it was interesting because you learnt so much about their use of colour and selection of plants – you had to respect their design.'

Dave has lit up this dry shady border with lemon-berried *Cotoneaster* 'Rothschildianus', the variegated perennial mugwort *Artemisia* 'Oriental Limelight' and both herbaceous and shrubby forms of phlomis. Two art deco stained glass window panels rhyme with the detailed planting here, their blue accents picked up beautifully by *Corydalis flexuosa* 'China Blue'.

The Antique Border on the other side of the lawn is equally subtle, a warm tapestry of peaches, pinks and rusts. This sepia vision begins in early spring with daffodils (*Narcissus*) and continues with perennials such as *Geum* 'Mai Tai', *Heuchera* Crème Brûlée, *Phygelius* × *rectus* 'African Queen' and *Rosa* 'Mrs Oakley Fisher', a striking, single, apricot-flowered rose bred in the 1920s.

After decades of expertly manicuring lawns in his capacity as a professional landscaper, Dave now prefers to allow the rings of grass in the circular lawn behind the house to grow naturally – unmown. They were inspired by the London 2012 Olympics. He has also become more generally tolerant of self-seeders and 'volunteers' in the garden.

OPPOSITE Quince trees frame the view into the Maritime Garden from the Paradise Garden.
RIGHT TOP The 'bus stop' is a playful reference to the submerged bus.
RIGHT CENTRE A winding path makes the Kitchen Garden seem bigger.
RIGHT BOTTOM The long grass in the Olympic lawn is a magnet for wildlife.

An evolving philosophy

In spring the garden now explodes with a profusion of pollinator-friendly ornamental onions (*Allium*) — from the white, early flowering *A. neapolitanum* Cowanii Group to attention-seeking *A.* 'Pinball Wizard' and *A.* 'Jackpot', while Midney's butterfly population is a beneficiary of the twenty-one varieties of buddleja (including the uncommon *B. lindleyana*) in the eponymous Butterfly Garden.

Dave's evolving philosophy stems from a lifetime of professional gardening, a career that started in the 1970s when as a punk-rocker school-leaver he was assigned to a florist on the Youth Training Scheme ('I had a baby-pink mohican at the time', recalls Dave). By eighteen he was a municipal gardener in his native Suffolk, 'flying' on a horizontal beam to tend seaside clock bedding schemes and soaking up traditional knowledge from much older colleagues, some of whom had learnt their trade from Victorian gardeners. 'I can still see that legacy in the way Dave gardens today', observes Alison, 'particularly how he works with the weather and prunes trees such as the pollarded weeping willow that centres the ringed lawn.'

Some of Dave's anarchic punk rock spirit lives on in Midney — it is no coincidence the gates to the garden open in different directions. Yet it is tempered with Alison's intuitive approach, where the modern world meets a mystical Somerset, in a garden where a path might be laid out with the help of a pendulum and where each visitor is greeted personally to put them at ease.

Free of the constraints of working for clients, Dave and Alison have been able to create a garden that is truly their own. That their efforts have been recognized by the RHS is the icing on one of Alison's delicious home-baked cakes, but most of all they love seeing other people enjoying 'a garden that is essentially "us" '.

ABOVE The reclaimed stained glass windows in the Sylvia Crowe-inspired border were purchased before Dave Chase and Alison Hoghton came to live at Midney.
RIGHT Being an inveterate 'skip diver', Dave relishes the creative challenge of incorporating unusual found objects into his garden design.

16
Milton Lodge Gardens
Wells

FASHIONS COME AND GO but the popularity of an Arts and Crafts garden never fades. Its evergreen appeal is easy to understand at Milton Lodge Gardens, where velvety lawns and gracious terraces, carved out of the southern slopes of the Mendip Hills, are a tangible reminder of a golden age before the horrors of the First World War.

The garden's significance has been recognized by Grade II listing in Historic England's Register of Historic Parks and Gardens, an accolade echoed by *Country Life*, which has featured Milton Lodge Gardens three times, including on the front cover of its 1977 Summer Gardens issue. Today owned by Simon Tudway Quilter, the gardens at Milton Lodge were created by his great-grandfather Charles Tudway between 1900 and 1909 and were restored by Simon's father David Tudway Quilter in the 1960s.

The Tudways' long and distinguished connection to Wells can be traced as far back as 1678, and the family's prominent role in the city can be inferred from the size and grandeur of the Cedars, the mansion they built in the centre of Wells in 1760. Today the Cedars is part of Wells Cathedral School, and it was Charles Tudway's decision to downsize from there that brought the family to Milton Lodge, 0.8 kilometres/½ mile north of the city. Originally known as 'The Folly' when it was built in the late eighteenth century, this pretty house was acquired by the Tudways in 1861, although not lived in by them for another forty years.

A well-made garden

Charles Tudway, who was a horticulturalist and the proprietor of a hardy plant nursery at the Cedars, made his new garden at Milton Lodge with the help of the garden design firm Parsons and Partridge, in which he was a partner. Making a virtue out of a necessity, the steep hillside site – described by H. Avray Tipping in his 1926 *Country Life* article as 'a very

LEFT Roses of all colours associate well with the stone structures in Milton Lodge Gardens, not least the brilliant pink *Rosa* Gertrude Jekyll on the far wall.

RIGHT The island beds that run alongside the Sundial Terrace are filled with the fragrant, creamy flowered hybrid musk *Rosa* 'Penelope', which has received the Award of Garden Merit (AGM).

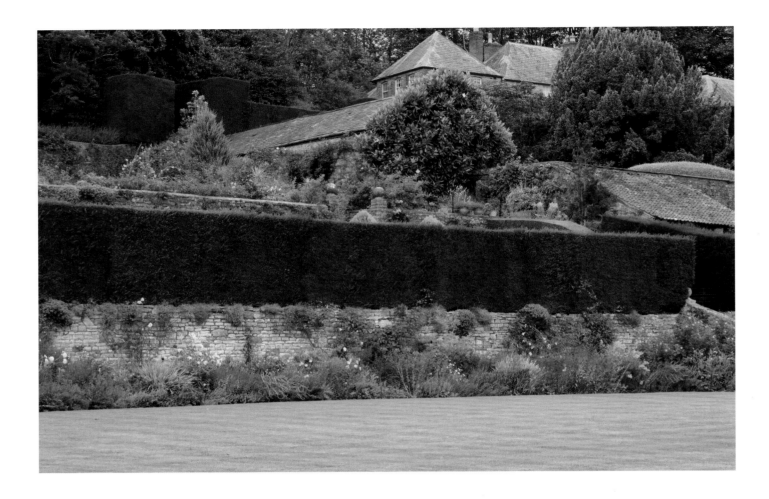

circumscribed horticultural patch' – was arranged into terraces that descended to meet the eighteenth-century parkland below the house. The pay-off was a panorama that encompasses Wells Cathedral, Glastonbury Tor and the Vale of Avalon.

The quality of the stonework specified by Charles Tudway and Walter Partridge speaks volumes about the determination of wealthy Edwardians to create ambitious, well-made gardens. The artist and garden designer Alfred Parsons advised on planting and layout. Parsons moved in Arts and Crafts circles, and illustrated the 1881 edition of William Robinson's influential book *The Wild Garden*, which advocated a more natural style of gardening and so helped shape the unforced informality of gardens such as Milton Lodge.

ABOVE Milton's steeply sloping site can be fully appreciated when seen from the Pool Terrace. *Magnolia grandiflora* makes a lush gable end to the old stable block on the Middle Terrace above.
OPPOSITE A stunning view towards St Cuthbert's tower and the Vale of Avalon can be enjoyed from the Top Terrace.

Post-war restoration

Avray Tipping's detailed *Country Life* article was a useful reference when David Tudway Quilter inherited Milton Lodge and came to live there with his young family in 1962. He found the 2-hectare/5-acre garden in a parlous state, the house having been occupied by a girls' school during the Second World War, and then by an impecunious boys' school.

Restoration was a labour of love: 'The original planting had all but gone, but once they cleared the weeds and brambles they found that the stonework and brickwork of the terracing structures were still pretty well intact. That was all the incentive they needed to go ahead and restore the garden', recalls David's son Simon. The painstaking process took eight years.

David then continued to develop the garden until his death in 2007, by adding an arboretum in the old orchard and renovating the 2.8-hectare/7-acre Combe, an eighteenth-century Pleasure Garden on the opposite side of Old Bristol Road. 'The garden was my father's passion', says Simon. 'He has been described as "a banker by profession, a gardener by passion and a public servant

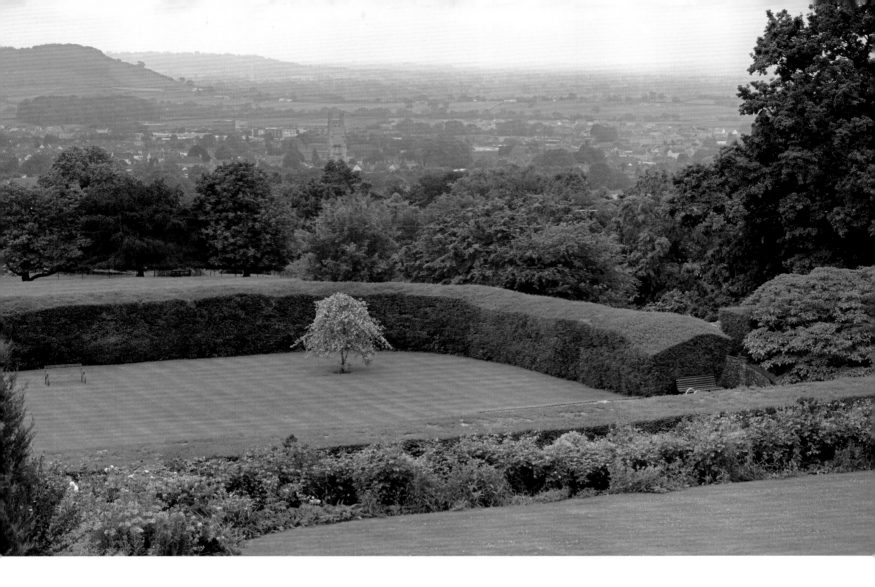

by sense of duty'' and that's right. He was very lucky to be able to pursue his interest alongside his career, and then even more fortunate to be able to enjoy twenty years of retirement here.'

As part of the restoration, masses of old-fashioned roses were planted along the Sundial Terrace and the lawns were reseeded. Although restocking was a priority, some labour-intensive Edwardian features were abandoned. The rose beds in the Front Lawn were not reinstated and the swooping crenellations of the perimeter yew (*Taxus*) hedge pictured in *Country Life* in 1926 were straightened.

Year-round colour

Simon inherited Milton Lodge in 2002, five years before his father died. 'Although I'm not the instinctive gardener my father was, I'm keen to continue what my parents did, and enjoy doing that', he says. He keeps up the tradition, started by his parents in 1962, of opening for the National Garden Scheme, and also opens to the public. He arranges the teas too, having recently taken over this role from his mother Elizabeth

'One of the most glorious views imaginable.'

GEORGE PLUMPTRE

who, in her nineties, 'has gone on strike' as he affectionately puts it.

In order to ensure that the garden is maintained to his parents' standards, Simon is fortunate to be able to entrust its care to two long-standing gardeners – senior gardener David Milnes and his colleague Andrew Piper – who between them have more than fifty years' experience of gardening at Milton Lodge.

Change is inevitable but David Milnes's knowledge has been invaluable in consolidating the Tudway Quilters' legacy: 'We try to keep the planting cottagey and herbaceous', he says, 'with colour throughout the year.' Early interest comes with a succession of snowdrops (*Galanthus*), daffodils (*Narcissus*), fritillaries (*Fritillaria*), cowslips (*Primula veris*) and camassias in the wildflower meadow in the Lower Garden.

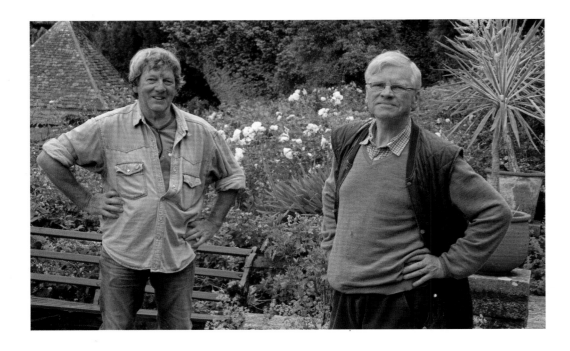

The paths that Andrew mows through the long grass wind past a magnificent *Ginkgo biloba* planted *c.*1910 and twenty-first-century additions such as *Malus × zumi* 'Golden Hornet'.

Roses are still the stars of the Sundial Terrace, where David has expanded the selection to showcase different groups in the genus. *Rosa* 'Königin von Dänemark' represents the Alba roses, *R.* 'Impératrice Joséphine' the Gallicas, while modern varieties include crimson-pink *R.* Darcey Bussell. The fragrant double flowers of *R.* 'Boule de Neige' argue the merits of the Bourbon group, first developed on the island of Réunion (previously known as Île Bourbon) in the early nineteenth century.

Milton Lodge's elevated, south-facing aspect as well as the protective green backdrop of the hanging wood above the garden allow half-hardy and tender plants to flourish. The lemon verbena (*Aloysia citrodora*) at the front of the house reaches almost up to the eaves, while *Azara petiolaris*, a tender Chilean native on the Sundial Terrace, is almost as voluminous.

The *Clerodendrum trichotomum* planted by Simon's father in the 1960s and 1970s are one of the garden's signatures. They have grown into attractive small trees and their white, star-shaped flowers scent the air with jasmine in late summer. They are enthusiastic self-seeders between the paving slabs by the swimming pool, with 'spares' potted up for sale.

Abutilons are another Milton Lodge hallmark and have grown statuesque in the warmth of the old stable wall on the Middle Terrace. The mallow-like flowers of *A. vitifolium* 'Album' and *A. × suntense* 'Jermyns' are followed by hollyhocks (*Alcea*) in midsummer, set amid a happy confection of French blue delphiniums, orange alstroemerias, sugar-pink *Lythrum salicaria* and magenta *Symphyotrichum novae-angliae* 'Andenken an Alma Pötschke'.

The 15m/50ft border that ranges along the Pool Terrace is a summer highlight. Its blue and yellow planting was admired by Lanning Roper in *Country Life* in 1977. 'The colour scheme was my father's favourite', confirms Simon, 'and we like to keep it going.' Here the English climbing rose Teasing Georgia adds a lemon accent against the soft grey stone terrace wall, echoed by *Dahlia* 'Glorie van Heemstede' and *Argyranthemum* 'Jamaica Primrose', a notably lofty variety. Soft blue contrasts come from *Caryopteris × clandonensis* 'Heavenly Blue', the blue trumpets of *Iochroma australe* and long-flowering *Geranium* 'Brookside'.

Fifty years after David Tudway Quilter began the Milton Lodge arboretum, his skill in placing trees is apparent, with specimens such as the weeping silver lime (*Tilia tomentosa* 'Petiolaris') now reaching maturity. *Fraxinus angustifolia* 'Raywood' with vivid autumn colour lives up to its common name of claret ash, and enjoys the bonus of having so far resisted ash dieback. Dawn redwood (*Metasequoia glyptostroboides*) and *Cornus* 'Porlock' are among the fine, now mature ornamental trees added to the Combe as part of its restoration. The Combe's Elysian lawns and woodland walks are freely open to the public for much of the year and make an atmospheric coda to the sunlit terraces of Milton Lodge, as well as a living memorial to generations of garden-making Tudways.

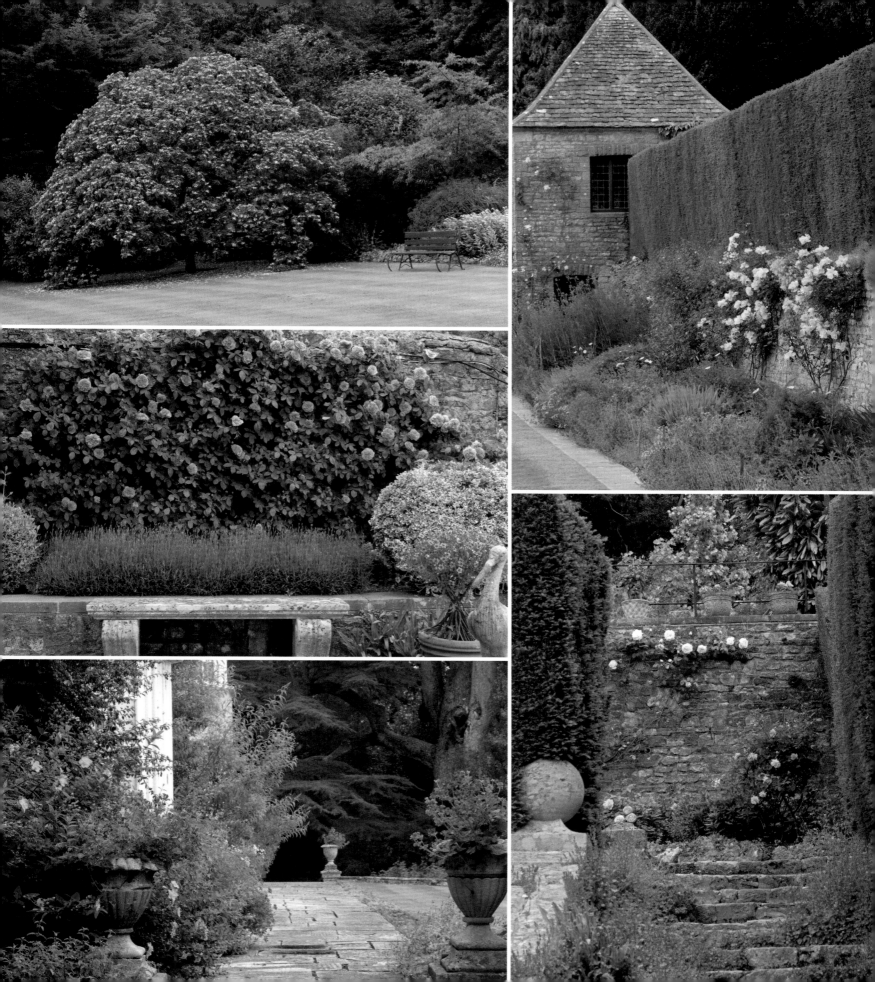

17
The Newt in Somerset
Hadspen

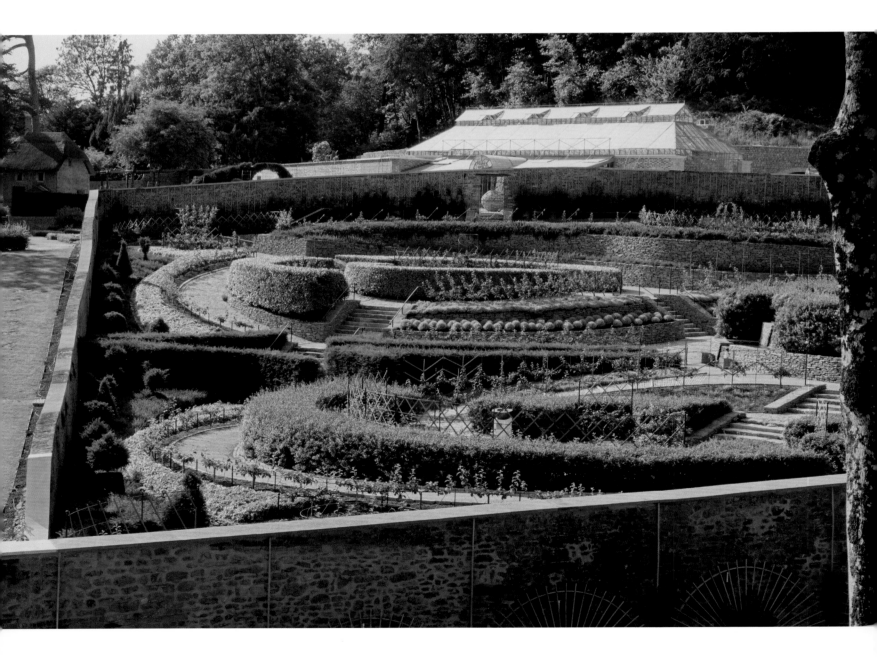

IN A REMARKABLE six-year metamorphosis, the historic Hadspen estate has become The Newt in Somerset, a luxurious hotel with expansive and ambitious new gardens.

Tucked below a ridge above the town of Castle Cary, the Hadspen estate is no stranger to makeovers, having undergone several in its history. In the eighteenth century the original farmhouse was moulded into the 'perfect gentleman's seat' by a succession of prosperous Bristol merchants and lawyers, and its grounds acquired fountains, tree-lined avenues and – the ultimate Georgian parkland accessory – a ha-ha.

From 1785 Hadspen was owned by the Hobhouse family, and in the 1880s Margaret Hobhouse began to develop the garden according to the tenets of William Robinson, whose influential book *The Wild Garden* was published in 1870. Following a period of neglect at Hadspen, in the 1960s the noted garden designer Penelope Hobhouse made her first garden here. This in turn inspired her book *The Country Gardener*. Then in the 1980s and 1990s Nori and Sandra Pope created their famous Colour Gardens within the parabola-shaped walled garden.

From South Africa to Somerset

Hadspen's latest transformation is its most radical yet, and has come courtesy of South African businessman Koos Bekker and his wife Karen Roos, a former editor-in-chief of *Elle Decoration South Africa*. They purchased the 324-hectare/800-acre estate in 2013. 'We chose this area because it felt familiar somehow', recalls Karen. 'When we found Hadspen it seemed perfect.'

The couple are both garden lovers and as the owners of Babylonstoren, a hotel in South Africa's wine-growing region, have experience in creating prestigious destinations based around historic houses and beautiful gardens. As at Babylonstoren, the Bekkers enlisted Italo-French architect Patrice Taravella to design a garden that would complement the Grade II listed Hadspen House. Taravella was an ideal fit

OPPOSITE Bold brackets of privet (*Ligustrum*) and osmanthus hedging amplify the sinuous contours of the Parabola's drystone terraces.
BELOW The Victorian Bathing Pond, like all water features at The Newt in Somerset, is equipped with amphibian-friendly exit ramps.

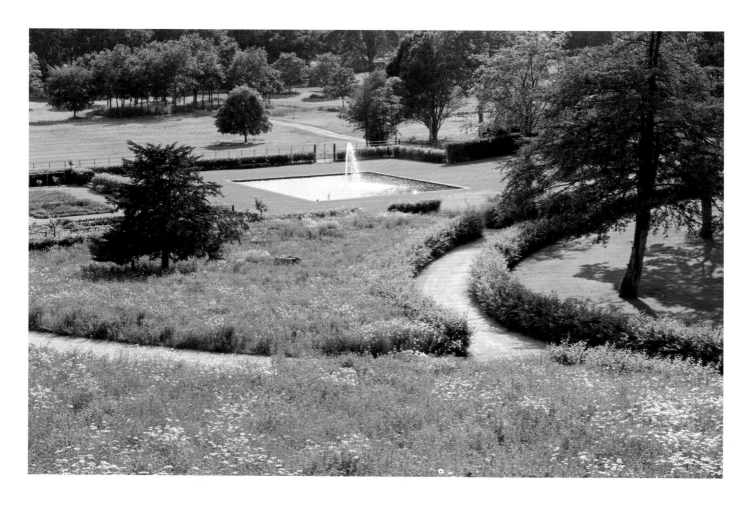

Being a protected species, the huge colony of great crested newts had to be moved to safety while work was underway – a complicated operation that inspired the estate's new name.

for the project, his own medieval-inspired garden at Prieuré Notre-Dame d'Orsan having captivated Karen Roos.

Taravella's garden master plan for Hadspen doesn't settle on recreating a single era but instead, inspired by Penelope Hobhouse's book *The Story of Gardening*, alights on moments in garden history, from geometric baroque gardens to the stage-managed vistas of the eighteenth-century landscape park to contemporary, prairie-style grass borders. Alongside the new elements, historic features such as the Lime Avenue, the Belvedere and the Viewing Mount have been restored.

Generously loaded with witty cultural allusions, the garden's 7 hectares/17 acres are dedicated as much to pleasure as they are to education. At the foot of the Cascade, there is a watery joke, inspired by the *giochi d'acqua* found in Italian mannerist gardens such as Villa d'Este. Set in a sleek modernist pavilion, the Garden Café sources much of its menu straight from the garden, and the overall mood is light-hearted, with chickens running free on the lawn, quirky sculptures and visual humour.

A huge endeavour

Reorganizing the existing gardens involved ground works on a scale that Capability Brown would have recognized. These included rerouting a section of the main road and moving the Victorian Bathing Pond (by all of 1m/3ft) to better align it with the house. Even Karen admits the project grew beyond their expectations: 'One thing simply led to another, and the project ran away with itself.'

The Bekkers assembled a team of top-flight gardeners to implement the project, drawing on the expertise of Eden Project alumni such as Iain Davies and Donald Murray. The period-correct planting schemes were designed by Head of Ornamental Planting Russell Rigler, a former gardener at Royal Horticultural Society (RHS) Wisley. As Head of Programmes (and former head gardener at Colesbourne Manor) Arthur Cole comments: 'It's a big endeavour. We're laying down a big new design and that's rare these days.'

All about the apple

The Newt also takes inspiration from its location in the heart of cider country. Apples are a leitmotif across the estate, from

OPPOSITE TOP *Dicksonia squarrosa* combines effectively with boulders of Hadspen stone in the Fernery.

OPPOSITE CENTRE The cloud-pruned yew (*Taxus*) hedge was grown as a piece in Belgium and transported to Somerset.

OPPOSITE BOTTOM In the Kitchen Garden rustic hazel poles support climbing crops while companion plants such as Californian poppies (*Eschscholzia*) attract pollinators.

ABOVE Vibrant orange-red salvias and dot-planted cannas make a strong statement in the Victorian Fragrance Garden.

LEFT This gentle, yellow and blue scheme suits the damp shady conditions beside the Cascade.

new cider orchards to the apple-patterned floor grills in the threshing barn. And while the Bekkers' South African estate produces award-winning wines, The Newt's in-house cider press uses local apple varieties to create a beverage that is equally rooted in its terroir.

The Newt's celebration of the forbidden fruit reaches a crescendo in the Parabola. Here Taravella regraded the old kitchen garden into curvaceous drystone terraces that set the stage for a baroque-inspired 'apple maze'. Planted with more than 250 English apple (*Malus domestica*) varieties, the maze showcases the art of espalier, with the trees being coaxed into all manner of shapes from criss-cross Belgian fences to complicated double helices. This horticultural origami is the work of Gilles Guillot, the head gardener at Prieuré Notre-Dame d'Orsan. Gilles visits The Newt regularly to finesse the juvenile fruit trees, and to pass on his traditional pruning knowledge to Newt gardener Andy Lewis. Techniques such as nicking and

notching, and weighting branches with pebbles sound arcane but are designed to make each tree as beautiful and productive as possible.

Horticulture and history

Productivity continues in the new Kitchen Garden, a purpose-built potager laid out with a parade-ground precision that recalls the ornamental vegetable gardens of the Château de Villandry in France. The Kitchen Garden is cultivated using the no-dig method, a technique popularized by Somerset grower Charles Dowding.

There's Gallic elegance too in the table-pruned plane (*Platanus*) tree plantation that shades diners in the newly built 'farmyard' at the top of the garden. The trees were grown en bloc in Belgium and transplanted to Somerset in 2019 as mature specimens, a remarkable horticultural feat. More usually seen in cities, the trees confer Parisian *savoir faire* to the rural setting, and even the surrounding gravel is fastidiously mixed to the same recipe as that used in the Jardin du Luxembourg.

Another part of the garden at The Newt could not be more English. It is the Cottage Garden, and is a paean to the Arts and Crafts style popularized by Gertrude Jekyll. Carefully researched by Russell, the planting scheme includes authentic

ABOVE The Newt's gardening team, here in the Parabola, possess a wide range of expert and specialist horticultural skills.
OPPOSITE Superb craftsmanship underpins the garden, from the pebble pavements in the Parabola and the Cascade to the quirky sculptural details and the chestnut sunbursts used to fan-train fruit trees.

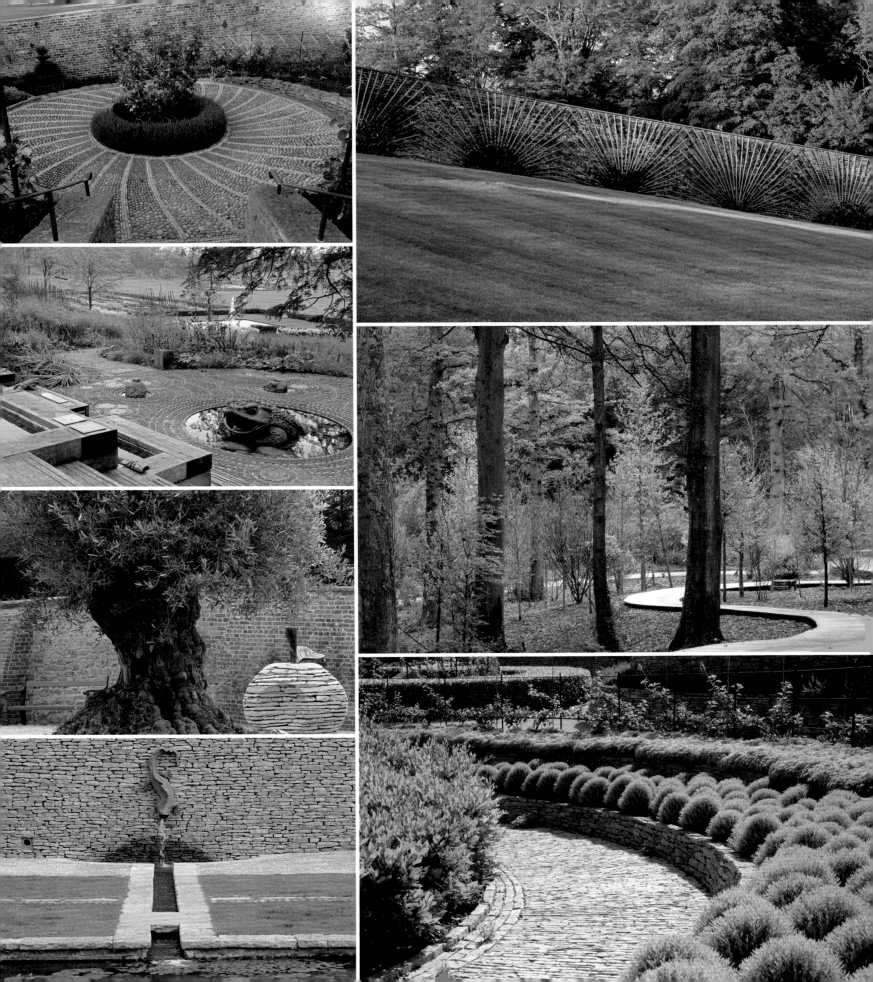

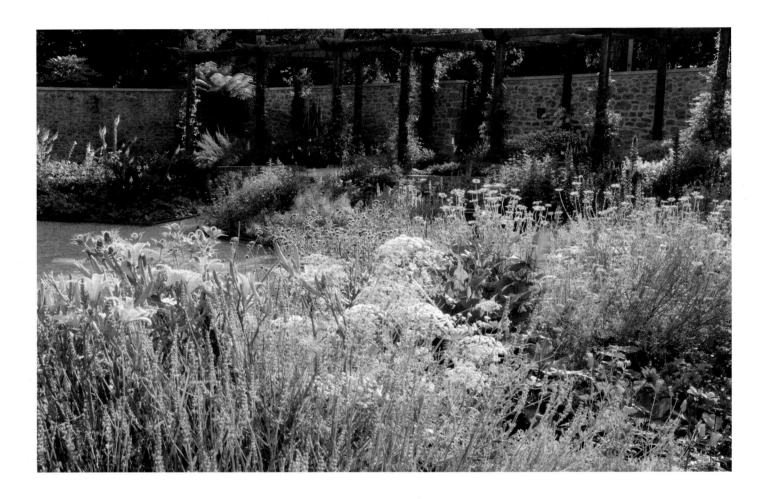

cottage-garden favourite bear's breeches (*Acanthus spinosus*, introduced in 1629) as well as Jekyll selections such as *Hylotelephium* 'Munstead Dark Red'.

The adjacent Victorian Fragrance Garden meanwhile stands for a formal style of gardening that was diametrically opposed to the naturalistic approach pursued by Jekyll. This formal parterre revels in colourful carpet bedding schemes of the sort that were so enjoyed by the Victorians. In spring the beds dazzle with vibrantly hued wallflowers (*Erysimum*), tulips (*Tulipa*) and forget-me-nots (*Myosotis*), which are followed by a summery potpourri of verbenas, heliotrope (*Heliotropium*), salvias and dot-planted cannas. The nearby, nineteenth-century-style Conservatory is a reminder that such vivid palettes were only made possible by the efforts of Victorian plant hunters and climate-cheating greenhouse technology.

Being contemporary in style, the timber-built Cascade is freed from the need for date-specific planting. Its watery descent is accompanied by lush marginal plants such as yerba mansa (*Anemopsis californica*), diaphanous stands of angel's

fishing rods (*Dierama pulcherrimum*) and cheerful yellow and orange giant cowslips (*Primula florindae*) and *P. bulleyana*.

Nori and Sandra Pope's tenure is referenced in the Colour Gardens. 'It's an important part of the garden's story, but we've simplified it', explains Russell of his planting scheme. 'We picked out red, blue and white, red being the colour of passion, blue calm and thoughtful, while white is pure and cleansing.' In contrast to the Blue and White Gardens, which contain spring planting, the Red Garden hits its stride in high summer with a fiery palette that includes *Crocosmia* 'Lucifer', *Dianthus cruentus* and *Astrantia* 'Hadspen Blood', one of the notable plants selected by the Popes.

A stroll through the deer park and across a vertiginous tree-top walkway leads to The Story of Gardening, whose exhibits chart the history of horticulture from the Roman Empire to the modern day. There, visitors can virtually explore gardens such as the Villa d'Este and Giverny before they venture back out into a Somerset estate whose reincarnation includes gardens that seem likely to become every bit as celebrated.

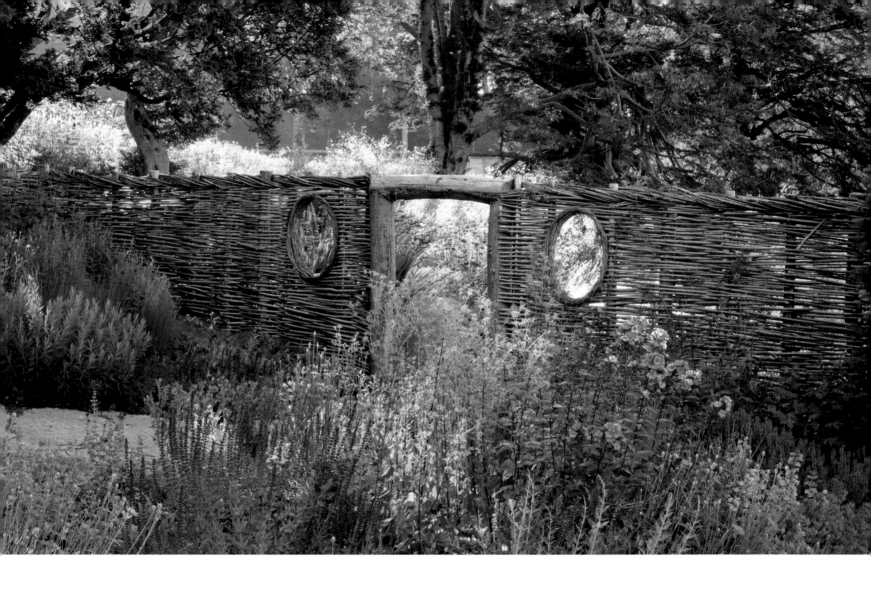

OPPOSITE Taking their cue from Gertrude Jekyll, the borders in the Cottage Garden are woven with colour and texture provided by brilliant day lilies (*Hemerocallis fulva* var. *aurantiaca*), frothy *Ammi majus*, spiky bear's breeches and sea holly (*Eryngium*).

ABOVE The restful plant palette in the Blue Garden includes *Phlox paniculata* 'Blue Paradise', *Salvia viridis* 'Oxford Blue' and *Perovskia* 'Blue Spire'.

LEFT In the Red Garden, the spent flower heads of *Angelica archangelica*, Mexican feather grass (*Nassella tenuissima*) and golden oats (*Stipa gigantea*) are the textural foil for plants such as *Hemerocallis* 'Crimson Pirate' and *Salvia* 'Royal Bumble'.

18
Stoberry House
Wells

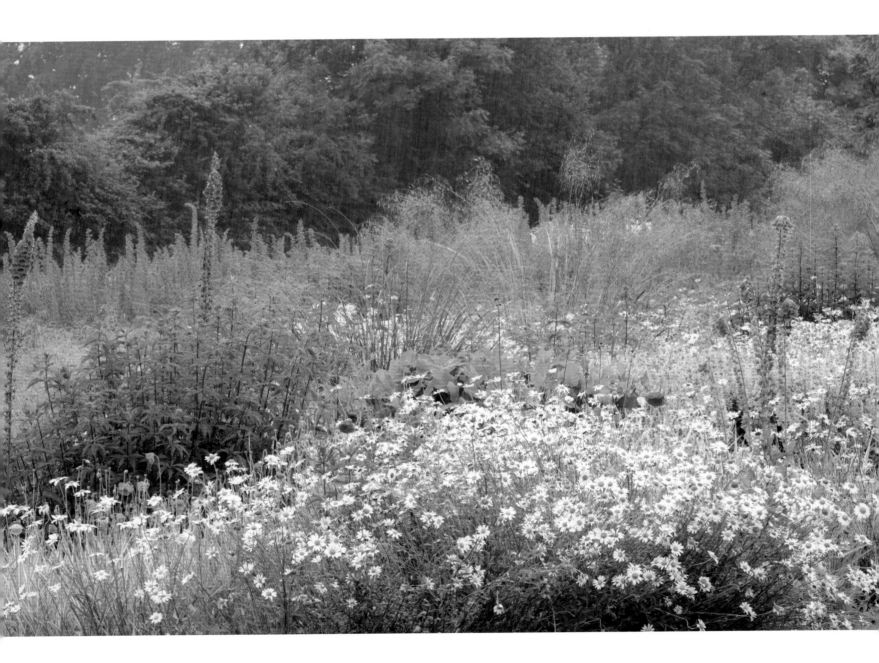

FROM ITS LOFTY POSITION on the south-facing slopes of the Mendip Hills, the 2.4-hectare/6-acre garden of Stoberry House surveys a sublime panorama that takes in the eighteenth-century parkland of Stoberry Park, the Gothic towers of Wells Cathedral, the iconic silhouette of Glastonbury Tor floating above the Vale of Avalon and even, on a clear day, the Purbeck Hills in distant Dorset. It is a quintessentially English vista but the garden created here by Frances and Tim Meeres Young is anything but parochial. There is more than a hint of Africa running through its veins, perhaps not surprisingly given that Frances is an artist who is African born and bred, and the couple came to Somerset after many years of living in Lesotho and Botswana.

When the Young family arrived here in 1997, Stoberry House was a dauntingly blank canvas. The house – now run as an award-winning luxury bed and breakfast by the Youngs – was once the coach house of Stoberry Park, and its Georgian mansion was demolished in 1957. The surviving 0.4-hectare/1-acre Walled Garden was full of thistles and brambles – and sheep. 'It was a wasteland', Frances recalls. 'When I first saw it I just burst into tears.' Tim however had fallen in love with the view and persuaded Frances to embrace the property's potential.

With Tim still working abroad, Frances overcame her misgivings and got stuck in. Starting in the Walled Garden by the house, she worked her way outwards, and over the years as her confidence increased 'the grass has got less, and the beds have got more'. Although Stoberry was much bigger than her previous garden in Botswana, Frances resisted advice to divide it into typically English garden rooms. 'It would have worked well but it's just not me', she explains. 'I wanted to do my own thing.'

Frances arranged her 'upstart' garden over four principal areas, with a free-flowing layout that reflects her vivacious personality and flair for spatial design. The latter is a by-product of dyslexia: 'I design in my head', says Frances. 'I hold a visual image in my mind and then put it in place.'

Tucked in the lee of the house, the sunken Gravel Terrace is a sunny *hortus conclusus*, where guests can enjoy morning coffee or afternoon tea. An archipelago of generously filled island beds harbours secluded seating areas from which the Walled Garden beyond can be glimpsed through the stilt-like trunks of the 'uplifted' leylandii (× *Cuprocyparis leylandii*) hedge.

Plants earn their keep in this continuously used area, and none do so more willingly than the sculptural, black and green aeoniums that constitute the Gravel Garden's signature plant. Descendants of a single specimen purchased on a holiday to the Scilly Isles, they are planted directly in the soil ('which they love', reports Frances), but are lifted at the first frost to overwinter in the greenhouse.

Giving no hint of the panorama beyond, the Walled Garden is an internally focused arrangement of semi-formal lawns and

LEFT The mixed meadow planting at Stoberry House is designed to attract a wide range of invertebrates including the large blue butterfly, which has been reintroduced locally.
RIGHT Wells Cathedral has an unmistakable silhouette, which makes a majestic focal point for the outer garden.

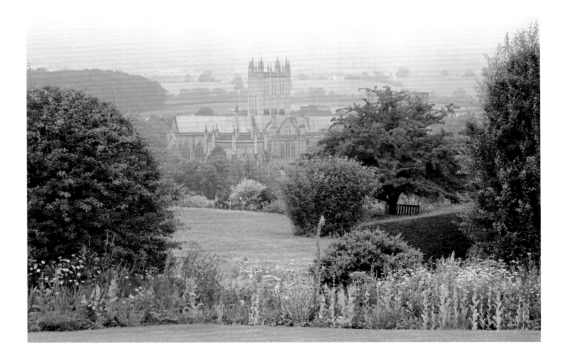

beds. Around these Frances has composed a mood journey that leads visitors from sunny Rose Parterre to the dappled calm of the Lime Walk, and from the sunlit warmth of the Hot Bed to the Bonfire Bed, aglow with *Acer griseum*, rosa mundi (*Rosa gallica* 'Versicolor') and *Lysimachia ciliata* 'Firecracker'. When the Walled Garden is lit at night the atmosphere changes again: 'it is like painting with light', says Frances.

With her artist's eye, Frances uses colour to unify her expansive garden design. Maroon is her continuity colour of choice, and *Berberis thunbergii* f. *atropurpurea* a favourite leitmotif plant, its warm tones echoed by the rich purple foliage of an eastern redbud (*Cercis canadensis*) cultivar and

Corylus avellana 'Red Majestic', as well as by perennials such as *Hylotelephium* 'Herbstfreude' and pineapple flower (*Eucomis comosa*). This purple palette makes a powerful foil to a zesty counterpoint of acid-yellows, typified by variegated maples (*Acer*), a skyrocketing, lemon-coloured foxtail lily (*Eremurus*) and architectural stands of *Phormium tenax* 'Variegatum'.

A Somerset savannah

The view was the starting point in the outer gardens, but as Frances explains: 'gardening with such an incredible view is actually quite difficult. You have to create something that works with it rather than fights it.'

The Youngs' response was to use water as the non-confrontational link between this more open part of the garden and the wider landscape. Installed early in the garden's development, the pond was masterminded by Tim, a water engineer who spent his career implementing major development schemes in Africa and the Middle East. While excavating the pond they discovered the well for the old house,

ABOVE Ever-thoughtful hosts, Tim and Frances Meeres Young have ensured that there are plenty of places where visitors can sit and enjoy the garden. This bench is in the Walled Garden.
OPPOSITE The mood journey through the garden leads from enclosed to open spaces, and from dark to light. The church seen beyond the pond (bottom left) is St Cuthbert's, often mistaken for the cathedral.

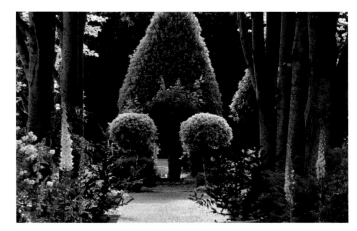

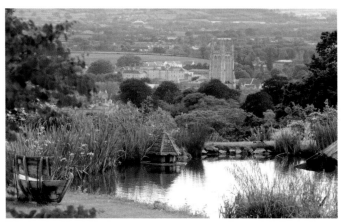

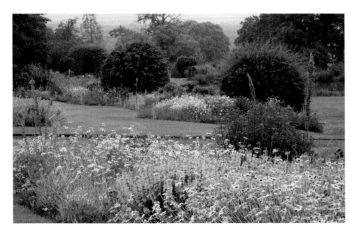

'but there were no other water features when we arrived', says Frances, 'and no frogs, but now we have plenty of both.'

Wildlife is a priority and Frances tries to avoid chemical intervention wherever possible. When the pond – located on the plateau where the original Stoberry House stood – became overrun with blanket weed, Tim solved the problem with eco-friendly grass carp. 'We introduced a hundred and fifty of them', he explains. 'They were one inch long when we got them, now they're huge.'

The pond has become home to a contented congregation of ducks, and Frances – who has a great sense of humour – could not resist adding a thatched rondavel beside its tranquil waters. 'I love the idea of visitors coming up this very English drive and discovering an African hut', she says mischievously. The rondavel is decorated with a Ndebele-inspired mural designed by Frances in the traditional South African style.

The invertebrate friendly meadow was a labour of love. 'I adore meadows, the waving grasses and the sound of grasshoppers remind me of Africa', said Frances, 'but it took three years to get it right because one species always wants to dominate.' Frances turned this to her advantage by creating intensively planted 'wildflower circles' within her Somerset savannah. In midsummer these form hazy blue pools of viper's bugloss (*Echium vulgare*) alongside the main axial path whose borders brim with ox-eye daisies (*Leucanthemum vulgare*) and other meadow favourites, as well as statuesque perennials such as *Miscanthus sinensis* 'Variegatus' and *Eupatorium maculatum*.

A sculpture garden

For Frances one of the pleasures of moving to Somerset was discovering its flourishing artistic community: 'the art here is fantastic', she enthuses. She has built a wonderful collection of work by West Country sculptors, as well as pieces by African artists: 'I love to place sculpture – I've noticed that sculptors aren't always good at it!'

She has wittily placed 'Lady on the Swing', one of several pieces by Vanessa Marston, so that it appears to hang from the

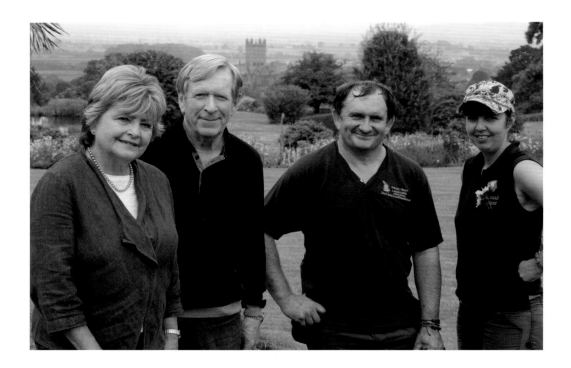

As an artist, Frances Meeres Young is passionate about integrating sculpture in the garden.

adjacent Tibetan cherry (*Prunus serrula*), and she has made an alluring eye-catcher out of Nick Dean's 'Portuguese Lady'. A tongue-in-cheek gift from Frances to Tim, the scantily clad Lady, is guarded by semicircles of fragrant lavender (*Lavandula*) encircled within a beech (*Fagus*) hedge screen inspired by Wells Cathedral.

One of the most poignant artworks is the figure by Somerset artist Lily Sawtell that watches over Jenny's Garden. Created as a memorial to a dear friend ('it was therapeutic', says Frances), this sunny terraced garden features resilient plants such as sea holly (*Eryngium*), black bamboo (*Phyllostachys nigra*) and hardy fuchsia that can cope with the dry exposed conditions where park and garden meet. *Cotinus coggygria* 'Royal Purple' and *Lonicera ligustrina* var. *yunnanensis* 'Baggesen's Gold' supply Stoberry's 'house colours'.

Frances's energy is boundless and she always likes to have a project. St Cuthbert's Walk is one such development – a 'wild and woodland walk' named after Wells's parish church, whose size and grandeur often cause it to be mistaken for the nearby cathedral. The walk is underplanted for spring interest with shade-loving hellebores (*Helleborus*), epimediums and lungwort (*Pulmonaria*), and leads to another new addition – a fern-festooned Stumpery.

Frances is quick to credit the 'brilliant' help she has in the garden. Dan Frost has been part of the team from the outset, while Sarah Handley is a more recent arrival, having joined from Barnsdale Gardens in Rutland. 'We complement each other well as we all have different strengths', comments Frances. 'I have strong ideas, but I'm always happy to listen. For example, the auricula theatre by the front door is a "Dan-ism", but the location was Sarah's suggestion.'

Gregarious and hospitable, Frances and her husband enjoy sharing the garden. Frances's 'every season' garden is rewarded by positive feedback from guests, many of whom return specifically to see it at different times of the year. 'That's the good thing about having a large garden', says Frances. 'You can create so many moods across the seasons and I feel very blessed I can do that.'

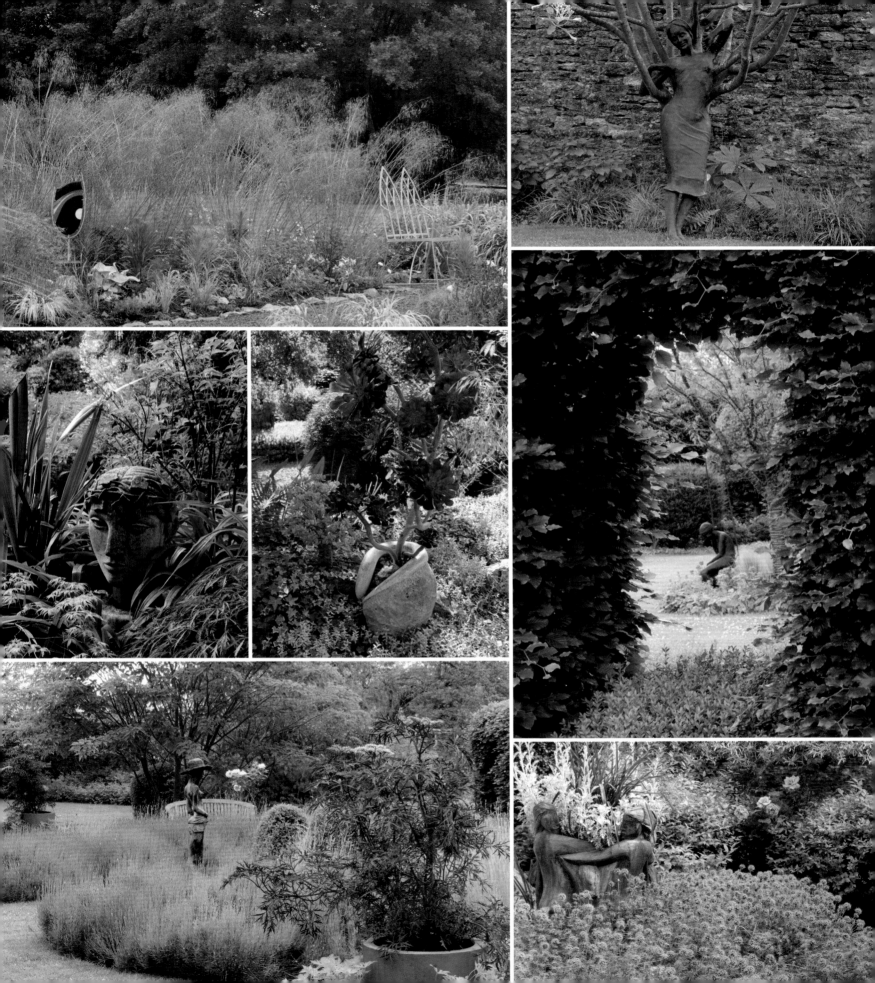

19
Westbrook House
West Bradley

POISED ON THE EDGE of the Levels near Glastonbury and surrounded by pastures and apple orchards, West Bradley is a quintessential Somerset village. No wonder Keith Anderson and David Mendel fell for the location when they were house-hunting sixteen years ago. Their previous house, an old rectory, was pretty but at under 0.4 hectare/1 acre its walled garden was rather small and after nine years there Keith, a garden designer, and David, a specialist painter, wanted somewhere with views and 'scope'.

Both David and Keith knew Westbrook House was 'the one' as soon as they saw it, even though it was late winter. The house – a handsome, double-fronted Victorian villa – and its 1.6 hectares/4 acres of horse paddocks, bounded on one side by Bradley Brook, offered just the right-sized blank canvas where they could create a new garden together.

Viewing in winter was a leap of faith, and proved even more so when they discovered that the house lies on heavy clay, with a very high water table. 'When neighbours found out we were planning a garden, their response was "good luck with that"', recalls David wryly. But luck was on the couple's side, and the clay turned out to be 'gardenable'. 'There's a good layer of silt above the clay', explains David, 'and, although the ground can dry with cracks big enough to break a leg in, roses and lots of other plants like it.' Another bonus was the abundance of well-rotted horse manure that the previous owner, a keen equestrienne, had bequeathed them: 'just wonderful'.

Keith and David concentrated initially on making the orchard and the formal gardens on three sides of the house, grazing the central paddock with a herd of frisky heifers until they were ready to make it into a meadow. The garden 'eases out' from formality and becomes wilder where it meets the landscape, with the alder (*Alnus*) and willow (*Salix*) trees alongside the brook forming a natural buffer zone. They were among only a few trees already *in situ* and were 'a saving grace', says Keith. 'I don't like gardens that look like they have been plonked down in a field.'

Although Keith and David have steadily added more trees, the solitary scarlet oak (*Quercus coccinea*) in the meadow was the key that unlocked the layout of the back garden, becoming the focal point of an axis that runs from the kitchen window through the back lawn and beyond.

This sight line, guided by parallel hedges of the Rugosa rose 'Roseraie de l'Hay' and a quartet of loosely clipped snow pears (*Pyrus nivalis*), creates the spine of the back garden. But all is not what it appears. 'It's actually an optical illusion', confesses Keith. 'The garden looks like it's all right angles but it absolutely isn't. The oak tree "lines up" with the kitchen sink only because the path we have mown through the grass draws your eye to it.'

This skilful sleight of hand is all the more remarkable since neither David nor Keith are believers in formal plans, relying instead on their well-trained eyes and 'a lot of string

LEFT A wirework gazebo makes an elegant focal point at the far end of the orchard.
RIGHT The planting in the back garden aligns around the original oak tree, here seen framed by autumnal stands of the Rugosa rose 'Roseraie de l'Hay'.

and sticks'. Their modesty is equally deceptive, as they each bring formidable expertise to this understated and exquisitely romantic garden.

A graduate of the English Gardening School, Keith began his career working for the revered garden designer Rosemary Verey. 'I learnt a lot from her', he says. 'Her plant combinations were amazing.' David, meanwhile, having gardened as a child with his mother, trained as an artist and worked at Colefax and Fowler under the legendary interior designer John Fowler. In recent years David's specialist paint skills and expertise as a colourist have contributed to award-winning restoration projects at Wilton House (in Wiltshire) and St Giles House (in east Dorset).

ABOVE The snow pears on the back lawn are pruned every winter by David Mendel to give the bare branches a wonderfully sculptural shape. 'It's hell to do', he says, 'as they are very vigorous.'

OPPOSITE The box balls and yew topiary in the Drawing Room Garden are clipped by eye, using long-bladed trimmers.

Informal formality

The back lawn at Westbrook House has been kept unfussy and semi-formal so that the double borders that lie to one side of it can shine. The deftly layered mixed scheme in soft pink, white and blue features the dainty lavender lanterns of *Fuchsia magellanica* and deep purple *Salvia* 'Amistad', and has been built around a backbone of pyramid-trained 'Doyonné du Comice' pears (*Pyrus*). The shocking crimson flowers of *Rosa* 'Mrs Anthony Waterer' are a deliberately punchy counterpoint to the pastel pink blooms of *R.* 'Comte de Chambord'. 'I always want a little "oomph" somewhere', observes Keith, 'and David and I agree on that completely.'

While the back garden is all about the long view, the Drawing Room Garden to the side of the house is a *hortus conclusus*, enclosed by hedges and walls. The perimeter borders are shallower than Keith would normally specify, but their slimline proportions ensure that the lawn isn't overpowered. Well-groomed yew (*Taxus*) pyramids and box (*Buxus*) balls anchor the cottagey planting, where self-seeded, lime-green

Nicotiana langsdorffii pop up among luminous blue phlox, clouds of white cosmos and the yellow bells of shade-loving *Kirengeshoma palmata*. 'As you get older, you realise how important structure is', reflects Keith, who notes that 'good edges and hedges' let you get away with a certain amount of chaos in the borders.

The turning circle in the front drive is original to the house, and after some deliberation Keith and David decided to keep it, using it as a clear 'start point' to the garden. They replaced the grass roundabout with a long-lasting scheme featuring a central 'path' of *Helianthemum* 'Wisley Primrose', lilac-pink *Geranium* 'Sirak' and dainty white *Gillenia trifoliata* flanked by *Rosa* 'Stanwell Perpetual'. Flowering nonstop from late spring to Christmas without needing to be deadheaded, this generous old rose is a boon in a labour-intensive garden that requires five days a week input from both David and Keith.

Encircling the roundabout, a modern-day take on a Victorian shrubbery screens the drive from the lane. Planted on repeat, the oversized flower heads of *Hydrangea* *arborescens* 'Annabelle' add a dreamy softness to the scheme while *Choisya × dewitteana* 'Aztec Pearl' and twice-flowering *Daphne tangutica* contribute irresistible fragrance. 'I'm a sucker for anything with scent', says Keith. 'We have lots of lilac around the garden too, including *Syringa vulgaris* 'Krasavitsa Moskvy', whose pink and white flowers are absolutely amazing.'

Signature plants

Although the heavy soil has claimed some surprising casualties (including the usually indestructible *Viburnum × bodnantense*), roses and spring bulbs adore such conditions and have become a Westbrook House signature. *Rosa* 'Buff Beauty' and *R.* 'Perle d'Or' are old favourites that Keith and David have grown before; others such as *R.* 'Martin Frobisher' and *R.* Jacqueline du Pré are noteworthy newcomers.

In the meadow, which is too fertile for traditional meadow flowers to thrive, David has planted thousands of old-fashioned, white and pale yellow daffodils (*Narcissus*)

The garden at Westbrook House, where colour, design and plantmanship combine, is the inspired co-production of Keith Anderson and David Mendel.

among the loose plantation of lilacs (*Syringa*) and species roses. The planting there took four years, with the layout being determined by individually placing scores of pots, each containing a different quantity of bulbs, in the grass. 'A very boring job' has paid dividends with a deliciously scented spring display featuring long drifts of *Narcissus pseudonarcissus*, *N. papyraceus* and *N.* 'Actaea', as well as the hoop-petticoat daffodil *N. bulbocodium* 'Conspicuus' and the rare nineteenth-century variety *N.* 'White Lady'.

In the orchard Nootka rose (*Rosa nutkana*) is 'an allusion to home' for American-born Keith, who grew up on Bainbridge Island (off the Seattle coast) where this rose was first described by Captain George Vancouver in the eighteenth century. In similar vein, David and Keith planted a *Prunus* 'Tai-haku' in honour of Collingwood 'Cherry' Ingram, the plant collector who reintroduced 'the great white cherry' to Japan in 1932 and who also happened to be the grandfather of Westbrook House's previous owner.

Also in the orchard, inspiration comes from closer to home, with smart rows of standard dessert, culinary and cider apple trees that reflect Somerset's apple-growing tradition. Chosen with help from Edward Clifton-Brown, who runs neighbouring West Bradley Orchards, the local varieties include *Malus domestica* 'Morgan's Sweet' and *M.d.* 'Somerset Redstreak'.

Although creating a garden in a rural location is not without challenges ('we had to do the orchard twice', admits David, 'because visiting deer didn't eat the grass, they ate the trees!'), after sixteen years the trees are beginning to look as though they are 'meant to be'. 'It's very satisfying being somewhere for a bit of time', reflects Keith on the garden-making process. 'Borders can come and go but I think the trees will be our legacy here.'

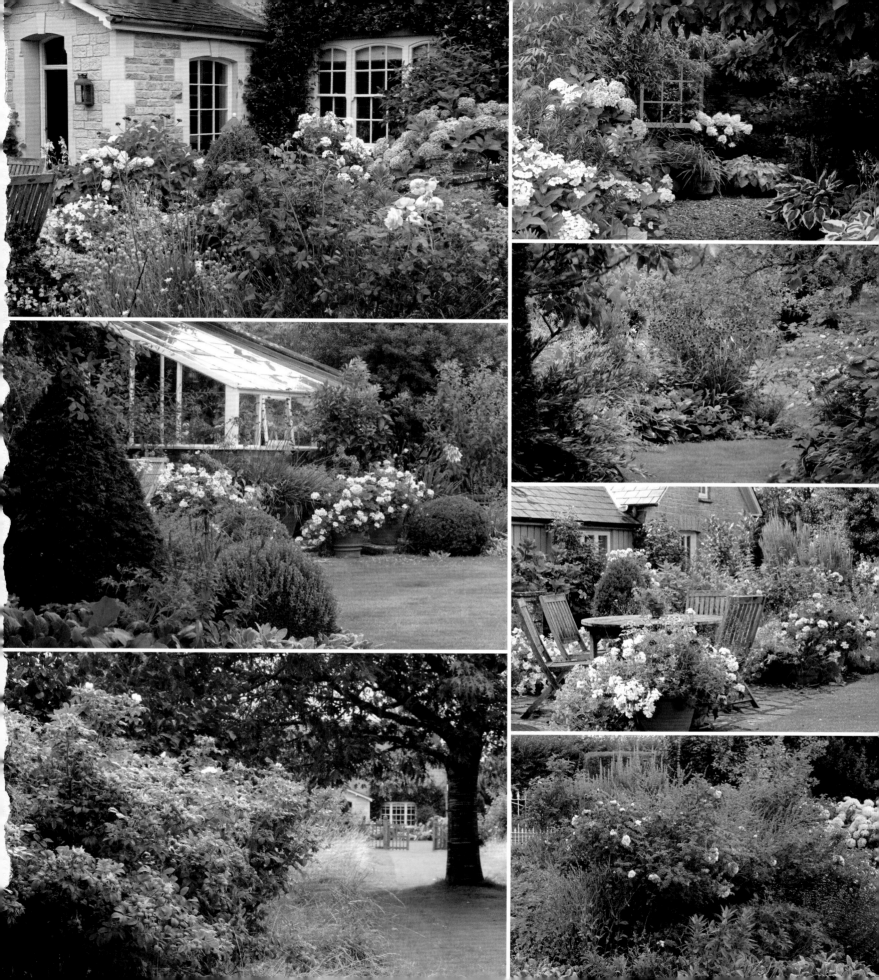

20
Yeo Valley Organic Garden
Blagdon

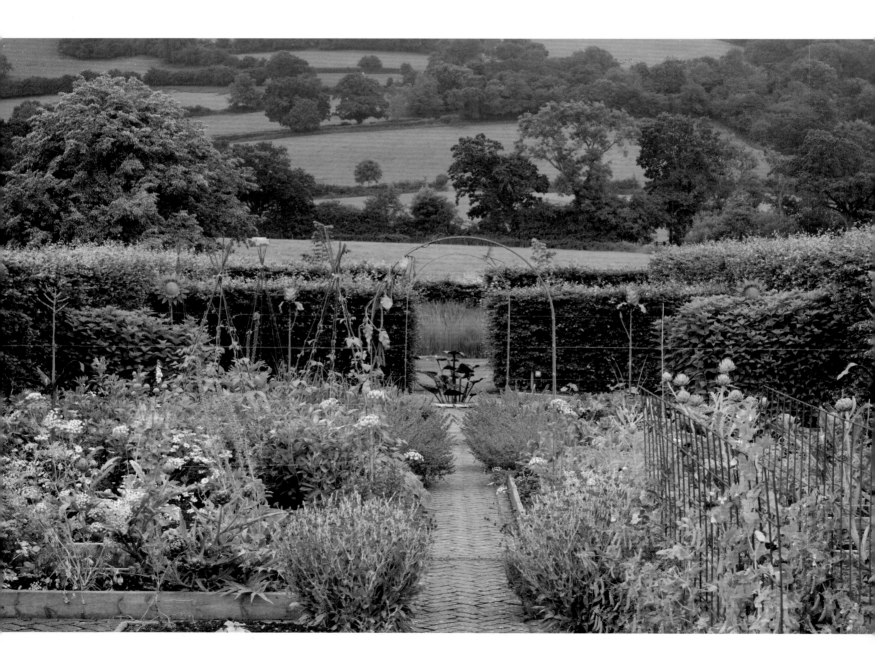

SOMERSET'S COUNTRYSIDE doesn't get much more green and rolling than at Holt Farm, the family farm that's at the heart of one of Britain's best-known organic brands. Yeo Valley founders Mary and Roger Mead bought the farm, at the foot of the Mendip Hills beside Blagdon Lake, sight unseen in 1961 on account of its fabulous grazing. Today its verdant fields and glossy-coated British Friesian cows embody the benefits of organic farming while also providing a pastoral backdrop to a garden where chemical-free cultivation is allied with great design and theatrical flair.

Created by the Meads' daughter-in-law Sarah since the mid-1990s, the Yeo Valley Organic Garden is one the few Soil Association-accredited ornamental gardens in the UK. 'It's

LEFT Being set on a sunny slope, the Vegetable Garden brims with edible produce and colourful companion plants.

BELOW The Yeo Valley Organic Garden benefits from the proximity of Blagdon Lake, a designated Site of Special Scientific Interest with a variety of wildlife-rich habitats.

important to me that, like the farm, we have accreditation', says Sarah. 'I want to show that proper organic gardening doesn't have to be "hair shirt". Although that's not to say it isn't a challenge.'

The garden's 2.6 hectares/6½ acres evolved piece by piece, gradually wrapping around the farmhouse where Sarah and Tim have lived since 1990, when Tim took over the business after his father died. Mary Mead – who still runs Holt Farm's herd of pedigree British Friesians – moved to a house in the village, leaving the newly married Sarah (a 'born and bred Londoner' who had experience of neither farming nor gardening) in charge of the farmhouse and its garden.

'My first reaction was "oh my God!" ', recalls Sarah, 'but I wanted to keep the garden nice for Mary so I started reading books, and visiting other people's gardens. It quickly became an obsession.' Landscape architect Eileen O'Donnell was a great ally early on, bringing practical know-how to Sarah's ideas and accompanying her on garden visits. Christopher Lloyd's book *The Well-Tempered Garden* was another formative

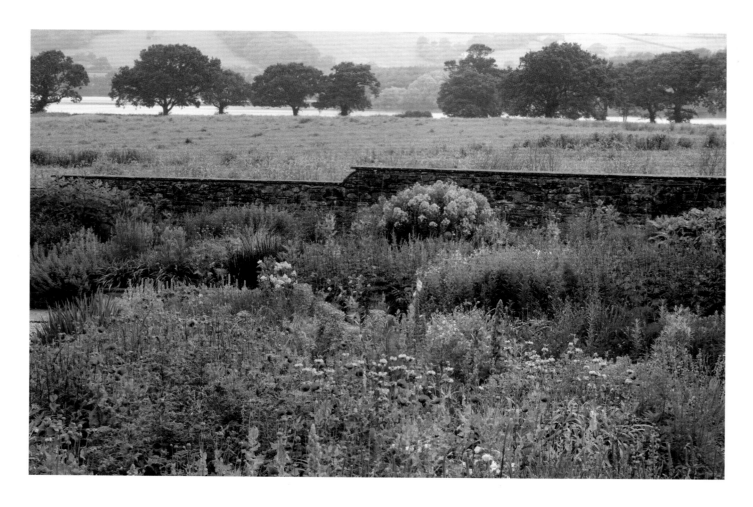

inspiration and responsible, Sarah says, for the avenue of *Malus hupehensis*, the first thing she planted. 'It's a bit of a "diva" moment', she admits, 'the blossom only lasts a week if it's windy – but what a week it is.'

Serious fun

Coming from a non-horticultural background, Sarah embarked on garden making with an open mind. 'I didn't set out to be an "organic gardener", it just never occurred to me not to be', she explains. 'The farm had been organic for years and it's just what we do here.' Sarah's original training as a dancer however has been influential, and her love of 'theatrical chutzpah' is evident in her extrovert planting and visual jokes such as the surreal neon thrones in the meadow and the vintage Mini repurposed as a planter.

Her sense of fun goes hand in hand with ambition and serious respect for the environment. As on the farm, the

approach is 'soil up'. 'The soil is our future, so we really take care of it', says Sarah. The large compost yard produces a ready supply of good-quality compost, although this is rationed, to avoid the soft and sappy growth that slugs and snails love. 'We grow our plants hard because they are not going to be mollycoddled with fertilizers and pesticides.'

Having been certified organic for nearly a decade, the garden's ecosystem supports a rich variety of invertebrate life including rare parasitic wasps and beetles. 'But we still have to hold our nerve and put nature first', explains Sarah. 'If you eradicate all your pests, there is nothing for predators to eat.' Successful organic gardening is also about picking your battles, and Sarah is reconciled to not having perfect lawns or being able to grow lilies (*Lilium*). 'We use plants that like us, and when they like us we tend to go mad with them. We've recently planted thousands of Dutch irises in the meadow, for example.'

Confident contemporary style

The garden is divided into different rooms, with each area being tended by a different member of the five-strong garden team – a point of principle for Sarah and head gardener Andi Strachan, who are both passionate about nurturing young horticultural talent. Sarah still regularly visits other gardens,

ABOVE A kite sculpture makes a witty statement above one of the miscanthus borders in the Ha-Ha Garden.
OPPOSITE Yeo Valley Organic Garden's other quirky details enhance the sense of fun and underline Sarah Mead's point that organic gardening doesn't necessarily preclude a sense of humour.

Over the years, the small, low-maintenance garden that Sarah inherited has evolved into a series of distinctive garden rooms that showcase her confident contemporary style.

with Eileen, Andi or en masse with the whole gardening team. 'I've been looking at gardens for thirty-odd years now, and I always come back buzzing with ideas.'

Overlooked by the Café Terrace and sheltered within beech (*Fagus*) hedges, the 'posh' Vegetable Garden occupies what used to be the family tennis court. Its immaculate rows of lettuce, squash, beans and onions offer a masterclass in ornamental productive growing. The crops are rotated for soil health and interplanted with clumps of pollinator-friendly plants such as fleabane (*Erigeron karvinskianus*), catmint (*Nepeta*) and *Ammi majus*.

Colour is key for Sarah, who meets with her team weekly to assess what's working and what's not. 'It's not enough to see flower colour in catalogues', she says firmly. 'You have to check it on the ground.' New plants are trialled for colour and habit in the Nursery Garden before being let loose in the borders, with less than 10 per cent making the grade.

The Red and Lime Garden is typical of Sarah's bold but meticulous approach. 'Lime-green was the starting point, and the red was chosen to "kick it up" a bit, but it has to be an orange-red, not a blue-red.' *Cornus alba* 'Aurea', yellow meadow rue (*Thalictrum flavum*), acid-yellow red hot poker (*Kniphofia*) and *Euphorbia epithymoides* provide the zingy counterpoint to *Pittosporum tenuifolium* 'Tom Thumb', ladybird poppies (*Papaver commutatum* 'Ladybird') and brilliant red *Rosa* L.D. Braithwaite and *R.* Trumpeter.

In the Bronze Garden the palette is softer, with twin borders filled with *R.* 'Buff Beauty', rusty foxglove (*Digitalis ferruginea*), *Primula bulleyana* and *Sisyrinchium* 'Biscutella'.

LEFT TOP A *Malus hupehensis* avenue separates the old and new wildflower meadows.

LEFT CENTRE The Big Grass Border echoes the lush green pastures of the borrowed landscape.

LEFT BOTTOM In early summer, field maples in the Ha-Ha Garden are accompanied by a dense underplanting of ox-eye daisies (*Leucanthemum vulgare*).

RIGHT ABOVE In the Red and Lime Garden the colour scheme is carefully calibrated, and plants of the wrong shade are swiftly removed.

RIGHT BELOW A very dark purple vegetable dye has been added to the pond in the Bronze Garden to give it an inky colour.

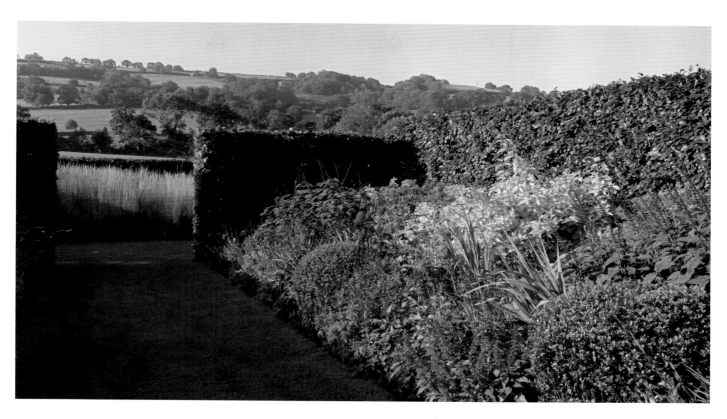

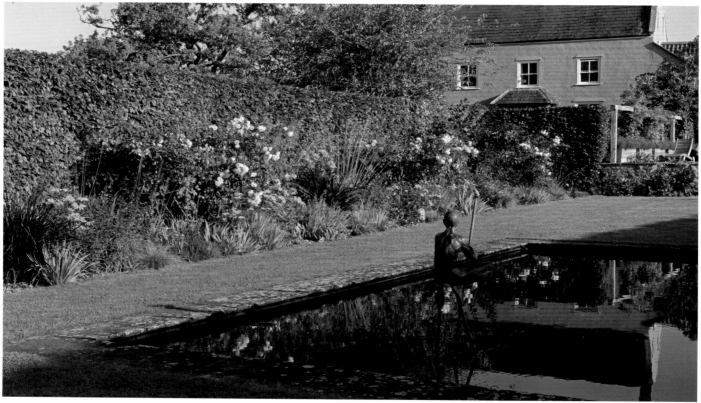

A bronze figure by Nicolas Lavarenne hovers over the inky water of the pond, an intentionally enigmatic presence. 'I like things that stop people in their tracks and become a talking point', explains Sarah. 'We're all too busy these days.'

The Big Grass Border is exactly what it says – a massed planting of *Calamagrostis × acutiflora* 'Karl Foerster' and golden oats (*Stipa gigantea*), which tower head high by summer's end. Ornamental onions (*Allium*), nectaroscordum and foxtail lily (*Eremurus robustus*) weave through the grasses, and Sarah plans to add more of the last. 'Their buff pink flower spikes look knockout against the stipa', she enthuses. 'Our approach is "that works, so let's go big on that".'

A variety performance

Creating not one but two wildflower meadows on Holt Farm's fertile clay has presented some challenges, but in the Old Wildflower Meadow a recent change of regime is already reaping results. By using a flail mower instead of heavy haymaking machinery and then hand raking the grass, Andi has encouraged yellow rattle (*Rhinanthus minor*) to spread, prompting a better display of fritillaries (*Fritillaria*) and camassias.

The Old Wildflower Meadow is over by midsummer but its counterpart, the New Wildflower Meadow planted by Andi in the winter of 2018/19, now takes up the baton with a dazzling high summer tapestry of cornflower (*Centaurea cyanus*), corn cockle (*Agrostemma githago*), cosmos, wild carrot (*Daucus carota*), corn poppies (*Papaver rhoeas*) and fragrant chamomile (*Chamaemelum nobile*), abuzz with hoverflies and bees.

Leading off the sunlit meadow, the shady Birch Grove is a change of tempo. Its soothing, white-on-white scheme teams pale birch (*Betula*) trunks with ghostly white foxglove (*Digitalis*) spires, simply underplanted with ferns. In spring the woodland floor is fleetingly carpeted with blue-flowered *Anemone blanda* and the yellow spikes of *Erythronium* 'Pagoda'.

Blagdon Lake – created in the late nineteenth century by damming the river Yeo to supply drinking water to nearby Bristol – and the gentle hills beyond are the bucolic borrowed landscape against which the Gravel Garden can shine. The high-octane performance starts with hundreds of yellow and blue Dutch irises and continues through until late summer with the radiant yellow spires of *Verbascum olympicum* and orange red hot pokers strutting their stuff amid a colourful chorus of drought-tolerant sage (*Salvia*), culver's root (*Veronicastrum virginicum*), rose campion (*Silene coronaria*) and *Phlomis russeliana*. After the intensely planted Gravel Garden, the Ha-Ha Garden is the calmly calibrated final act, where visitors can flop on an expansive lawn flanked by huge borders of miscanthus and groves of field maple (*Acer campestre*).

Sarah loves sharing the garden, and over the years it has become an important ambassador for Yeo Valley. 'The Meads have been farming in this area for over 400 years', she says, 'and we are so lucky here. We are in a beautiful place.'

OPPOSITE Yeo Valley owner Sarah Mead, here in the Birch Grove, works closely with her team of gardeners: Andi Strachan, Fay Sizer, Paul Warford, Zelah Cornelius-Richards and Matt Coe. Their canine helpers are Olive the spaniel and pugs Mabel and Ivy.

ABOVE Groves of coral bark willow (*Salix alba* var. *vitellina* 'Britzensis') anchor the New Wildflower Meadow. In winter their pollarded stems turn a vivid red and provide late season interest.

LEFT 'Divas' in the Gravel Garden include fiery red hot pokers and intense violet-blue delphiniums, which, as they are grown hard, do not require staking.

Visiting information

GARDENS

At the time of publication, all these gardens open to the public at some time during the year. Before travelling please check opening times on each garden's website or (if applicable) on the National Garden Scheme (NGS) website (www.ngs.org.uk/).

The American Museum and Gardens (see also page 8)
Claverton Manor, Bath BA2 7BD
Tel: 01225 460503; www.americanmuseum.org/
Open to the public March to November, and under the NGS once a year.

Barley Wood Walled Garden (see also page 14)
Long Lane, Wrington BS40 5SA
Tel: 01934 863713; www.walledgarden.co.uk/; www.theethicurean.com/
Working garden open to the public; home to The Ethicurean restaurant, Barley Wood Cider Barn and several artists' studios.

Barrington Court
Barrington, near Ilminster TA19 0NG
Tel: 01460 241938; www.nationaltrust.org.uk/barrington-court/
Romantic, Jekyll-influenced garden from the 1920s, with White Garden and productive walled Kitchen Garden; also roses, apple orchard and water features.

Batcombe House (see also page 20)
Gold Hill, Batcombe, Shepton Mallet BA4 6HF
www.mazzullorusselllandscapedesign.com/
Open to the public under the NGS once a year.

The Bishop's Palace (see also page 28)
Wells BA5 2PD
Tel: 01749 988111; www.bishopspalace.org.uk/
Open to the public year-round. RHS Partner Garden.

Broadleigh Gardens
Barr House, Bishops Hull, Taunton TA4 1AE
Tel: 01823 286231; www.broadleighbulbs.co.uk/
The gardens created at Barr House by Lady Christine Skelmersdale combine superb plantsmanship with the chance to see 'behind the scenes' at a leading UK nursery. As an authority on bulbs, and an RHS Chelsea Flower Show gold medallist, Christine's garden is a masterclass in using bulbs for year-round interest. Showtime starts in late winter with snowdrops (*Galanthus*), followed by drifts of spring bulbs beneath flowering trees and shrubs; irises then feature. Agapanthus provides a midsummer highlight, and colchicums and nerines bring up the rear in early autumn. A newly planted South African bed in the Walled Garden reflects Christine's interest in plants from this area, while in the Gravel Garden she is trialling amarines, a new hybrid of amaryllis and nerines. Visitors can also look around the nursery, where Christine has raised numerous successful cultivars including Pacific Coast irises such as 'Broadleigh Angela' and the AGM-winning *Agapanthus inapertus* subsp. *intermedius* 'August Bells'.

Chalice Well Gardens
Chilkwell Street, Glastonbury BA6 8DD
Tel: 01458 831154; www.chalicewell.org.uk/
Some 1.2 hectares/3 acres of gardens and orchards surround the Chalice Well, whose healing chalybeate waters have been in demand for more than 2,000 years, and can still be sampled here. Soak up the peaceful atmosphere or perhaps meditate on the view to Somerset's most iconic landmark, Glastonbury Tor.

Common Farm (see also page 36)
Barrow Lane, Charlton Musgrove BA9 8HN
Tel: 01963 32883; www.commonfarmflowers.com/
Working flower farm that can be visited on pre-booked tours in June and July.

Cothay Manor (see also page 40)
Greenham TA21 0JR
Tel: 01823 672283; www.cothaymanor.co.uk/
Open to the public April to September and by appointment to groups year-round. Also open under the NGS once a year.

Dunster Castle
Dunster, near Minehead TA24 6RL
Tel: 01643 821314; www.nationaltrust.org.uk/dunster-castle-and-watermill/
Occupying a fairy-tale location on a wooded hill overlooking Dunster beach and the Bristol Channel, the garden's balmy micro-climate is reflected with subtropical and Mediterranean plants.

East Lambrook Manor (see also page 48)
South Petherton TA13 5HH
Tel: 01460 240328; www.eastlambrook.com/
Open to the public February to October, and under the NGS twice a year. RHS Partner Garden.

Elworthy Cottage (see also page 56)
Elworthy, Taunton TA4 3PX
Tel: 01984 656427; www.elworthy-cottage.co.uk/
Open to the public under the NGS on selected days February to August. Also open by appointment April to September and in February.

Forde Abbey & Gardens

Forde Abbey, Chard TA20 4LU

Tel: 01460 220231; www.fordeabbey.co.uk/

Forde Abbey's history stretches back to the twelfth century, when it was a Cistercian monastery, while its modern gardens have their origins in the eighteenth century, when Sir Francis Gwyn laid out lawns, ponds and avenues of trees according to the landscape fashion of the day. Today the 12-hectare/30-acre gardens, which include huge herbaceous borders, a walled Kitchen Garden and a joyfully over-the-top Bog Garden, are enjoying a renaissance under the inspired head gardenership of Joshua Sparkes, formerly a gardener at Sissinghurst. Sparkes is known for his sustainable style of gardening, and his nature-inspired planting is putting Forde Abbey on the map. Every spring thousands of colourful massed tulips now weave their way through the border perennials and lawns, with Sparkes choosing long-lasting varieties such as *Tulipa* 'Apeldoorn' and 'Negrita'; he plants them deeper than usual to encourage their perennial tendencies.

Forest Lodge (see also page 60)

Pen Selwood BA9 8LL

Tel: 07974 701427

Open to the public under the NGS twice a year. Also open to groups by appointment April to September.

Greencombe Gardens (see also page 66)

Porlock TA24 8NU

Tel: 01643 862363; www.greencombe.org/

Open to the public daily April to July, and under the NGS twice a year.

Hauser & Wirth Somerset (see also page 72)

Durslade Farm, Dropping Lane, Bruton BA10 0NL

Tel: 01749 814060; www.hauserwirth.com/locations/10068-hauser-wirth-somerset/

Open to the public year-round.

Hestercombe (see also page 78)

Cheddon Fitzpaine, Taunton TA2 8LG

Tel: 01823 413923; www.hestercombe.com/

Open to the public year-round (except Christmas Day); also under the NGS three times a year.

Iford Manor (see also page 86)

Iford, Bradford-on-Avon BA15 2BA

Tel: 01225 863146; www.ifordmanor.co.uk/

Open to the public April to September, and under the NGS once a year.

Kilver Court (see also page 92)

Kilver Court, Kilver Street, Shepton Mallet BA4 5NF

Tel: 01749 340410; www.kilvercourt.com/

Open to the public year-round, and under the NGS twice a year. RHS Partner Garden.

Lower Severalls Farmhouse & CB Plants

Lower Severalls, Crewkerne TA18 7NX

Tel: 07851 468430; www.cbplants.co.uk/

A cottage garden in the Margery Fish tradition. Mary Pring is the third generation of the family to garden here, and she grew up gardening alongside her parents, who took her to visit East Lambrook Manor (see page 48). Mary started her own nursery in the 1980s and specialized in herbs before expanding into old-fashioned cottage garden perennials. She soon began hosting Plant Heritage plant fairs. In the garden alongside the nursery Mary showcases a magnificent double border that runs alongside the seventeenth-century longhouse and a 'wadi' garden flanked by banks of cranesbill (*Geranium*). Mary switched her focus to running Lower Severalls as a B&B in 2011. The nursery is now called CB Plants (see page 141). Although Lower Severalls no longer opens to the public, the garden can be seen on RHS workshop and plant fair days, and by appointment for groups.

Lytes Cary Manor

near Somerton TA11 7HU

Tel: 01458 224471; www.nationaltrust.org.uk/lytes-cary-manor/

Arts and Crafts garden with mature topiary, community allotments and a popular circular walk along the river Cary.

Midney Gardens (see also page 98)

Mill Lane, Midney TA11 7HR

Tel: 01458 274250; www.midneygardens.co.uk/

Open to the public from Easter to July, and under the NGS once a year. RHS Partner Garden.

Milton Lodge Gardens (see also page 104)

Old Bristol Road, Wells BA5 3AQ

Tel: 01749 679341; www.miltonlodgegardens.co.uk/

Open to the public from Good Friday to September, and under the NGS three times a year.

Montacute House

Montacute TA15 6XP

Tel: 01935 823289; www.nationaltrust.org.uk/montacute-house/

Elizabethan mansion surrounded by parkland and with gardens featuring massed tulip displays in spring, and mixed flower borders in summer.

The Newt in Somerset (see also page 110)

Hadspen House, Castle Cary BA7 7NG

Tel: 01963 577777; www.thenewtinsomerset.com/

Open to the public year-round.

Stoberry House (see also page 118)

Stoberry Park, Wells BA5 3LD

Tel: 01749 672906; www.stoberryhouse.co.uk/

Open to the public under the NGS once a year, and by appointment for groups.

Templecombe Railway Station

www.templecombevillage.uk/station.html/
Gardened by the green-fingered Friends of Templecombe Station, this station garden on Great Western Railway's Waterloo to Exeter line makes departure or arrival a delight. With a neatly mown lawn and well-stocked mixed borders, the station offers much more than the usual displays of hanging baskets, as its numerous awards attest. Being located on the disused southbound platform side, the garden cannot be accessed by visitors, but can be admired from the far platform (or from the train). The bronze sculpture, *Tempus Fugit,* is part of a sundial depicting a railwayman scattering a timetable to the wind.

Tintinhull Garden

Farm Street, Tintinhull, Yeovil BA22 8PZ
Tel: 01458 224471; www.nationaltrust.org.uk/tintinhull-garden/
Well-tended Arts and Crafts garden with 'rooms', created by Phyllis Reiss between 1933 and 1961 and later gardened by Penelope Hobhouse.

Tyntesfield

Wraxall, Bristol BS481NX
Tel: 01275 461900; www.nationaltrust.org.uk/tyntesfield/
The restored High Victorian gardens feature formal terraces with colourful bedding schemes, Rose Garden and productive walled Kitchen Garden, set against the backdrop of a sprawling Gothic Revival house, built by William Gibbs as a family home in 1844.

University of Bristol Botanic Garden

The Holmes, Stoke Park Road, Stoke Bishop, Bristol BS9 1JG
Tel: 0117 4282041; https://botanic-garden.bristol.ac.uk/
Established in 1882, the garden moved to its current site in 2005. Highlights include a local flora and rare native collection, Chinese and Western herb gardens, tropical and subtropical collections and the evolution collection, telling the 200-million-year-old story of plants.

The Walled Garden at Mells

5 Rectory Cottages, Selwood Street, Mells BA11 3PN
Tel: 01373 812597; www.thewalledgardenatmells.co.uk/
The origins of this peaceful walled garden date to medieval times when it was owned by Glastonbury Abbey and would have grown medicinal herbs. Its current incarnation began in 2009 when Jo Illsley, an ecologist, developed its cottagey herbaceous borders. Sam Evans took over in 2018 and has refocused the garden to encompass a horticulture-based social enterprise alongside the plant nursery and a café, which opens April to September. In spring visitors dine amid effervescent ornamental onions (*Allium*), columbine (*Aquilegia*), rocket (*Eruca vesicaria*), lady's mantle (*Alchemilla mollis*) and voluptuous peonies. In high summer, the borders brim with agapanthus and Japanese anenomes (*Anemone × hybrida*) while apples (*Malus domestica*) hang heavy on the trees and grasshoppers chirr in the neighbouring meadow. Sam is passionate about the garden's potential for promoting well-being at the heart of the community. Her vision is gaining momentum, with a redesign of the nursery space planned and community groups already reaping the rewards of holistic horticulture.

The Walled Gardens of Cannington

Church Street, Cannington TA5 2HA
Tel: 01278 655042; www.canningtonwalledgardens.co.uk/
This mini botanic garden packs a lot of interest into its 0.8 hectares/2 acres. Set within the walls of a medieval priory near the Somerset coast, the garden's warm microclimate nurtures a variety of planting schemes including a hot-coloured herbacacous border, a Southern Hemisphere Garden, a Dry Garden and a Stumpery. The Botanical Glasshouse (the only one of its kind in Somerset) contains six biomes and is full of curiosities. An RHS Partner Garden, the Walled Gardens is run on organic lines by head gardener Aymeric Huguerre. The garden's show-stopping centrepiece, the subtropical borders, are presided over by three pairs of foxglove trees (*Paulownia tomentosa*). Aymeric pollards these heavily so they produce enormous jungly leaves that set the scene for an exotic collection that includes lilies (*Lilium*), Indian shot plant (*Canna*), pineapple flower (*Eucomis*) and angels' trumpets (*Brugmansia*).

Wayford Manor

Wayford, Crewkerne TA18 8QG
Somerset is book-ended by sublime Harold Peto gardens. Like Iford Manor (see page 86) to the east, Wayford was a family affair for Peto, being designed for his sister Helen and her husband Lawrence Ingham Baker in 1902–1905. Italianate balustrades, terraces and architectural antiquities mark Wayford as a Peto garden, but its legacy of magnificent trees is due to Ingham Baker, and his friendship with the plantsman Sir Eric Savill. Ingham Baker's long-serving head gardener Ron Garrett also played a key role, nurturing the rhododendrons and magnolias that are a Wayford signature. The most venerable of these, a vast *Magnolia × soulangeana* in the Rose Garden, is a Peto planting. For the current head gardener, Chris Whitfield, gardening at Wayford is about 'keeping the balance of it, not getting caught up in the detail and seeing the bigger picture'. His light-touch approach ensures that the garden doesn't become too manicured or fussy. With 1.6 hectares/4 acres in his care, his workload is varied, from 'colour correcting' the all-blue scheme in the Iris Garden to haymaking in the Wildflower Meadow. In spring this area is a glorious riot of old-fashioned daffodils (*Narcissus pseudonarcissus* and *N. poeticus*). Recently Chris made a woodland path along which newly planted rhododendron cultivars such as 'Cunningham's White' and 'Blue Peter' are settling in among established specimens and other acid lovers such as enkianthus and drimys. The most secret of Somerset's 'secret' gardens, Wayford is at its best in spring, when it opens for the NGS, a tradition that has been continued by successive owners since 1927. Open to the public under the NGS once a year.

Westbrook House (see also page 124)
West Bradley BA6 8LS
Tel: 01458 850604
Open to the public under the NGS twice a year, and by appointment April to September.

Yeo Valley Organic Garden (see also page 130)
Holt Farm, Blagdon BS40 7SQ
Tel: 01761 462798; www.yeovalley.co.uk/
Open to the public April to September, and under the NGS once a year, and for groups by appointment. (NB Do not use sat nav when travelling to the garden, please see map on website for directions.)

NURSERIES

Avon Bulbs
Burnt House Farm, Mid Lambrook, South Petherton TA13 5HE
Tel: 01460 242177; www.avonbulbs.co.uk/
Visitors to RHS shows will know the quality and range of plants produced by Avon Bulbs from their stands, which regularly win gold medals (thirty from RHS Chelsea Flower Show alone). The 1.6-hectare/4-acre nursery ground near East Lambrook Manor (see page 48) produces temptation aplenty for the discerning gardener, including lovely selections of nerine, agapanthus, eucomis and gladioli. Their snowdrops (*Galanthus*) are particularly sought after, and include such collectors' varieties as 'Bitter Lemons', 'Ariadne' and their own 'Midas'. The nursery is not open to the public, but their twice-yearly catalogues make up for this, being beautifully illustrated and informative.

CB Plants
Lower Severalls Nursery, Crewkerne, TA18 7NX
Tel: 07851 468430; www.cbplants.co.uk/
Delightful small nursery run by Catherine Bond and based at Lower Severalls Farmhouse (see page 139) selling a well-edited selection of pollinator-friendly, cottage-garden perennials and herbs.

Chelston Nurseries
Chelston, Wellington TA21 9PH
Tel: 01823 662007; www.chelstonnurseries.co.uk/
Now a retail operation, this long-standing family nursery has been going since 1951. Many of their plants are still grown on site, and the selection includes bedding plants, herbaceous perennials, shrubs and climbers.

Chew Valley Trees
Winford Road, Chew Magna, Bristol BS40 8HJ
Tel: 01275 333752; www.chewvalleytrees.co.uk/
Founded in 1986 with the aim of growing native broadleaved trees from seed, this specialist tree and hedge nursery container grows a wide range of hardy trees, shrubs, hedging and fruit trees.

Cleeve Nursery
138 Main Road, Cleeve, Bristol BS49 4PW
Tel: 01934 832134; www.cleevenursery.co.uk/
A well-stocked general nursery selling a useful range of plants that are grown at their own nursery.

Desert to Jungle
Lower Henlade, Taunton TA3 5NB
Tel: 01823 443701; www.deserttojungle.com/
An exotic-plant nursery stocking palms, bamboos, tree ferns, cacti, agave, ginger (*Zingiber*) and canna.

Elworthy Cottage Plants
Elworthy, Taunton TA4 3PX
Tel: 01984 656427; www.elworthy-cottage.co.uk/
Unusual hardy cottage plants, with a focus on herbaceous perennials such cranesbill (*Geranium*), geums and astrantias, as well as violas and primroses (*Primula vulgaris*). The nursery is also known for snowdrops (*Galanthus*). See also page 56.

Greenshutters Nurseries & Garden Centre
Fivehead, Taunton TA3 6PT
Tel: 01823 39006; www.greenshutters.co.uk/;
www.evergreenhedging.com/
Garden centre and on-site nursery stocking trees, shrubs and herbaceous perennials, with a major sideline in growing evergreen hedging plants.

Hewitt-Cooper Carnivorous Plants
The Homestead, Glastonbury Road, West Pennard BA6 8NN
Tel: 07702 190518; www.hccarnivorousplants.co.uk/
Nick Hewitt-Cooper's selection of sarracenia, drosera, darlingtonia and other carnivorous plants can be purchased online or from his always eye-catching stand at flower shows around the country.

In Clover
1 Rose Cottage, Long Lane, Dinder, Wells BA5 3PH
Tel: 01749 676893
Specializes in hardy perennials as well as unusual native shrubs and perennials. Open to the public by appointment.

Kapunda Plants
Kapunda, Southstoke Lane, Bath BA2 5SH
Tel: 01225 832165; www.kapundaplants.co.uk/
Owner Juliet Davis specializes in hybridizing Lenten roses (*Helleborus × hybridus*), displays of which can be seen in the 0.8-hectare/2-acre garden, which opens by appointment for garden societies and clubs in spring and early summer. Kapunda Plants is a regular exhibitor at the rare plant fair at The Bishop's Palace, Wells (see page 28).

Kelways Garden Centre & Nursery
Picts Hill, Langport TA10 9EZ
Tel: 01458 250521; www.kelways.co.uk/
Nursery founded in 1851 and specializing, then as now, in peonies and bearded irises.

Kerton Sweet Peas
North Farm Cottage, 14 Bristol Road, Pawlett, Bridgwater TA6 4RT
Tel: 01278 683517; www.kertonsweetpeas.co.uk/
Offers more than fifty varieties of sweet peas (*Lathyrus odoratus*) including many award-winning varieties such as 'Kate Cumberpatch'. Plants and seeds are available to buy online, from local shows and from the nursery from early to mid-spring; in summer, bunches of cut sweet peas can be bought at the garden gate.

Longacre Plants
South Marsh, Charlton Musgrove, Wincanton BA9 8EX
Tel: 01963 32802; www.plantsforshade.co.uk/
Mail-order nursery specializing in unusual woodland plants and plants for shade. The extensive selection includes cranesbill (*Geranium*) and ferns, hellebores and tiarella and plants such as epimedium and brunnera for dry shade.

Mallet Court Nursery
Marshway, Curry Mallet, Taunton TA3 6SZ
Tel: 01823 481493; www.malletcourt.co.uk/
Specializes in rare and unusual trees, with a particular focus on oaks (*Quercus*) and maples (*Acer*), as well as shrubs and other woody plants. Recent introductions include *Quercus glabrescens* (from Mexico) and *Q. griffithii* (from the Himalayas). The nursery prides itself on growing plants from seed so its trees have their own roots and are not grafted.

Margery Fish Plant Nursery
East Lambrook Manor Gardens, East Lambrook, South Petherton TA13 5HH
Tel: 01460 240328; www.eastlambrook.com/
Cottage garden plants, with snowdrops (*Galanthus*) and cranesbill (*Geranium*) being a special focus. See also page 48.

Mill Cottage Plants
Henley Mill, Wookey BA5 1AW
Tel: 01749 676966; https://millcottageplants.co.uk/
Specializies in rare hydrangeas, Benton irises and epimediums. The nursery and garden are open by appointment. Sally Gregson's 0.8-hectare/2-acre garden has been developed over thirty years and is open for groups by appointment with good things to see from spring to summer, including hellebores and old roses, as well as her signature epimediums and hydrangeas.

Somerset Sweet Peas
17 King George Road, Minehead TA24 5JD
Tel: 01643 705521; www.somersetsweetpeas.com/
Peter King's mail-order seed catalogue includes homebred varieties (such as the AGM-winning Spencer sweet pea *Lathyrus odoratus* 'Somerset Lady'), Grandifloras and old-fashioned scented varieties (such as 'Lord Nelson'). Also stocks varieties bred by the award-winning New Zealand plant breeder Dr Keith Hammett, including the justly popular 'High Scent'.

Triscombe Nurseries
West Bagborough, Taunton TA4 3HG
Tel: 01984 618267; www.triscombenurseries.co.uk/
Offers a large selection of herbaceous and alpine plants as well as a huge choice of roses. Also specializes in fruit trees, stocking unusual local varieties such as the 'Dunster Plum' and apples including 'Yarlington Mill' and 'Cheddar Cross'.

GARDEN EVENTS
Glorious Somerset Gardens
www.st-margarets-hospice.org.uk/
Every summer more than fifty Somerset gardens, great and small, open to raise funds for St Margaret's Hospice, a charity that cares for patients and their families facing a life-limiting illness. Season tickets are available.

PLANT FAIRS
https://plantfairs.co.uk/
Charity plant fairs held in summer at handpicked gardens in Somerset and Dorset and featuring an equally eclectic and worthwhile selection of specialist nurseries. Somerset locations include Yarlington House and Midney Gardens (see page 98).

Rare Plant Fair
Tel: 0845 468 1368; www.rareplantfair.co.uk/
Organizes plant fairs featuring selected specialist nurseries. Fairs are held in the grounds of beautiful and unusual gardens around the country, including The Bishop's Palace, Wells (see page 28).

Shepton Mallet Snowdrop Festival
www.sheptonsnowdropfestival.org.uk/
A mid-February festival celebrating James Allen, aka the 'Snowdrop King'. A native son of Shepton Mallet, Allen was a self-taught horticulturalist who bred some one hundred new snowdrop (*Galanthus*) varieties in the nineteenth century – 'Merlin' and the AGM-winning 'Magnet' among them. The Snowdrop Festival – one of the earliest in the horticultural calendar – offers galanthophiles the opportunity to buy interesting varieties from local specialist nurseries such as Avon Bulbs (see page 141) and Elworthy Cottage Plants (see page 141).

Somerset gardens open for charity

www.ngs.org.uk/

The National Garden Scheme (NGS) harnesses the English and Welsh obsession with gardening to raise money for nursing and health charities. When the scheme started in 1927 some 600 private gardens opened their gates to the public for a 'shilling a head'; today more than 3,500 gardens take part in the scheme and help to raise millions of pounds every year. More than 150 gardens open for the NGS in Somerset, and these range from country estates to small urban gardens.

Taunton Flower Show

Vivary Park, Taunton [sat. nav. code] TA1 3QE
Tel: 01823 332010; www.tauntonfs.co.uk/

This is the country's 'oldest, longest-running flower show' and it has been organized by Taunton Deane Horticultural and Floricultural Society since 1831. The show takes place every August in the centre of Taunton, and is a highlight of the local horticultural calendar. Nicknamed 'the Chelsea of the West', it's on a very much smaller scale than the London flower show, but is nonetheless a great place to discover local nurseries, and chat to specialist plant breeders and local plant societies.

HORTICULTURAL SOCIETIES

Plant Heritage

www.plantheritagesomerset.org.uk/

Plant Heritage is a charity dedicated to conserving cultivated plants in the British Isles through 'living libraries' of plant collections, looked after by its members. The Somerset group meets at Edington Village Hall, TA7 9HA and runs a busy programme including plant sales, talks and visits to gardens and National Collections.

Somerset Gardens Trust

www.somersetgardenstrust.org.uk/

This voluntary organization and educational charity works with garden owners, local authorities and the community to protect and care for the county's parks and gardens.

Somerset Hardy Plant Society

https://somersethps.com/

Hardy herbaceous perennials are the backbone of many a British garden, and the Hardy Plant Society (HPS) is dedicated to promoting and conserving this valuable group of plants. Membership benefits include access to the HPS Seed List of rare and unusual seeds, as well as garden visits and talks. The Somerset group meets at West Monkton Village Hall, Monkton Heathfield, Taunton TA2 8NE.

ACKNOWLEDGMENTS

I would like to thank all the garden owners and head gardeners for greeting the initial idea of this book with such enthusiasm and for allowing me to share their gardens in these pages. They have been unfailingly generous with their time and knowledge; I am indebted to them. Sharing the journey around Somerset's gardens with Clive Boursnell has been a delight, and I thank him for the energy and commitment he has brought to the project, and of course for his masterful photography. My thanks go also to Helen Griffin at Frances Lincoln for commissioning and guiding the book to publication, to Joanna Chisholm for so skilfully editing my copy and to Anne Wilson for her painstaking and beautiful design.

This book would probably not have happened without the timely encouragement of Susan Bennett, the indefatigable National Garden Scheme (NGS) organizer for north-west London.

The book would not have been possible without the following people, who I also thank: Janet Alcock; Helen Allsebrook; Catherine Bond; Laura Briggs; Emma Busby; Andrew Cannell; Arthur Cole; Laura Cook; Mark Cox; James Cross; Iain Davies; Nickie Davies; Mark Dumbelton; Samantha Evans; Mandy Fowler; Mike Glier; Claire Greenslade; Eric Groft; Elly Hawley; Debra Henderson; Lili Herrera; Erica Holt; Laura Howard; Aymeric Huguerre; Chris Inchley; Kim Legate; Rob Lyons; Merryn Kidd; Ben Knight; You Li; Ludo McCormick; Justin Maglione; Chris Marchant; David Milnes; Margaret Moles; Jessica Parkhouse; Pek Peppin; Hayley Philp; Carolyn Phimister; Mary Pring; Russell Rigler; Sue Seager; Barbara Segall; Troy Scott Smith; Lady Christine Skelmersdale; Bella Skertchly; Jane Southcott Andi Strachan; Richard Wendorf; Philip White; and Chris Whitfield. **Abigail**

The joy, privilege and honour of being able to work in so many gardens never leaves me, not for a minute, and this time is no exception, plus the wonderful bonus of discovering Somerset in a way I have not been able to do before. I have felt utter delight as I entered each of the gardens for this book, each and every one a new world opening its very soul to me, while the generous warmth of welcome I have received from every owner and head gardener with their teams has been second to none. It is to all the garden owners and gardeners that I offer from my heart a very big thank you. I have been so happy being able to sleep in my camper bus in your gardens; my excitement and delight to see and work in your gardens at first light will forever remain with me.

Not alone could I have made this book. I thank Helen Griffin my editor from Frances Lincoln for the commission and her never-ending support. To Abigail Willis, the author, who has been a total delight to work with. To Anne Wilson, the designer, who I'm sure has nearly drowned in just my edited pictures that I gave her to work with. To Joanna Chisholm for keeping me on track. And to my better half Barbara who has had so much to put up with, with my comings and goings and, when I was at home, my being for hours, days on end eyes glued to the computer, downloading, editing or making Tiffs of the chosen pictures for printing. To one and all, thank you from my heart for the privilege to work. **Clive**

Index